ARTIST'S HANDBOOK:

WATERCOLOR

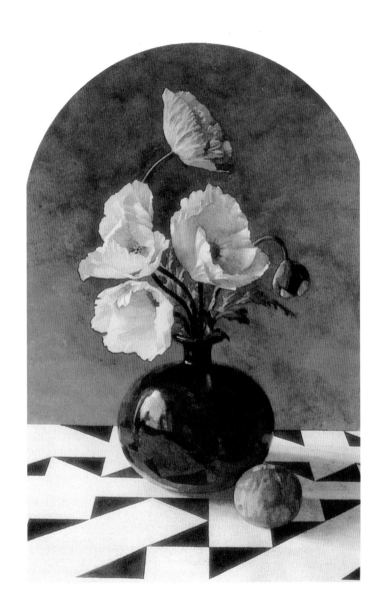

ARTIST'S HANDBOOK:
WATERCOLOR

materials • techniques • color and
composition • style • subject

Edited by SALLY HARPER

BARRON'S

AN OCEANA BOOK

First edition for North America published in 2003 by
Barron's Educational Series, Inc.

Copyright © 2003 Quantum Publishing Ltd.

All inquiries should be addressed to:
Barron's Educational Series, Inc.
250 Wireless Boulevard
Hauppauge, New York 11788
http://www.barronseduc.com

International Standard Book No. 0-7641-5619-5

Library of Congress Catalog Card No. 2002107842

This book is produced by
Oceana Books
6 Blundell Street
London N7 9BH

QUMWAH

Manufactured in Singapore by Pica Digital Pte Ltd.
Printed in Hong Kong by Paramount Printing Co. Ltd.

9 8 7 6 5 4 3 2 1

Contents

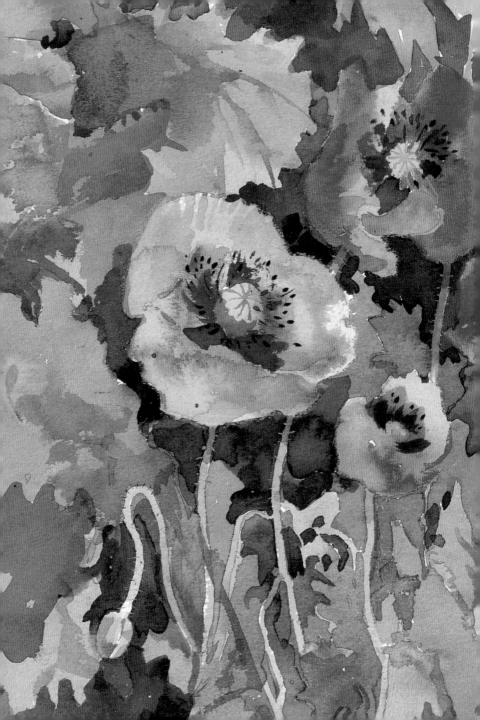

Introduction

Of all the paint media, watercolor is perhaps the most idiosyncratic. With watercolor, what is done is done. Depending on the technique used, once applied to paper, a watercolor wash will stay there. But the very unpredictable nature of watercolor painting also brings special satisfaction to the artist. There is intense pleasure involved in working with watercolor and adapting to it, rather than determining from the outset what the result will be.

The art of watercolor painting has a history that stretches back over 40,000 years. The first known examples were cave paintings, using thick applications of opaque water-based paint. Early Chinese artists, however, used soft-haired brushes and worked on silk and rice paper, whose absorbent surfaces encouraged the use of delicate, transparent washes. With just a few fine strokes, these artists captured a mood of atmospheric space in their landscapes, anticipating by several centuries the work of western watercolor artists such as Turner and Girtin.

This is the strength of watercolor: its ability to let the texture and tone of the paper mingle with the vivacity of the paint, creating that illusion of light and depth for which many artists strive. True, watercolor may have a mind of its own, but that is all part of the excitement of this intriguing medium.

"I don't do watercolor, it's far too difficult" is a remark often heard from amateur painters, even those who regard themselves as reasonably proficient in other media, such as oils. It cannot be denied that some people find watercolors a little harder to use than oils. This very attractive medium is sometimes unpredictable, but this very unpredictability should be regarded as a virtue, not a drawback. What people really mean when they make this kind of remark is that watercolors cannot be altered over and over again as oils can; a color or wash, once laid down on the paper, must stay there. To some extent this is true, and it is understandable that people should feel a certain nervousness when approaching a watercolor. But, in fact, many alterations can be made, and often are, as a painting progresses: a wash in a color that has not come out quite right can be changed dramatically by applying another wash on top of it; areas can be sponged out or worked over; and if the worst comes to the worst the whole painting can be put under running water and washed away.

Watercolor has many virtues, its main attraction for artists being its freshness and translucence, making it ideal for a variety of subjects, especially landscapes and flower paintings. As its name implies, pure watercolor is mixed with water and is transparent, so that it must be applied from light to dark, unlike oil paint or acrylics, which are opaque and can be built up from dark to light. Highlights consist of areas of the paper left white or very pale washes surrounded by darker ones. A certain amount of pre-planning is necessary at an early stage to work out where the highlights are to be, but some planning is always needed for painting or drawing, whatever medium is being used.

No one ever quite knows how watercolor will behave, and many watercolor artists find this very unpredictability one of its greatest assets. The purely practical advantages of watercolor painting are that you need little expensive equipment, the painting can be done more or less anywhere provided there is enough light, and paints can be cleaned up quickly, leaving no mess. Since the paper is relatively cheap, experiments and mistakes are not very expensive.

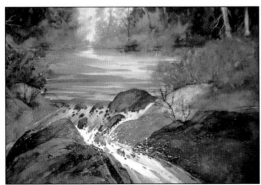

LIBERTY WATERFALL
Shirley McKay

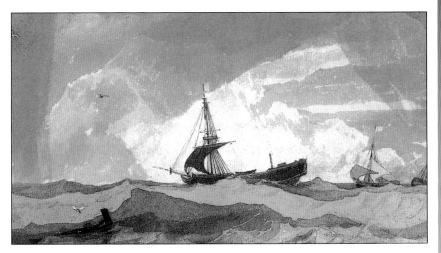

The Medium

Watercolor, like all paint, is made by mixing pigment with a binding agent, in this case gum arabic, which is soluble in water. There are two types of watercolor, "pure" or "classical" watercolor, which is transparent, and gouache, or "body color," which is the same pigment made opaque by adding white pigment to the binder. The technique of gouache painting is similar to that of oil or acrylic, since light color can be laid over dark, and is outside the scope of this book; but gouache is quite frequently used in conjunction with pure watercolor. Its use is a source of constant controversy among watercolorists: some claim that it destroys the character of the medium – its luminosity – and should never be used; others combine the two with considerable success. Nowadays there is a general trend toward mixing

THE DISMASTED BRIG John Sell Cotman
The rain-swept sky has been treated in bold, broad masses, and the swirling movement of the waves has been used to make a geometric pattern of different-sized triangles.

different media, and watercolor is often used with pastel, pen and ink, pencils or crayons (see "Techniques"). It can be a useful exercise, when a watercolor has "gone wrong," to draw into it with inks or pastels to see the effects that can be achieved.

The History of Watercolor Painting

It is commonly believed that watercolor was invented by the English landscape painters of the eighteenth century, but this is far from so. Watercolor has been in use in various forms for many centuries. Indeed the ancient Egyptians used a form of it for painting on plaster to decorate their tombs; the great frescoes of Renaissance Italy were painted in a kind of watercolor; it was used by medieval manuscript illuminators, both in its "pure" form and mixed with body color; the great German artist, Albrecht Dürer (1471–1528), made use of it extensively, and so did many botanical illustrators of the sixteenth century and the Dutch flower painters of the seventeenth century.

It was, even so, in eighteenth-century England that watercolor painting was elevated to the status of a national art. A new interest in landscape painting for its own sake culminated in the work of John Constable (1776–1837), the fore-runner of the Impressionists. Landscape had hitherto been purely topographical – a truthful and detailed record of a particular place – but in the hands of artists such as Paul Sandy (1725–1797), Thomas Girtin (1775–1802), Francis Towne

STUDY OF CIRRHUS CLOUDS
John Constable
English painter John Constable revolutionized the art of watercolor, bringing to it his acute observations of weather, light, and atmosphere.

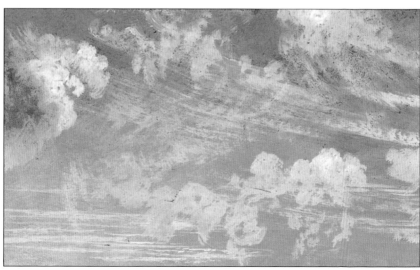

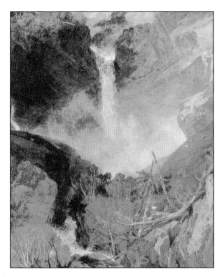

GREAT FALLS OF REICHENBACH
J. M. W. Turner

(1740–1816), John Sell Cotman (1782–1842) and Peter de Wint (1784–1849) it became much more than that. Watercolor was at last fully exploited and given the recognition that was its due.

Most of these artists worked in watercolor alone, regarding it as the perfect medium for creating the light, airy, atmospheric effects they sought; Constable used watercolor mainly for quick sketches of skies. The greatest watercolorist of all, J. M. W. Turner (1775–1851), achieved his fame as an oil painter, but he produced watercolors of an amazing depth and richness. Quite uninhibited by any "rules," he exploited accidental effects like thumbprints and haphazard blobs of paint, turning them into some of the most magical depictions of light and color that have ever been seen in paint.

Throughout the nineteenth century the techniques of watercolor continued to be developed and the subject matter became more varied. The poet and artist, William Blake (1757–1827), evolved his own method of conveying his poetic vision in watercolor, as did his follower, Samuel Palmer (1805– 1881), who used swirls and blocks of opaque color in his visionary and symbolic landscapes. With the end of the Napoleonic Wars in 1815, travel once again became easier, and the topographical tradition reached new heights in the work of artists like Samuel Prout (1783–1852), a superlative draftsman who painted the buildings and scenery of western Europe in faithful detail. Traveling further afield, John Frederick Lewis (1805–1876) made glowing studies of Middle Eastern scenes, and new techniques, such as the "dragged" wash, were pioneered by Richard Parkes Bonington (1802–1828) for both landscape and figure subjects, to be taken further by his friend, the French artist, Eugène Delacroix (1798–1863).

British artists of the twentieth century have not ignored the possibilities of watercolor, its greatest exponents being Graham Sutherland (1903–1980) and Paul Nash (1889–1946) and his brother John (b. 1893). It remains a popular medium with both professional artists and amateurs, and new ways are constantly being found of exploring its full potential.

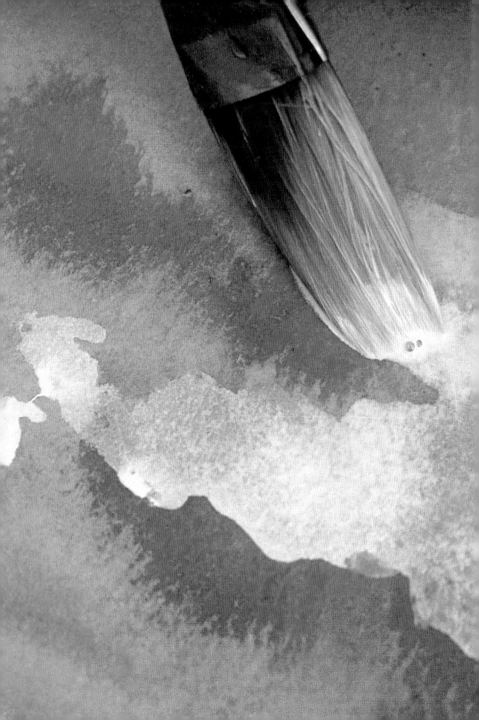

Materials

"To get the right results, start with the right tools": it's a rule that applies to many undertakings, including watercolor painting. If you are just starting to experiment with watercolor, you may not want to invest a great deal of money in equipment. Certainly, there is no need to rush out and buy an expensive easel and an enormous range of paint colors. It is perfectly acceptable to start small, and purchase equipment when you are sure of precisely what you require. It may be that you never get around to buying that expensive easel: many professional watercolorists work at an ordinary table, with their board supported by a pile of books. All the same it is just as well not to scrimp in some areas. Good quality paints and brushes will stand the watercolor artist in good stead, and you will not need an enormous range of paints and brushes to start with. Few watercolorists use more than a dozen colors, and most rely on only two or three brushes. The choice of papers available to the watercolor painter can also be daunting. Again, feel free to experiment: buy just a few sheets at a time until you are familiar with the characteristics of different types of paper.

Perhaps the greatest single advantage of watercolor painting is that only a small amount of equipment is needed, equipment which is easy to store. Paints and brushes, although not cheap, last for a long time; indeed brushes should last virtually for ever if looked after. The best paper for watercolor work is hand-made from pure linen rag. Machine-made paper is less expensive but as the surface will not take the paint readily, the beginner should avoid using the cheaper brands.

Paints and Colors

Ready-made watercolor paint is sold in various forms, the commonest being tubes, pans, and half-pans. These all contain glycerine and are known as semi-moist colors, unlike the traditional dry cakes, which are still available in some artist's suppliers, but are not used much today. Dry cakes require considerable rubbing with water before the color is released. It is a slow process, but the paints are therefore economical.

Gouache paints, or designer's colors as they are sometimes called, are normally sold in tubes. These paints, and the cheaper versions of them, poster colors and powder paints, have chalk added to the pigment to thicken it, and are thus opaque, unlike true watercolor. Watercolors themselves can be mixed with Chinese white to make them opaque or semi-opaque, so that they become a softer and more subtle form of gouache.

Success in watercolor painting depends so much on applying layers of transparent, but rich, color that it is a mistake to buy any but the best-quality paints, known as "artist's quality." There are cheaper paints, sold for "sketching," but since these contain a filler to extend the pigment, the color is weaker and the paint tends to be chalky and unpredictable.

Whether to use pans, half-pans, or tubes is a personal choice. Each type has its advantages and disadvantages. Tubes are excellent for those who work mainly indoors on a fairly large

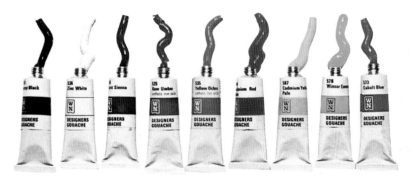

scale, as any quantity of paint can be squeezed out of them on to the palette. Any paint left on the palette after a painting is completed can be used again later, simply by moistening it with a wet brush. Pans and half-pans, which can be bought in sets in their own palette and are easy to carry, are the most popular choice for working outdoors on a small scale. Watercolors can also be bought in concentrated form in bottles, with droppers to transfer the paint to the palette. These are eminently suitable for broad washes which require a large quantity of paint, but they are less easy to mix than the other types.

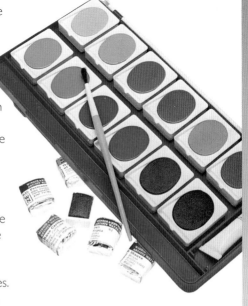

The choice of colors is personal, though there are some colors that everyone must have. Nowadays there is such a vast range of colors to choose from that a beginner is justified in feeling somewhat bewildered, but, in fact, only a few are really necessary. One point to bear in mind is that some colors are considerably less permanent than others, which may not be an important consideration for quick sketches and "note-taking," but clearly is for any painting that is intended to be hung or exhibited. A wise course, therefore, is to rule out any colors classified as "fugitive." All the major paint manufacturers have systems of grading permanence. These appear on the manufacturer's color chart. The tubes or pans will also bear a code indicating the relative price of each

color, some being more expensive than others according to the cost of the pigment used.

The golden rule when choosing a range of colors, or "palette" as professionals call it, is to keep it as simple as possible. Few watercolorists use more than a dozen colors. For landscape painting, useful additions to the basic palette are sap green, Hooker's green, raw umber, and cerulean blue, while monastral blue (called Winsor blue in the Winsor and Newton range) is sometimes recommended instead of Prussian blue. For flower painting the basic range might be enlarged by the addition of cobalt violet and lemon yellow. See the "Color and Composition" section for more information on color choice.

Suggested Palette

Warm and cool versions of the primaries are essential, plus some secondaries and some of the so called "earth colors." The latter may seem rather nondescript to the beginner, but they are of vital importance, because they are close to many of nature's colors. Black is not included, but can be a good addition as it is more or less impossible to produce by mixing other colors. Other useful but not strictly essential colors are raw umber and indigo.

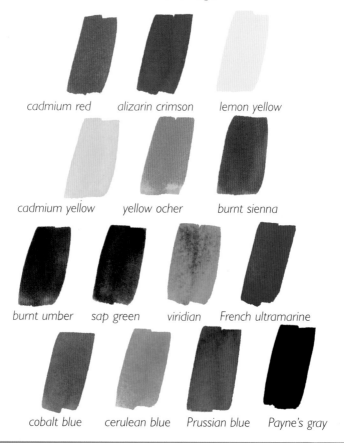

cadmium red alizarin crimson lemon yellow

cadmium yellow yellow ocher burnt sienna

burnt umber sap green viridian French ultramarine

cobalt blue cerulean blue Prussian blue Payne's gray

How to Choose Paper, Boards, Canvas, etc.

The traditional support – the term used for the surface on which any painting is done – is white or pale-colored paper, which reflects back through the transparent paint to give the translucent quality so characteristic of watercolors. There are many types of watercolor paper. Each individual will probably need to try several before establishing which one suits his method of working, though sometimes a particular paper may be chosen to create a special effect.

The three main types of machine-made paper are hot-pressed (HP), cold-pressed (CP), which is also rather quaintly known as "not" for "not hot-pressed," and rough. Hot-pressed paper is very smooth and, although suitable for drawing or pen-and-wash, is not a good choice for building up layers of washes in the standard watercolor technique as it becomes clogged very quickly. Cold-pressed paper, which is slightly textured, is the most popular and is suitable for both broad washes and fine detail. Rough paper, as its name implies, is much more heavily textured, and the paint will settle in the "troughs" while sliding off the "peaks," giving a speckled effect which can be effective for some subjects but is difficult to exploit successfully. Among the best-known makes of good watercolor papers are Saunders, Fabriano, Arches, Bockingford, Strathmore, and R.W.S. (Royal Watercolor Society), some of which also include handmade papers.

Hand-made papers are made from pure linen rag and specially treated with size to provide the best possible surface for watercolor work. Such papers are sized on one side only and thus have

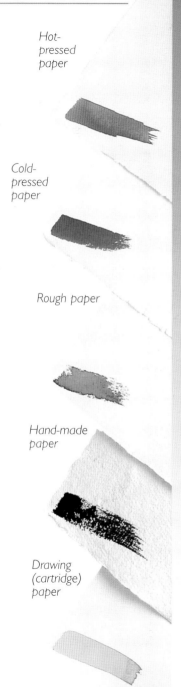

Hot-pressed paper

Cold-pressed paper

Rough paper

Hand-made paper

Drawing (cartridge) paper

a right and a wrong side, which can be checked by holding the paper up to the light so that the watermark becomes visible. Many of the better machine-made papers also have a watermark and hence a right and wrong side.

Some papers have surfaces that are tough enough to withstand a great deal of preliminary drawing and erasing without damage, but others do not. Bockingford paper, for instance, although excellent in many ways, is quickly damaged by erasing, and the paint will take on a patchy appearance wherever the surface has been spoiled. One of its advantages, however, is that paint can easily be removed by washing out where necessary; the paint, moreover, can be manipulated and moved around in a very free way. Arches paper and Saunders paper are both strong enough to stand up to erasing, but mistakes are difficult to remove from the former, which holds the paint very firmly. Saunders paper is a good choice for beginners: it is strong, stretches well, and has a pleasant surface.

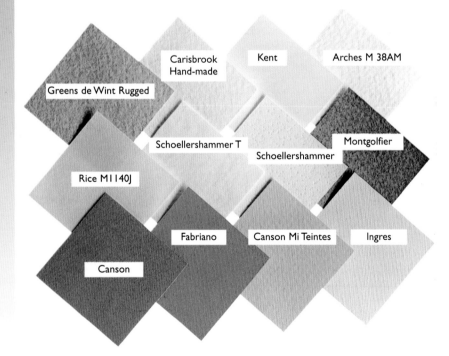

Stretching paper

If you have tried watercolor painting on fairly thin paper, you will have noticed its tendency to buckle when you apply wet washes, and then to dry unevenly, in a series of waves. This is due to the rapid expansion of the paper when wet, a tendency that you can turn to your advantage. If you tape it down when wet and fully expanded, it will shrink as it dries, pulling itself taut as a drum, producing a lovely springy surface not unlike a canvas.

1 The paper must be fully submerged in water for a few moments, either in the bathtub or sink or slowly passed through a large bowl, as shown here. This ensures that every inch of both sides is thoroughly wet.

2 Take the paper out of the water, still dripping wet, and lay it on the board in position to be stretched. Leave it for a few minutes for the water to be completely absorbed, and when the buckling process has reached maximum, wipe off surplus water with tissue. Then pull the paper at one end, holding the other end down.

3 Dry the edges of the paper where the gumstrip will go with some fresh tissue, then cut the strip into lengths, wet the sticky side with a damp sponge, and stick down.

4 When all four sides are taped down, use more tissue to wipe over the top of the gumstrips. Press it down to squeeze out any excess water and ensure good adhesion between the two surfaces. Also wipe up any nearby pools of water which could run into the gumstrip, dissolving the glue and weakening the adhesion.

5 Leave the paper to dry for a few hours, or if you are in a hurry, speed up the process with a hairdryer. It is advisable to check on it during drying; if one side has not stuck properly, you can reinforce it with a fresh piece of gumstrip.

Brushes

Soft brushes are normally used for watercolor. The best ones are sable, made from the tips of the tail hairs of the small rodent found chiefly in Siberia. Sable brushes are extremely expensive, but if looked after properly they should last a lifetime. Watercolor brushes are also made from squirrel hair (known as "camel hair" for some reason) and ox hair. These are good substitutes for sable, but have less spring. There is now a wide range of synthetic brushes, usually made of nylon or a mixture of nylon and sable, and although they do not hold the paint as well as sable, they are excellent for finer details and are much cheaper.

Only by experimenting will an individual discover which shapes and sizes suit them. It is not necessary to have a great many brushes for watercolor work; for most purposes three or four will will be adequate, and many artists use only two. A practical range would be one large chisel-end for laying washes and two or three rounds in different sizes. Some watercolorists use ordinary household brushes for washes, but care must be taken to prevent hairs from falling out as you work.

If you want your brushes to last, it is essential to look after them well. Wash them thoroughly in running water after use — if they are still stained use a little soap. Never leave brushes pointing downward in a glass of water, as this will bend the hairs out of shape, possibly permanently. If they need to be stored for a length of time in a box or can make sure that they are absolutely dry; otherwise mildew may form. Store them upright.

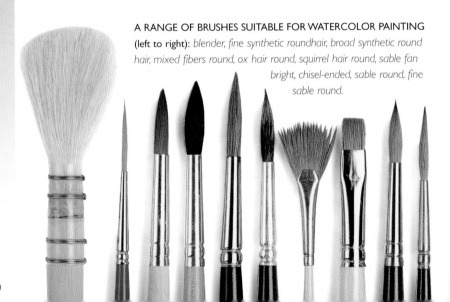

A RANGE OF BRUSHES SUITABLE FOR WATERCOLOR PAINTING
(**left to right**): *blender, fine synthetic roundhair, broad synthetic round hair, mixed fibers round, ox hair round, squirrel hair round, sable fan bright, chisel-ended, sable round, fine sable round.*

Easels

Watercolors, unlike oils, are best done at close quarters, with the support held nearly horizontal, so that an easel is not really necessary for indoor work. However, an easel can be helpful. It allows you to tilt the work at different angles (many artists prefer to do preliminary drawings with the board held vertically) and to move it around to the best light, which is more difficult with a table. The most important aspects to consider – apart, of course, from price – are stability and the facility for holding the work firmly in a horizontal position.

For outdoor work, the combined seat and easel, which folds and is carried by a handle, is particularly useful. For indoor work, the combination easel, which can be used both as a drawing table and a studio easel, is more convenient. Both are adjustable to any angle from vertical to horizontal. Good easels are not cheap, however, so that it is wise to do without one until you are sure of your requirements; many professional watercolorists work at an ordinary table with their board supported by a book or brick.

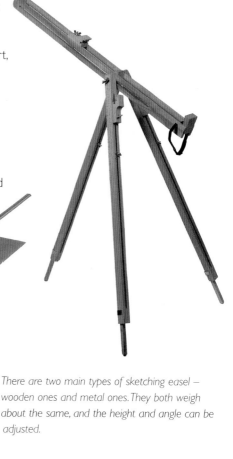

There are two main types of sketching easel – wooden ones and metal ones. They both weigh about the same, and the height and angle can be adjusted.

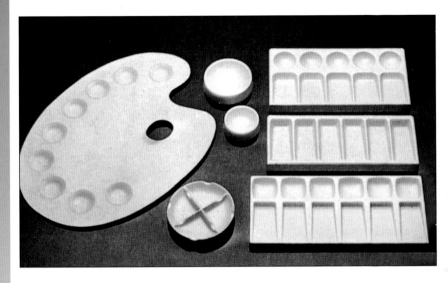

Boards, Palettes and Other Equipment

You will need a drawing board, or possibly two boards of different sizes, to support the paper and stretch it where necessary. A piece of plywood or blockwood is perfectly adequate provided the surface is smooth and the wood soft enough to take drawing pins. For outdoor work a piece of illustration board can be used, with the paper clipped to it, though the paper must be heavy enough not to require stretching.

If you buy paints in paintbox form you will already have a palette; if not, you will need one with compartments for mixing paint. Watercolor palettes are made in plastic, metal, or ceramic,

in a variety of sizes, and some have a thumbhole so that they can be held in the nonpainting hand when working outdoors. Water containers are another necessity for outdoor work; there is nothing worse than arriving at your chosen spot to find that you have forgotten the water. Special containers can be bought, but plastic soft drink bottles can be used to carry the water and any light (unbreakable) container such as a yogurt container will suffice to put the water in when you reach your destination.

Various other items, though not strictly essential, can be useful and inexpensive aids for watercolor work. Small sponges can be used instead of brushes to apply washes, to sponge out areas, and to create soft, smudgy cloud effects; paper towels, blotting paper, and cotton wool can be used in much the same way. Toothbrushes are

useful for spattering paint to create textured effects: to suggest sand or pebbles on a beach, for example. A scalpel, or a razor blade, is often used to scrape away small areas of paint in a highlight area. And both masking tape and masking fluid can serve to block out areas while a wash is laid over the top, leaving a hard-edged area of white paper when removed. The specific uses of such aids and devices are more fully explained in the "Techniques" section.

Starter Palette

These colors will provide a perfectly adequate range for most needs. Some artists work with fewer. From top to bottom: cobalt blue, Prussian blue, viridian, yellow ocher, cadmium yellow, lemon yellow, cadmium red, alizarin crimson, burnt umber, Payne's gray, and ivory black.

Lighting

For indoor work it is vital to organize a good system of lighting. Working by a window with light coming over your left shoulder (or right shoulder if you are left-handed) can be quite satisfactory if the window faces north (or south in the southern hemisphere) and gives an even and relatively unchanging light. It is less so if the window faces the sun, since the light may constantly change from brilliant to murky and may even throw distracting patches of light and shade across your work. An artificial light of the fluorescent "daylight" type will enable you to work in a poorly lit room or corner and to continue working when the light has faded – winter days can seem very short for those dependent on daylight. Such light can be used either instead of natural light or to supplement it, and there is one type with a base that can be clamped to the edge of a table or an adjacent shelf.

A desk lamp can be angled so that it does not cast too much shadow. Such lamps can be fitted with daylight simulation bulbs.

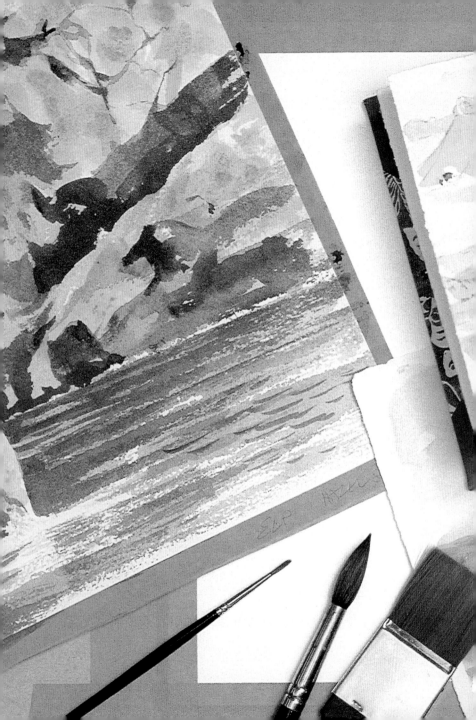

Techniques

The two most important characteristics of watercolor are, first, that it is always unpredictable to some extent, even in the hands of experts; and second, that because dark is always laid over light, some planning is needed before starting a painting. The classic watercolor technique is known as wet-on-dry because each new wash is laid over paint that has already dried. The basis of this technique is the wash, in which a thin skin of paint is laid over the whole paper, or a part of it. That first wash is the moment of decision, because you must then know which areas you wish to "reserve" as white paper.

In this section, the techniques have been grouped roughly in the order you would use them in creating a painting, moving from washes and foundation techniques through brush techniques and color effects and, lastly, to making changes and corrections. Approach each method in a spirit of experimentation — it may be worthwhile to set up some practice paper and use it to try out different techniques before launching into a complete composition. Don't be too quick to discard your early efforts, though: it is often possible to rescue apparent mistakes by reworking them using methods such as scumbling or wax resist.

Laying Washes

The term "wash" is a rather confusing one, as it implies a relatively broad area of paint applied flatly, but it is also sometimes used by watercolor painters to describe each brushstroke of fluid paint, however small it may be. Here it refers only to paint laid over an area too large to be covered by one brushstroke.

LAYING A FLAT WASH

Beginners are often encouraged to practice laying perfectly flat washes, but while it teaches you control of the watercolor it is in fact a technique rarely used to create paintings, except as an underwash for a whole picture.

1 Load the brush and lay the paint in even strokes across the paper from one side to the other. Tilting the board a little will help the bands of color run into each other.

2 Never go back over the wet paint; it will usually dry flat, though it may look uneven while still wet. You can dampen the paper before laying the wash, which helps the colors blend together.

LAYING A GRADUATED WASH

This is a one-color wash that changes tone as it progresses. Mix up plenty of color in the palette, but this time as you lay each successive band of color, gradually add more water to the mixture.

1 Try on both dry and wet paper. Start with a strong solution of yellow ocher and lighten it gradually by the addition of water to each new stroke across the paper. The last band should be almost pure water. If the wash appears slightly uneven tilt the paper to encourage the paint to flow. Do not touch it with your brush.

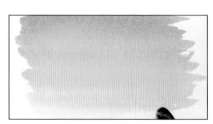

2 Sometimes a more dramatic tonal gradation is required. Dampen the paper and lay two or three bands of full-strength color, followed by really pale color and finally pure water for the last stroke.

VARIEGATED WASHES

These are washes blending two or more colors together. A sunset might require linear bands of red, yellow, and blue whereas a tumultuous sky could be depicted with blobs or splotches of different colors blended in a more irregular way.

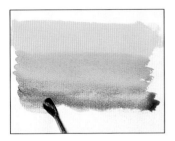

1 Mix your colors before you start. Lay the colors on dry paper in even bands allowing the wet edges to blend with each other. Resist the temptation to touch up with your brush while the wash is drying.

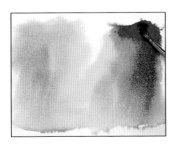

2 Dampen the paper then brush in the palest colors. Tilt the paper and allow the colors to blend.

TEXTURES

Watercolor washes can be many things: some simply play the role of a flat backdrop to a visual "drama," while others serve the purpose of providing an underpainting for subsequent work. They can also be an end in themselves, conveying mood and atmosphere by means of a few brushstrokes swept over white paper. In creating a wash, the illusion of texture can be achieved by choosing the right paper and pigments.

One of the best ways to make a wash say more is to use the texture of the paper as an integral part of the painting. Watercolorists who paint mainly in washes choose their supports very carefully, fully aware of the contribution they make to the finished work.

The granulation of the pigment that sometimes occurs when a wet wash is applied over a dry one can add extra interest to a painting. It is particularly useful in shadow areas, which can become flat and dull.

WET-IN-WET

This means exactly what its name implies – applying each new color without waiting for earlier ones to dry so that they run together with no hard edges. This is a technique that is only partially controllable, but is a very enjoyable and challenging one. Any of the water-based media can be used, providing no opaque pigment is added, but in the case of acrylic, it is helpful to add retarding medium to the paint to prolong the drying time.

The paper must first be well dampened and must not be allowed to dry completely at any time. This means, first, that you must stretch the paper (unless it is a really heavy one of at least 200 pounds) and second,

that you must work fast. Paradoxically, when you keep all the colors wet, they will not actually mix, although they will bleed into one another. Placing a loaded brush of wet paint on top of a wet wash of a different color is a little like dropping a pebble into water; the weight of the water in the new brushstroke causes the first color to draw away.

The danger with painting a whole picture wet-in-wet is that it may look altogether too formless and undefined. The technique is most effective when it is offset by edges and linear definition, so when you feel that you have gone as far as you can, let the painting dry, take a long, hard look at it, and decide where you might need to sharpen it up.

Step-by-step: Wet-in-wet

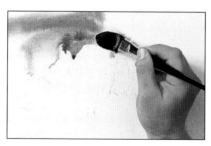

1 Flood the whole picture area with clean water and let it soak in for a few seconds. With a large, flexible brush such as a squirrel-hair, paint in ultramarine, Payne's gray, and violet in separate areas defined by your sketch.

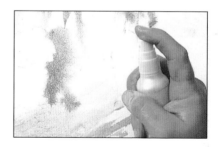

2 Prolonged wet-in-wet painting is required for this picture. If the paint starts to dry halfway through, creating unwanted hard edges, spray on clean water with an atomizer. This will take effect in seconds, softening hard edges and enhancing the flow.

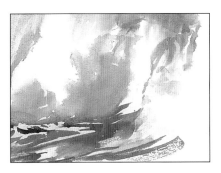

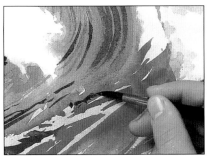

3 Subsequent washes need more definition, so pre-wet only selected areas. Apply cerulean blue in the central area, softening some parts with water. Paint ultramarine streaks at the bottom, then stroke over them with a wet brush. Allow the two areas to fuse.

4 Mix a little emerald green with cerulean blue and a hint of Payne's gray, and use to give the wave more shape underneath. Then, with a darker mix, paint the curve lines underneath. Add a touch of black to the same mix and paint in the small, dark areas immediately under the crest.

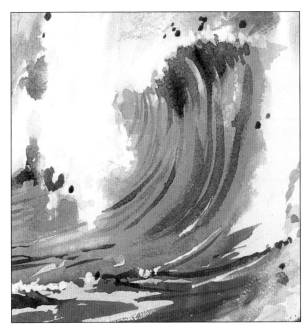

5 Go around the picture, adding a few dark spots and very pale, undulating washes in the foam. Finally, dab spots of Chinese white foam in any places you have accidentally painted over. Then add streaks of dry-brush white over the blue for texture.

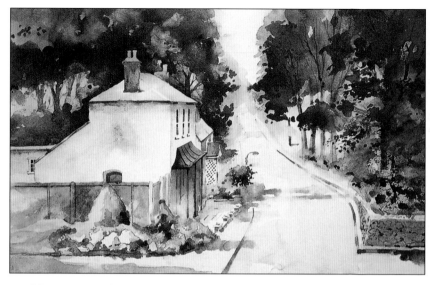

HARD AND SOFT EDGES

CHURCH HILL, WINCHMORE HILL
John Lidzey

A wet watercolor wash laid on dry paper forms a shallow pool of color which, if left undisturbed, will form hard edges as it dries, rather like a tidemark. This can be alarming to the novice, particularly in the early stages of a painting, but it is one of the many characteristics of the medium that can be used to great advantage. By laying smaller, loose washes over previous dry ones you can build up a fascinating network of fluid, broken lines that not only help to define form and suggest shapes, but also give a lovely sparkling quality to the work. This is an excellent method for building up rather irregular shapes such as clouds, rocks, or ripples on water.

You will not necessarily want to use the same technique in every part of the painting; however, a combination of hard and soft edges describes the subject more successfully and also gives the picture more variety.

There are several ways of avoiding hard edges. One is to work wet-in-wet by dampening the paper before laying the first wash and then working subsequent colors into it before it dries so that they blend into one another with subtle transitions. A wash on dry paper can be softened and drawn out at the edges by using a sponge, paintbrush, or cotton swab dipped in clean water to remove the excess paint. A wash "dragged" or "pulled" over dry paper with either a brush or sponge will also dry without hard edges, since the paint is prevented from forming a pool.

BACKRUNS

These are both a nuisance and a delight to watercolor painters. If you lay a wash and apply more color into it before it is completely dry, the chances are that the new paint will seep into the old, creating strangely shaped blotches with hard, jagged edges – sometimes alternatively described as "cauliflowers." It does not always happen: the more absorbent or rough-textured papers are less conducive to backruns than the smoother, highly sized ones, and with practice it is possible to avoid them altogether.

There is no remedy for a backrun except to wash off the entire area and start again. However, many watercolor painters use them quite deliberately, both in large areas such as skies or water and small ones such as the petals of flowers, as the effects they create are quite unlike those achieved by conventional brushwork. For example, a realistic approximation of reflections in gently moving water can be achieved by lightly working wet color or clear water into a still damp wash. The paint or water will flow outward, giving an area of soft color with the irregular, jagged outlines so typical of reflections. It takes a little practice to be able to judge exactly how wet or dry the first wash should be, but as a guide, if there is still a sheen on it, it is too wet and the colors will merge together without a backrun, as they do in the wet-in-wet technique.

LEFT: *The results of working into a wash before it is thoroughly dry vary widely according to the paper used and the degree of wetness or dryness, but it can look something like this example.*

BELOW: *Here backruns have been deliberately induced and then blown with a hairdryer so that they form definite patterns. Techniques such as this are particularly useful for amorphous shapes such as clouds, reflections, or distant hills.*

Foundations

BUILDING UP WATERCOLOR

Because watercolors are semi-transparent, light colors cannot be laid over dark. Thus, traditional practice is to begin a painting with the lightest tones and build up gradually toward the darker ones by means of successive washes or brushstrokes.

Many, but by no means all, artists start by laying a flat wash all over the paper, leaving uncovered any areas that are to become pure white highlights (known as reserving). This procedure obviously needs some planning, so it is wise to start with a pencil drawing to establish the exact place and shape of the highlights to be reserved. The tone and color of the preliminary wash also need to be planned as they must relate to the overall color key of the finished painting. A deep blue wash laid all over the paper might be the correct color and intensity for the sky in a landscape, but would not be suitable for a foreground containing pale yellows and ochers. Another variation of the overall wash is to lay one for the land. Both these procedures have the advantage of covering the paper quickly so that you can begin to assess colors and tones without the distraction of pure white paper.

OVERPAINTING

When the first wash or washes are dry, the process of intensifying certain areas begins, done by laying darker washes or individual brushstrokes over the original ones. A watercolor will lose its freshness if there is too much overpainting, so always assess the strength of color needed for each layer carefully and apply it quickly, with one sweep of the brush, so that it does not disturb the paint below. As each wash is allowed to dry, it will develop hard edges, which usually form a positive feature of watercolor work, adding clarity and crispness.

Some artists find it easier to judge the tone and color key of the painting if they begin with the darkest area of color, then go back to the lightest, adding the middle tones last when the two extremes have been established.

Building up a painting in washes is not the only method. Some artists avoid using washes altogether, beginning by putting down small brushstrokes of strong color all over the paper, sometimes modifying them with washes on top to soften or strengthen certain areas.

Step-by-step: Building Up

 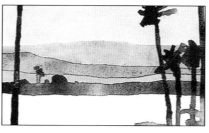

1,2 Having laid a gray-blue wash over the sky and a slightly darker one for the distant hills, the artist blocks in the details of the middle distance. He leaves these washes to dry and then paints the dark trees in the foreground.

3 The final touch is to lay a green-ocher wash over the area behind the trees. The warm color creates a sense of recession, as it advances toward the front of the picture, while the cool blues are pushed back.

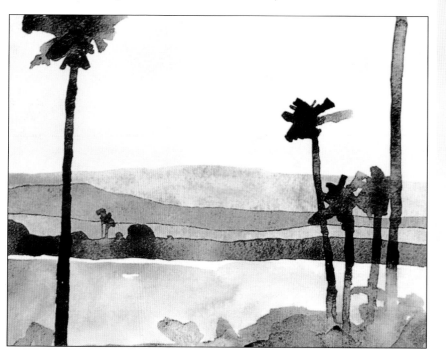

GOUACHE AND ACRYLIC

If either of these paints is used thinly, without the addition of white, the procedures are much the same as those for watercolor described on the previous pages. The beauty of acrylic, however, is that no amount of over-painting will stir up earlier paint, because, once dry, it is immovable (a disadvantage of this being that lifting out is impossible). If used opaquely, acrylic can be built up in more or less infinite layers, dark over light or light over dark. Paintings in opaque gouache can, to a certain extent, be built up from dark to light. If the paint is used thick and dry, a light layer will cover a dark one completely, but there is a limit to the number of layers you can apply as this paint continues to be soluble in water even when dry, so that a new application of moist paint will churn up and muddy layers underneath. The most satisfactory method is to begin by using the paint thin, increasing its opacity gradually as you work. The building up process is aided by working on a toned ground, which serves the same function as a preliminary wash in watercolor and helps to avoid too many layers of paint.

Step-by-step: Working in Gouache

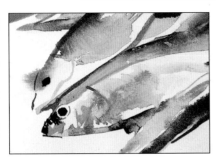

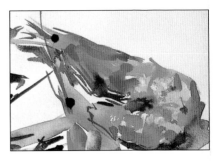

1 Working in gouache, the artist begins with the paint well thinned, laying broad washes and allowing runs to occur in places. When the first washes have dried, she begins to define the detail. The paint is still used as watercolor in most areas, but she intends to build up the textures of the fish more thickly, and has applied a broad stroke of opaque yellow.

2 The prawns are painted less solidly than the fish, as befits their delicate, slender forms, and the opaque paint is restricted to small areas of highlight.

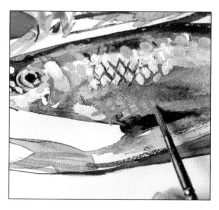

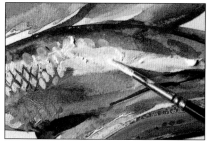

3 Using a strong mixture of gouache, the artist "draws" with the point of the brush on the underbelly of the fish.

4 Now using really opaque white, she accentuates the silvery highlights. Raised blobs and swirls can be seen where the pigment has been used straight from the tube.

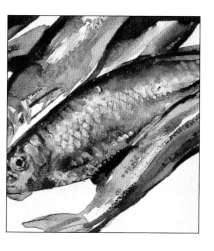

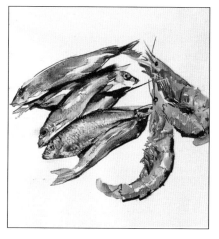

5 The scales of the fish are suggested by a combination of scraping into the paint and working small brushstrokes both wet-in-wet and wet-on-dry.

6 One of the exciting properties of gouache is that it allows a contrast of thick and thin paint, thus providing additional surface interest.

UNDERPAINTING

This involves building up a painting over a monochrome tonal foundation. It is usually associated with oil painting, but the early watercolorists used a modified version of the same technique, particularly for detailed topographical or architectural subjects. You can see the effects of underpainting if you have ever had to wash down a watercolor by dunking it in a bathtub. Faint shadows of the original will remain, which can often provide a good basis for the next attempt. This kind of "accidental" underpainting highlights the value of a deliberately planned one: establishing the tonal balance of a painting is not always easy, and doing this at the outset avoids having to alter or correct (and possibly overwork) the painting later on.

It is essential to use a pale color and one that will not interfere with the colors to be placed on top. In a predominantly green landscape, for instance, blue would be a good choice and, since blues tend to stain the paper, a blue wash is less likely to be disturbed by subsequent washes. The paper should be a fairly absorbent one, such as Arches, which allows the undercolor to sink into it. Any areas to be reserved as bright highlights should, of course, be left uncovered so the white paper will show through.

An underpainting for acrylic is much less restricted as it will be permanent when dry and the tonal range can be greater because the later colors can be used opaquely to cover the first one. Underpainting provides a good basis for the technique of glazing, in which colors are built up in successive thin skins.

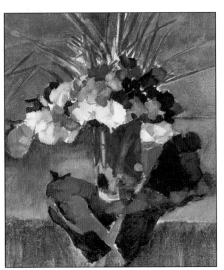

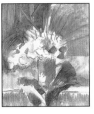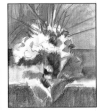

ABOVE AND LEFT:
This painting was begun with a monochrome underpainting in dilute cobalt blue, an unusual but deliberate choice of color, as the blue is repeated throughout the picture. The flowers and drapery were then built up in thicker paint, the method known as "fat over lean," the background and foliage being left quite thin.

Step-by-step: Tonal Underpainting

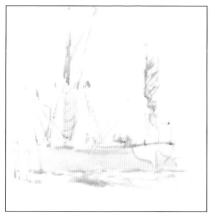

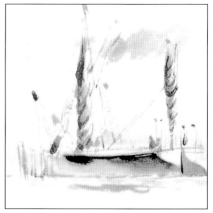

1,2 A tonal underpainting can provide a better basis than an outline drawing, as pencil lines quickly become obscured. The artist begins with a very light gray, building up to deeper tones in areas that are to remain as dark shadows.

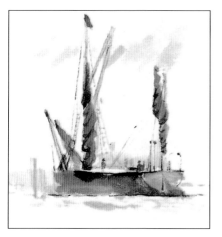

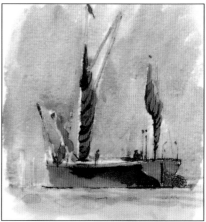

3,4 The gray chosen for the underpainting is slightly modified by the colors laid over it, but in the shadows it remains virtually unchanged, which highlights the importance of choosing the right color. Notice that the brightest parts, the stern of the boat and areas of the water, have been left white in the underpainting.

GLAZING

This is a technique that was perfected by the early painters using oils. They would lay thin skins of transparent pigment one over the other to create colors of incredible richness and luminosity. In watercolor painting, over-laying washes is sometimes described as glazing, but this is misleading as it implies a special technique, whereas in fact it is the normal way of working when one is using watercolor paints.

Acrylic paint is perfectly suited to the glazing technique because it dries so fast: each layer must be thoroughly dry before the next one is applied. The effects the technique creates are quite different from those of color applied opaquely, as light seems to reflect through each layer, almost giving the appearance of being lit from within. The use of a brilliant white ground

(acrylic gesso is ideal) on a smooth surface such as illustration board further enhances the luminosity.

Special media are sold for acrylic glazing – available in both gloss and matte – and these can be used either alone or in conjunction with water.

A whole painting can be built up layer by layer in this way – as can be seen in some of David Hockney's acrylic paintings – but this is not the only way of using the technique. Thin glazes can also be laid over an area of thick paint (impasto) to great effect. The glaze will tend to slide off the raised areas and sink into the lower ones – a useful technique for suggesting textures, such as that of weathered stone or tree bark. Other ways of conveying rough textures using watercolor include wax resist, spattering, and sponge painting.

1 **With only one color**
To glaze with one color, lay a small wash and allow to dry. Overpaint with a few brushstrokes of the same color.

2 When dry paint more strokes of the same color over the top. This could be used for a grassy foreground.

Step-by-step: Glazing

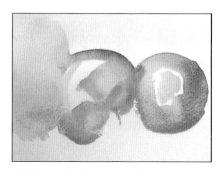

1 Working in acrylic on water-color paper, the artist starts with the paint heavily diluted with water. Acrylic used in this way is virtually indistinguishable from watercolor, but it cannot be removed once dry, a considerable advantage in the glazing technique.

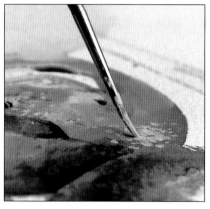

2 A layer of darker color mixed with special glazing medium has been laid over the orange, and the artist now builds up the highlights with opaque paint.

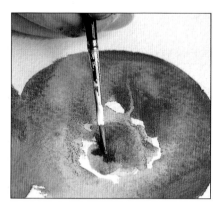

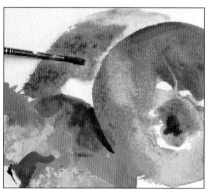

3 Deep-toned glazes are now laid on the apple. The way earlier layers of color reflect back through subsequent glazes gives a rich, glowing effect.

4 Here the transparent, slightly gluey quality of the paint can be seen. Either water or the special medium can be used for acrylic glazes, but it takes a little practice to achieve the right consistency.

DRAWING

Because watercolors cannot be changed radically (except by washing off and beginning again), they need to be planned in advance and it is usual to begin a painting by drawing the subject directly onto the paper. Some artists dispense with this stage, but this is usually because they are familiar with the subject, have painted it before, and have a clear idea of how they want the finished painting to look.

There are certain inherent problems with underdrawings for watercolor. One is that the drawn lines are likely to show through the paint in the paler areas. The lines should, therefore, be kept as light as possible and any shading avoided so that the drawing is nothing more than a guideline to remind you which areas should be reserved as highlights and where the first washes should be laid.

Another problem is that on certain papers, such as the popular Bockingford, erasing can scuff the surface, removing parts of the top layer, so that any paint applied to these areas will form unsightly blotches. If you find that you need to erase, use a kneaded eraser, applying light pressure.

For a simple land- or seascape your underdrawing will probably consist of no more than a few lines, but a complex subject, such as buildings or a portrait, will need a more elaborate drawing. Then you may find that the squaring up method (see opposite) is helpful, using either a sketch or photograph of the subject.

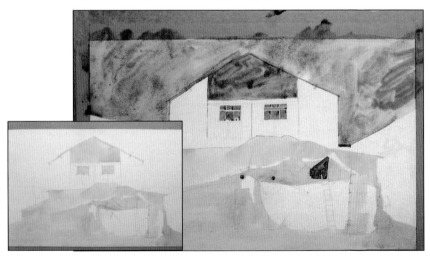

Having made a preliminary drawing with a very sharp B pencil, the artist lays the first washes. The pencil lines can be erased at this stage, but it is not always necessary as they are unlikely to show in any but the palest areas of the painting.

Step-by-step: Squaring up

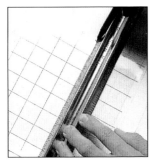
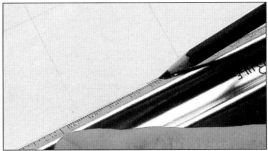

1 The method demonstrated here avoids damaging the original drawing or photograph. A grid is drawn with a felt-tipped pen on a sheet of acetate. The grid is traced from a sheet of graph paper below, which saves time and is very accurate.

2 The next stage is drawing an enlarged version of the grid onto the working paper. Pencil, set square, and ruler are needed for this and the pencil lines should be as faint as possible.

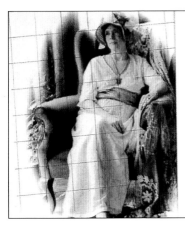

3 The acetate sheet is then placed over the photograph or working drawing, and the image is transferred to the working paper square by square. Do not rush this process as you could place one part of the composition in the wrong square.

Brush Techniques

BRUSH DRAWING

Drawing freely and directly with a brush is enormously satisfying and, like blots, is an excellent way to loosen up your technique. Down through the centuries, artists have made brush sketches, sometimes using pen marks as well, sometimes not, and the Chinese and Japanese made the technique into a fine art.

Opaque paints are not suitable for brush drawing, as the marks and lines must be fluid – flowing easily from brush to paper. You can use ordinary watercolor, watercolor inks, or acrylics thinned with water. Good, springy brushes are also essential.

Light pressure with the tip of a medium-size pointed brush will give precise, delicate lines. A little more pressure and the line will become thicker, so that it is possible to draw a line that is dark and thick in places and very fine in others. More pressure still, bringing the thick part of the brush into contact with the paper, will give a shaped brush mark

rather than a line. Thus, by using only one brush you can create a variety of effects and, if you use several brushes, including broad, flat-ended ones, the repertoire is almost endless.

The technique can be combined with others in a painting, and is particularly useful for conveying a feeling of movement, in figures, animals, or even landscapes.

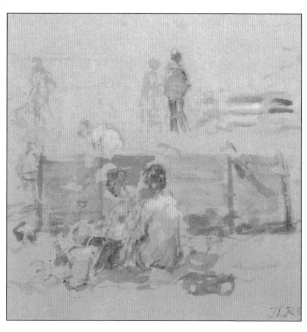

FAMILY ON THE BEACH Jacqueline Rizvi
Watercolor and body color on pale gray paper. Working rapidly on the spot, the artist has used the brush very much as a drawing medium.

BRUSH MARKS

The marks made by the brush as a contributing factor to a finished painting are exploited most fully in the thick, buttery medium of oil paint. This has often led people to ignore the importance of brush marks in watercolor, but they can play a vital and expressive part in a painting, making all the difference between a lively, dynamic picture and a dull, routine one.

The dull obvious example of visible brush marks in watercolor occurs in the technique of stippling. Then the painting is built up entirely with tiny strokes of a pointed brush. However, it is possible to discern the strokes of the brush in most watercolors to a

greater or lesser degree. Some artists use a broad, flat brush, allowing it to follow the direction of a form, while others use a pointed one to create a network of lines in different colors and tones. A popular technique for creating the impression of squalls of rain or swirling mist is to work into a wet wash with a dry bristle brush to "stroke" paint in a particular direction, while an exciting impression of foliage can be conveyed by dabbing or flicking paint onto paper using short strokes of a small square-ended brush. Another useful technique for foliage – a notoriously tricky subject – is dry brush, which creates a pleasing feathery texture because the dry paint only partially covers the paper

STRANDE WATER AND HOGWOOD Juliette Palmer
Palmer uses her small brush marks descriptively to build up pattern and texture. Notice the variety of different marks – little left-shaped blobs and dots at the top, long strokes for the clumps of rushes, and broader squiggles for the reflections.

43

EVENING, PANTYGASSEG David Bellamy
The outer twigs and branches of the trees are suffused by light from the sky. The artist uses a lighter tone for the fine outer branches and merely suggests the twigs using quick dry brush strokes.

DRY BRUSH

This technique is just what its name implies – painting with the bare minimum of paint on the brush so that the color only partially covers the paper. It is one of the most often used ways of creating texture and broken color in a watercolor, particularly for foliage and grass in a landscape or hair and fur textures in a portrait or animal painting. It needs a little practice, as if there is too little paint it will not cover the paper at all, but if there is too much it will simply create a rather blotchy wash.

As a general principle, the technique should not be used all over a painting as this can look dull. Texture-making methods work best in combination with others, such as flat or broken washes.

Opaque gouache and acrylic are also well suited to the dry brush technique. In both cases the paint should be used with only just enough water to make it malleable – or even none at all – and the best effect are obtained with bristle brushes, not soft sable or synthetic-hair brushes (these are, in any case, quickly spoiled by such treatment).

Step-by-step: Dry Brush – Animal Texture

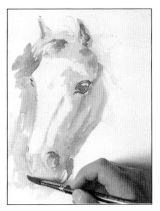

2 A square-ended brush is dipped into paint and partially dried. Make sure that there is not too much paint on the brush by experimenting on a spare piece of paper before painting.

1 As before, dry brush work is applied over washes. The main colors of the horse's head are lightly painted and allowed to dry before shadows are added.

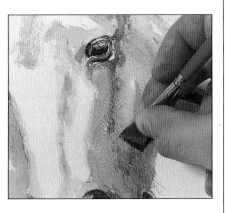

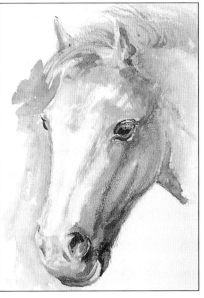

3 Because he wants to give just a hint of the hair texture, the artist uses a color that is only very slightly darker than the wash beneath, and makes quick, light brush strokes.

4 By means of successive light applications of dry brush, the artist models the forms accurately, suggesting the different textures of the horse's head and mane.

SCUMBLING

This is one of the best known of all techniques for creating texture and broken color effects particularly in the opaque media. It involves scrubbing very dry paint unevenly over another layer of dry color so that the first one shows through, but only partially.

Scumbling can give amazing richness to colors, creating a lovely glowing effect rather akin to that of a semi-transparent fabric with another, solidly colored one beneath.

There is no standard set of rules for the technique, as it is fundamentally an improvisational one. You can scumble light over dark, dark over light, or a vivid color over a contrasting one, depending on the circumstances, but do not try to use a soft, sable-type brush or the paint will go on too evenly (and you will quickly ruin the brush). A bristle brush is ideal, but other possibilities are stenciling brushes, sponges, crumpled paper, or your fingers.

The particular value of the method for gouache is that it enables colors to be overlaid without becoming muddy and dead looking – always a danger with this medium.

Scumbling is less well suited to watercolor, but it is possible to adapt the dry brush method to scumbling, using the paint as thick as possible – even straight out of the tube – and working on rough paper.

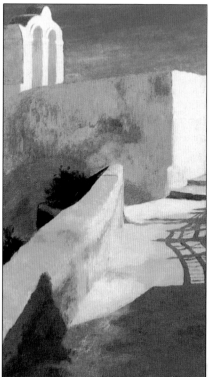

SUN AND SHADOW, SANTORINI
Hazel Harrison *Here successive layers have been built up over a pre-tinted yellow ocher ground. The detail shows thin over thick scumbling with a bristle brush.*

STIPPLING

This is a method of applying paint in a series of separate, small marks made with the point of the brush, so that the whole image consists of tiny dots of different colors. It was and still is a technique favored by painters of miniatures, and is seldom used for large paintings for obvious reasons. However, for anyone who enjoys small-scale work and the challenge of a slow and deliberate approach, it is an attractive method and can produce lovely results quite unlike those of any other watercolor technique.

The success of stippled paintings relies on the separateness of each dot: the colors and tones should blend together in the viewer's eye rather than physically on the paper. Like all watercolors they are built up from light to dark, with highlights left white or only lightly covered so that the white ground shows through, while dark areas are built up gradually with increasingly dense brush marks. However, it is quite permissible to use body color to emphasize the smaller highlights and to establish a larger, darker area of color by laying a preliminary wash.

The beauty of the technique is that it allows you to use a great variety of colors within one small area – a shadow could consist of a whole spectrum of deep blues, violets, greens, and browns. As long as these are all sufficiently close in tone, they will still read as one color, but a more ambiguous and evocative one than would be produced by a flat wash of, say, dark green.

MARGARET'S JULY
Carol Ann Schrader
This artist uses stipple as a form of detailing. The very fine dots can be seen only by close inspection.

SPATTERING

Spraying or flicking paint onto the paper, once regarded as unorthodox and "tricksy," is now accepted by most artists as an excellent means of either enlivening an area of flat color or of suggesting texture.

Spattering is a somewhat unpredictable method and it takes some practice before you can be sure of the effect it will create, so it is wise to try it out on some spare paper before running the risk of spoiling a painting. Any medium can be used, but the paint must not be too thick or it will simply cling to the brush. To make a fine spatter, load a toothbrush with fairly thick paint, hold it horizontally above the paper, bristle side down, and run your forefinger over the bristles. For a coarser effect, use a bristle brush, loaded with paint of the same consistency, and tap it sharply with the handle of another brush.

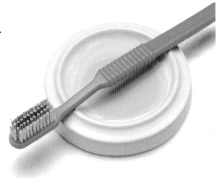

The main problem with the method is judging the tone and depth of color of the spattered paint against that of the color beneath. If you apply dark paint – and thick watercolor will of necessity be quite dark – over a very pale tint it may be too obtrusive. The best effects are created when the tonal values are close together. If you are using the technique to suggest the texture of a pebbled or sandy beach, for which it is ideal, you may need to

Step-by-step: Spattering

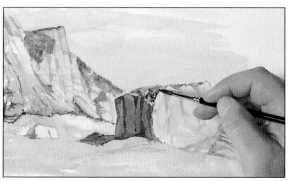

1 Spattering is one of the final stages in a painting. Here the artist has completed the cliffs and rock. The foreground, however, looks fairly flat and lifeless.

spatter one pale color over another. In this case the best implement is a mouth diffuser of the kind sold for spraying fixative. The bristle brush method can also be used for watery paint, but will give much larger drops.

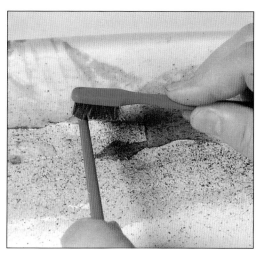

2 Because he wants to prevent the spattered paint from going over the finished areas of the picture, the artist masked these with tracing paper. He now spatters two layers of paint over the light brown foreground wash.

3 Any overlarge or overdark blobs can be removed with a cotton ball or sponge while the paint is still wet.

4 The spattered paint gives a realistic impression of the rough sand and pebble beach. The dark line formed by the paint collecting at the edge of the mask helps to suggest the shadow where the beach meets the cliff.

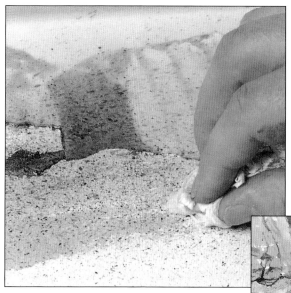

Color Effects

BODY COLOR

This slightly confusing term simply means opaque water-based paint. In the past it was usually applied to Chinese white, either mixed with transparent watercolor in parts of a painting or used straight out of the tube for highlights. Nowadays, however, it is often used as an alternative term for opaque gouache paint.

Some watercolorists avoid the use of body color altogether, priding themselves on achieving all the highlights in a painting by reserving areas of white paper. There are good reasons for this, as the lovely translucency of watercolor can be destroyed by the addition of body color, but opaque watercolor is an attractive medium when used sensitively.

Transparent watercolor mixed with either Chinese white or gouache zinc (not flake) white is particularly well suited to creating subtle weather effects in landscapes, such as mist-shrouded hills. It gives a lovely, milky, translucent effect slightly different from that of gouache itself, which has a more chalky, pastel-like quality.

A watercolor that has gone wrong – perhaps become over-worked or too bright in one particular area – can often be saved by overlaying a semi-opaque wash, and untidy highlights can be tidied up and strengthened in the same way.

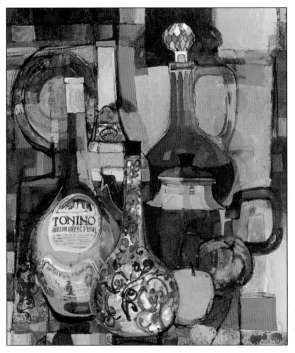

STILL LIFE WITH TEAPOT AND DECANTER
Moira Huntly RI, RSMA

INTERVAL AT THE GLOBE THEATRE

Jacqueline Rizvi

This artist uses watercolor mixed with opaque white and builds up very gradually, usually working on a toned paper (the ground for this painting is a light beige-gray). The red of the velvet was brought out in places by laying transparent red watercolor over a slightly opaque crimson and white mixture.

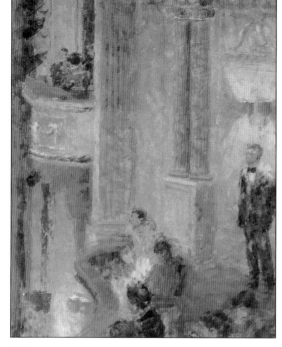

TONED GROUND

For a picture that is planned as an exercise in dark, rich tones and colors it can be an advantage to begin with a pre-tinted ground. It is possible to buy heavy colored papers for watercolor work, but these have to be sought out; few of the smaller, less specialist art supply shops stock them.

A quick and simple way to pre-tint watercolor paper is to lay an overall wash of thinned acrylic (after stretching the paper if you are doing this). The color, when dry, will be permanent, so there is no danger of stirring it up with the next layer of paint.

The advantages of toned grounds are two-fold. First, they help you to achieve unity of color because the ground shows through the applied colors to some extent. Secondly, they allow you to build up deep colors with fewer washes, thus avoiding the risk of muddying.

The main problem with pre-tinting is deciding what color to use. Some artists like to paint a cool picture, such as a snow scene, on a warm, yellow ocher ground so that the blues, blue-whites, and grays are heightened by small amounts of yellow showing through. Others prefer cool grounds for cool paintings and warm grounds for warm ones. You need to think carefully about the overall color key of the painting and you will probably have to try out one or two ground colors.

How a Toned Ground Works

A toned canvas helps you to judge the relative intensity, or value, of your color mixtures more accurately than a white canvas. This is because the toned canvas gives you an idea of how the colors will look when surrounded by other colors. To demonstrate how a toned ground works, this illustration (below) shows a piece of canvas, of which half is painted with a toned ground of raw umber and half is left white. Small squares of ultramarine and cadmium yellow are applied to each half: observe closely and you will see how much more intense the colors appear on the toned ground than they do on the white canvas.

BELOW: **1.** *Generally, the color for a toned ground is mixed on the palette and applied to the support with smooth, even strokes. Here, however, the artist begins by applying the color in loose strokes which will be blended together on the canvas. Cadmium red, yellow, ocher, and white, well diluted with water, are freely and loosely painted over the white surface.*

2. *When the canvas is well covered, and thoroughly dry, a thin wash of white paint is scumbled over it. The result is a medium-to-light toned surface in which the brush strokes are only partially blended. The colors blend in the viewer's eye, however, and the effect is more vibrant than a flat wash of color mixed on the palette.*

Step-by-step: Cool Tinted Ground

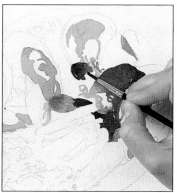

2 Paint the shadow of the plate with cobalt green in an even flat wash using a No. 3 round sable. This color harmonizes with the pale green background.

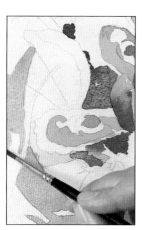

1 Stain the paper surface with a pale wash of viridian and cobalt blue. After you have completed the pencil drawing, use gamboge followed by Prussian blue and alizarin crimson to paint the shells. Apply simple flat washes with a little wet-in-wet mingling.

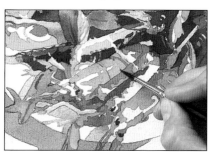

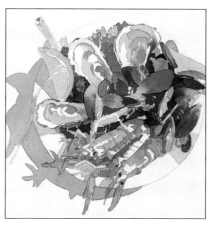

3 Gradually build up the color areas, methodically laying down flat washes. Overlay the green shadow with Hooker's green. Add cobalt blue deep to the mussels and paint the lobsters with magenta, gamboge, and alizarin crimson.

4 The cool green of the ground causes the bright yellows and reds to stand out in contrast and "vibrate." These opposing color values create a dynamic tension. The tinted background also imparts a depth that could not be achieved with stark white paper.

BLENDING

This means achieving a soft, gradual transition from one color or tone to another. It is a slightly trickier process with the water-based paints than with oil or pastel, because they dry quickly, but there are various methods that can be used.

One of these is to work wet-in-wet, keeping the whole area damp so that the colors flow into one another. This is a lovely method for amorphous shapes such as clouds, but is less suited to precise effects, such as those you might need in portraits, as you cannot control it sufficiently. You can easily find that a shadow intended to define a nose or cheekbone spreads haphazardly.

To avoid the hard edges formed where a wash ends or meets another wash, brush or sponge the edge lightly with water before it is dry. To convey the roundness of a piece of fruit or the soft contours of a face, use the paint fairly dry, applying it in small strokes rather than broad washes. If unwanted hard edges do form, these can be softened by "painting" along them using a small sponge or cotton swab dipped in a little water.

The best method for blending acrylics is to keep them fluid by adding retarding medium. This enables very subtle effects, as the paint can be moved around on the paper. Opaque gouache colors can be laid over one another to create soft effects, though the danger is that too much overlaying of wet color stirs up and muddies the earlier layers.

Step-by-step: Blending Colors

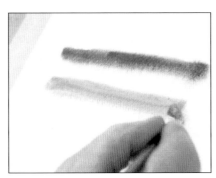

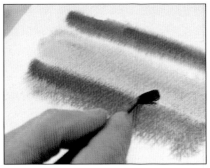

1 This is a more controllable technique than that of laying a variegated wash. Lay two parallel strips of color on dampened paper and allow to dry.

2 A middle strip of color is laid and the edges blended into the existing strips of paint with gentle brush strokes.

WATERCOLOR

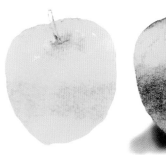

A pale green wash is laid and some darker greens and browns flooded into it while still wet. This is allowed to dry and the tones are built up with small brush strokes of paint carefully blended together with a moistened brush.

GOUACHE

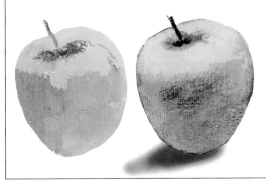

The same technique can be used for thin gouache, but here the paint is used thickly, with the blending done by working very dry paint over the underlayer with a bristle brush. On the top of the apple, light paint has been applied over dark.

ACRYLIC

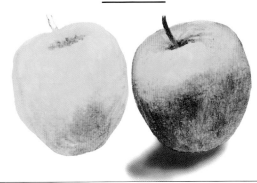

Because acrylic dries so fast it cannot be moved around on the paper as watercolor can, retarding medium has been used to slow the drying time. This also increases the transparency of the paint, so that the brush strokes used to build up the shadows are clearly visible.

BROKEN COLOR

It is one of the paradoxes of painting that a large area of flat color seldom appears as colorful, or, indeed, as realistic, as one that is textured or broken up in some way. The Impressionists, working mainly in oils, discovered that they could best describe the fleeting, shimmering effects of light on foliage or grass by placing small dabs of various greens, blues, and yellows, side by side instead of using just one green for each area. This technique can be adapted very successfully to watercolor, but there are many other ways to break up color.

If you "drag" a wash over a heavily textured paper, the paint will sink into the troughs, but will not completely cover the raised tooth of the paper – a broken color effect much exploited by watercolorists. If you then apply drier paint over the original wash – in a different color or a darker version of the same one – the effect will be even more varied and the painting will have a lively and interesting surface texture.

In gouache and acrylic, broken color effects are best achieved by applying the paint rather dry with a stiff brush. Acrylic is perfect for this kind of treatment as it is immovable once dry, which means that more or less endless layers can be laid one over the other. This is not true of gouache: although it is opaque, it is also absorbent and so too many new layers will disappear into those below.

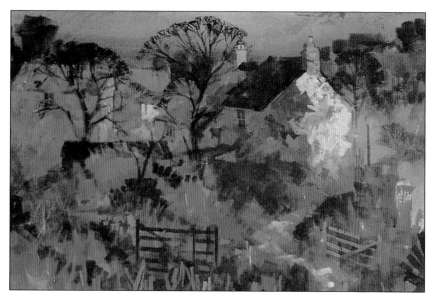

CORNISH FARM I Michael Cadman acrylic and watercolor

HIGHLIGHTS

The light reflecting off white paper is an integral part of a watercolor painting, giving good watercolors their lovely translucent quality. For this reason the most effective way of creating pure, sparkling highlights is to "reserve" any areas that are to be white by painting around them. This means that when you begin a painting you must have a clear idea of where the highlights are to be, so some advance planning is necessary.

Not all highlights, of course, are pure white: in a painting where all the values are dark, whites could be overly-emphatic. Thus, before the painting has advanced very far you will have to decide whether to reserve areas of an initial pale wash or to build up really dark values around a later, mid-value one.

When you lay a wash around an area to be reserved for a highlight, it will dry with a hard edge. This can be very effective, but it is not necessarily what you want. You might, for example, need a softer, more diffused highlight on a rounded object such as a piece of fruit. In such cases, you can achieve a greater transition by softening the edge with a brush, small sponge or cotton swab dipped in water, so that it blends into the white area.

Small highlights, such as the points of light in eyes or the tiny sparkles seen on water, which are virtually impossible to reserve, can either be achieved by masking or added with thick Chinese white or zinc white gouache paint as a final stage. Highlights can also be made by removing paint.

Step-by-step: Highlighting

1 The shapes of the fruit are initially left white, their outlines

defined by the pale brown wash.

2 A middle strip of color is laid and the edges blended into the existing strips of paint with gentle brush strokes.

Step-by-step: Highlighting continued

3,4 Instead of applying a flat wash all over the fruit and then adding darker value, each area of color is treated separately, though some washes will overlap at a later stage. With all the paper covered and the main washes in place, the artist decides where further light and dark emphasis is needed.

5 She darkens the cast shadows on and below the green apple and uses opaque white to add additional highlights on the fruit at left and right. Those on the orange have been applied lightly with the point of the brush, giving a realistic impression of the slightly pitted texture of the peel. The artist has been conscious of texture throughout, using the granulated quality of the wetly applied paint to add surface interest.

6 The grapes are given further modeling, with the dark paint again kept very wet. The original reserved highlights are not touched again, but the stalks are defined with a combination of opaque paint and reserving.

7 The treatment is impressionistic rather than literal, and the patch of dark green at the top of the apple, which could be either a shadow or a leaf, has been added primarily to separate it from the background and emphasize the highlighted areas.

MASKING

Many watercolorists use masking fluid and masking tape for reserving areas of white paper. Masking fluid, which is specially made for the purpose, is a kind of liquid rubber sold in small bottles and applied with a brush. Some watercolorists feel a certain disdain for masking methods, regarding them as "cheating," or as being too mechanical. However, very attractive and exciting effects, quite different from those produced by the classic method of laying washes around an area, can be gained by it. Stopping out with masking fluid is a method of painting in "negative"; the precise and subtle shades made by the brush remain when the liquid is removed.

The paper must be quite dry before the fluid is applied, and the fluid itself must be allowed to dry before a wash is laid over it. Once the wash has dried, the fluid can be rubbed off with a finger or a soft eraser, leaving the white area, which can be modified and worked into if required. Masking fluid should never be left on the paper for longer than necessary, and care must be taken to wash the brushes immediately; otherwise fluid will harden in the hairs and ruin them. Masking fluid is not suitable for all papers, especially ones with a rough surface.

Masking tape is particularly useful for straight-edged areas, such as the light-catching side of a building or the edge of a windowsill. Masking tape enables you to use the paint freely without worrying about spoiling the area to be reserved.

Yet another way of keeping the paint away from the paper is to use wax in what is called the resist method. This differs from the previous techniques in being permanent; once the wax is on the paper it cannot be removed except by laborious scraping with a razor blade. The paint, moreover, will lie on top of the wax to some extent, leaving a slightly textured surface. The effect can be very attractive, particularly for flowers or fabrics. An ordinary household candle can be used, or a white wax crayon for finer lines.

BELOW *Here the artist used masking fluid to mask certain areas during painting. This enabled the artist to work freely, resulting in a fresh, spontaneous style.*

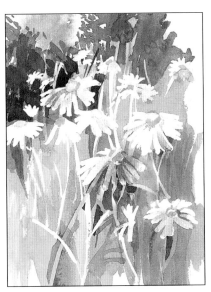

Step-by-step: Masking Fluid

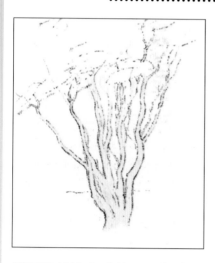

1 The tree trunks are carefully drawn, masking fluid is applied, and then left to dry before any further work is done. The artist is working on Bockingford paper with a not surface, from which the rubbery fluid is easily removed; it is not suitable for use on rough papers as it sinks into the "troughs" and cannot be peeled off.

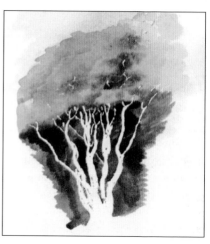

2 With the fluid protecting the intricate shapes of the trunks and branches, dark washes are built up behind and above without fear of paint splashing onto the pale areas. When the washes are dry, the fluid is removed by rubbing with a finger.

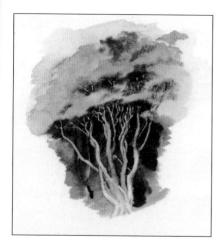

3 The trunks and branches are modeled with darker paint in places and touches of white gouache define the highlights.

Step-by-step: Spattering Masking Fluid

1 For this painting masking fluid is applied in two consecutive layers. Apply an initial wash of pale burnt sienna. Allow to dry completely, then spatter on some masking fluid by loading a toothbrush and flicking the bristles with a finger.

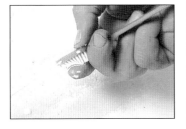

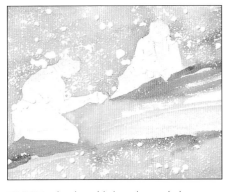

2 Paint a second wash over the dried masking fluid, reserving the shapes of the figures. When dry, rub off the second layer of masking fluid and spatter on a second layer, creating larger blobs as well as a fine spray. Cover almost half the surface and allow the fluid to dry.

3 Apply a third wash – a darker combination of burnt sienna and violet. When dry, rub off the second layer of masking fluid. Finish painting the two fishermen mending their nets using the same limited palette with the addition of black and ultramarine.

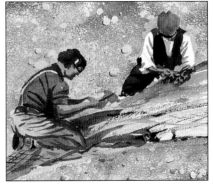

LEFT *Masking tape can be very helpful for buildings. It takes the tension out of painting, allowing you to work freely without the danger of spoiling an edge that needs to be straight and crisp.*

LIFTING OUT

Removing paint from the paper is not only a correction method, it is a water-color technique in its own right and can be used to great effect to soften edges, diffuse and modify color and create those highlights that cannot be reserved. For instance, the effect of streaked wind clouds in a blue sky is quickly and easily created by laying a blue wash and wiping a dry sponge, paintbrush or paper tissue across it while it is still wet. The white tops of cumulus clouds can be suggested by dabbing the wet paint with a sponge or blotting paper.

Paint can also be lifted out when dry by using a dampened sponge or other such tool, but the success of the method depends both on the color to be lifted and the type of paper used.

Certain colors, such as sap green and phthalocyanine blue, act rather like dyes, staining the paper, can can never be removed completely, while some papers absorb the paint, making it hard to move it around.

Bockingford, Saunders, and Cotman papers are all excellent for lifting out in this way, so if you become addicted to the technique, choose your paper accordingly. Another useful aid to lifting out is gum arabic. Add it in small quantities to the color you intend to partially remove.

Large areas of dry paint can be lifted with a dampened sponge, but for smaller ones the most useful tool is a cotton swab. Never apply too much pressure when using a cotton swab, as the plastic may poke through the cotton tip, scratching the surface of the paper.

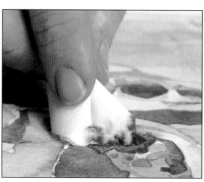

When working with lots of wet washes, tissue is useful for wiping areas that have become too wet, and for controlling the flow of paint. Use a blot-and-lift motion. Tissue paper can also be used to lift out amorphous shapes in a wet wash.

Blotting paper is thicker and more absorbent than tissue and, once dry, it can be reused. If you wish to lift out a small, precise area, hold the corner of the blotting paper against the surface until the excess paint is absorbed.

Step-by-step: Lifting Out

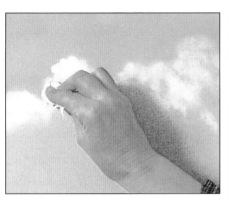

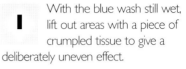

With the blue wash still wet, lift out areas with a piece of crumpled tissue to give a deliberately uneven effect.

2 Use less pressure toward the bottom of the sky; clouds are always smaller and less distinct just above the horizon.

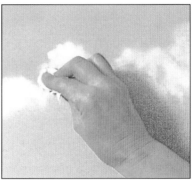

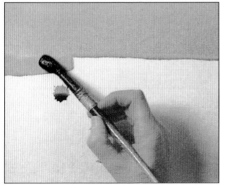

In this case two washes have been laid, and the blue is to be lifted out to reveal the dried pink wash below.

2 Again, use a small piece of tissue to dab into the paint. For broader effects you might try using a sponge, rag, or large piece of cotton wool.

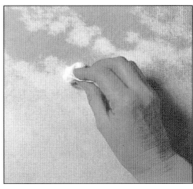

TEXTURES

There are two main kinds of texture in painting; surface texture, in which the paint itself is built up or manipulated n some way to create what is known as surface interest; and imitative texture, in which a certain technique is employed to provide the pictorial equivalent of a texture seen in nature. These overlap to some extent: surface texture is sometimes seen as an end in itself, but in many cases it is a welcome by-product of the attempt to turn the three-dimensional world into a convincing two-dimensional image.

Surface texture Since watercolors are applied in thin layers, they cannot be built up to form surface texture, but this can be provided instead by the grain of the paper. There are a great many watercolor papers on the market, some of which – particularly the hand-made varieties – are so rough and they appear almost to be embossed. Rough papers can give exciting effects, as the paint will settle unevenly (and not always predictably), breaking up each area of color and leaving flecks of white showing through. Reserved highlights on rough paper stand out with great brilliance – because the edges are slightly ragged, the white areas appear to be raised above the surrounding colors.

Acrylic paints are ideal for creating surface interest because they can be used both thickly and thinly in the same painting, providing a lively

contrast. You can vary the brushmarks, using fine, delicate strokes in some places and large, sweeping ones in others. You can put on slabs of paint with a knife, and you can even mix the paint with sand or sawdust to give it an intriguing, grainy look.

Imitative texture Several of the best-known techniques for making paint resemble rocks, tree bark, fabrics, and so on are described in other entries (see DRY BRUSH, SCUMBLING, SPATTERING, SPONGE PAINTING, WAX RESIST), but there are some other tricks of the trade. One of these – unconventional but effective – is to mix watercolor paint with soap. The soap thickens the paint without destroying its translucency. Soapy paint stays where you put it instead of flowing outward, and allows you to use inventive brushwork to describe both textures and forms.

Intriguingly unpredictable effects can be obtained by a variation of the resist technique. If you lay down some turpentine or white spirit on the paper and then paint over it, the paint and the oil will separate to give a marbled appearance. A slightly similar effect can be gained by dropping crystals of sea salt into wet paint. Let it dry, brush off the salt, and you will see pale, snowflake shapes where the salt has absorbed the surrounding paint. If the crystals are close together these shapes will run into one another to form a large mottled blob rather resembling weathered rock.

Step-by-step: Textures

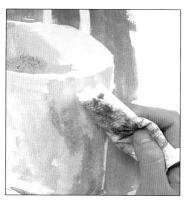

1 The basket is first drawn in lightly, and then washes are applied to the background, foreground, and to the basket itself. The paint is left to dry completely. Shadowed areas are painted in, and, while the paint is still wet, the textured side of a piece of paper towel is pressed into it to lift off some of the paint and leave an imprint of the paper behind. The paint is then left to dry.

2 Spots of darker color are then dabbed onto the basket using bubble wrap, bubble-side out, to suggest the mottled textured weave of the basket.

3 When this is dry, a strip of corrugated cardboard is used to apply paint for the woven border along the top edge of the basket.

4 An imaginative application of paint, using the kind of scrap materials that most people have in their homes, has resulted in the almost tactile surface texture of this basket.

Alternative Techniques

SPONGE PAINTING

Sponges are an essential part of the artist's tool kit. As well as being useful for mopping up unwanted paint, cleaning up edges, and making corrections, they can be used for applying paint – either alone or in conjunction with brushes.

Laying a flat wash is just as easy with a sponge as it is with a brush. The only thing it cannot do satisfactorily is take a wash around an intricate edge – for which a brush is best – but if you intend to begin a painting with an overall wash of one color, the sponge is ideal. For a completely even wash, keep the sponge well saturated and squeeze it out gently as you work down the paper. If you want a less

regular wash, squeeze some of the paint out so that the sponge is only moistened. This will give a slightly striated effect, which can be effective for skies, seas, the distance in a landscape, or hair in a portrait.

Dabbing paint onto paper with a sponge gives an attractive mottled effect quite unlike anything that can be achieved with a brush, particularly if you use the paint reasonably thick. This method is an excellent way in which to describe texture, and you can suggest form at the same time by applying the paint lightly in some areas and densely in others.

There is no reason why whole paintings should not be worked using this method, but the one thing the sponge cannot do is create fine lines or intricate details, so brushes are usually brought into play for the later stages of a picture when extra definition is needed.

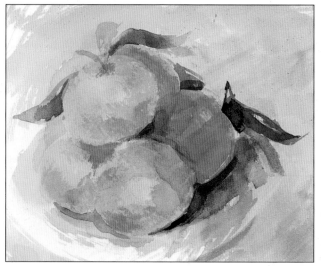

LEFT: *The mottled finish that sponging creates is ideal for conveying the pitted surface of fruit such as oranges.*

Step-by-step: Painting with a Sponge

1,2 It is often necessary to employ some system of masking when painting with a sponge, as you cannot take paint around edges as precisely as you can with a brush. The artist has masked the window bars, which are to remain white, by the simple method of holding a ruler against each edge as he works. He does not worry unduly if paint splashes over in places, as he is aiming at a soft, impressionistic overall effect.

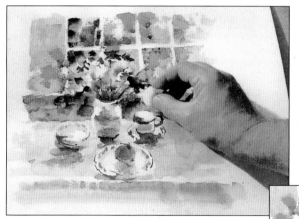

3 Working carefully, the artist continues to build up the painting, using the paint fairly wet so that each new application merges with the surrounding colors.

4 One of the problems with combining sponge painting and brushwork is that the contrast of techniques, if over-emphasized, can destroy the unity of the composition. Although the artist has used conventional brush washes in places, he has kept the paint loose and fluid throughout, blurring the edges of the brush marks on the crockery so that they blend in with the sponge work.

PAINTING FOLIAGE WITH A SPONGE

The sponge is frequently used to portray vegetation and trees, as in this atmospheric painting by Maurice Read. The natural impressions left by a sponge mimic the appearance of foliage. The overall effect is soft and is consistent with the treatment of the rest of the painting.

A sponge was used to apply some sepia to the dome to give an aged look. It was applied rather wet, to allow it to fuse and blend a little, assisted by some brushwork.

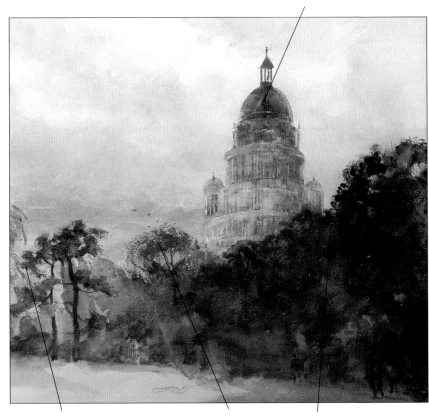

The foliage of these trees was built up with a fine sponge, with a more stippled effect around the edges.

The fine grain made by the sponge has been enhanced with brushwork to bulk it out, and cause some of the grain to merge.

The main body of trees has been built up with wet-in-wet washes applied fairly concentrated and overlaid with sponge painting to give texture.

BLOTS

Blot painting is a technique most often associated with monochrome ink drawing, but since watercolors are available in liquid (ink) form I have included this technique here. The other reason for its inclusion is that it is an excellent way of loosening up technique. Like backruns, blots are never entirely predictable, and the shapes they make will sometimes suggest a painting or a particular treatment of a subject quite unlike the one that was planned. Allowing the painting to evolve in this way can have a liberating effect and may suggest a new way of working in the future.

The shapes the blots make depend on the height from which they are dropped, the consistency of the paint or ink and the angle of the paper. Tilting the board will make the blot run downhill; flicking the paint or ink will give small spatters; wetting the paper will give a diffused, soft-edged blot. A further variation can be provided by dropping a blot on to the paper and then blowing it, which sends tendrils of paint shooting out into various directions. Blots can also be used in a controlled, selective way to suggest the texture of trees, flowers, or pebbles in a particular part of a painting.

Blot painting is a form of constructive doodling. Because you are freed from the constraints imposed by the need to "make a painting," you can loosen up and enjoy yourself. Sometimes a random effect of colored blots will suggest an actual subject, and can be developed into a roughly representational treatment, but often, as here, they are simply pleasing as abstract patterns. These examples have been produced dropping colored inks on to the paper from different heights. Some of the colors have been used undiluted and some mixed with a little water. The lines and tendrils of ink spreading outward are the result of blowing the blots, a useful and simple technique for flower and foliage effects.

LINE AND WASH

This technique has a long history, and is still much used today, particularly for illustrative work. Before the British watercolorists of the 18th century began to exploit the full possibilities of watercolor as a painting medium it had been used mainly to put pale, flat tints over pen drawings, a practice that itself continued the tradition of the pen and ink-wash drawings often made by artists as preliminary studies for paintings.

The line and wash technique is particularly well suited to small, delicate subjects such as plant drawings or to quick figure studies intended to convey a sense of movement. Rembrandt's sketchbooks are full of monochrome pen and wash drawings, conveying everything he needed to record in a few lines and one or two surely placed tones.

The traditional method is to begin with a pen drawing, let it dry, and then lay in fluid, light color with a brush. One of the difficulties of the technique is to integrate the drawing and the color in such a way that the washes do not look like a "coloring in" exercise, so it is often more satisfactory to develop both line and wash at the same time, beginning with some lines and color and then adding to and strengthening both as necessary.

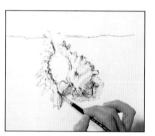

1 A line medium, such as pen or pencil, is the perfect partner for the delicacy of watercolor. Usually the line drawing is done first, as in this case, but there is no hard-and-fast rule.

2 The artist has used a water-soluble pen, so that the lines are softened and spread by the washes laid on top. This prevents the line drawing from appearing too hard and clear in contrast to the watercolor.

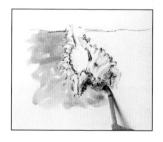

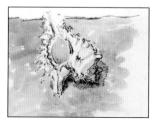

3 The washes on the shell have been kept to a minimum to preserve the delicate effect for which the technique – which is often used for flower drawings – is so well suited.

SCRAPING BACK

This technique, sometimes called *sgraffito*, simply means removing dry paint so that the white paper is revealed. The method is most often used to create the kind of small, fine highlights that cannot be reserved, such as the light catching blades of grass in the foreground of a landscape. It is a more satisfactory method than opaque white applied with a brush, as this tends to look clumsy and, if laid over a dark color, does not cover it very well.

Scraping is done with a sharp knife, such as a scalpel or craft knife, or with a razor blade. For the finest lines, use the point of the knife, but avoid digging it into the paper. A more diffused highlight over a wider area can be made by scraping gently with the side of the knife or razor blade, which will remove only some of the paint.

This technique is not successful unless you use a good-quality, reasonably heavy paper – it should be no lighter than 140 pounds. On a flimsier paper you could easily make holes or spoil the surface.

The same method can be used for gouache or acrylic, but only if the surface is one that can withstand this treatment.

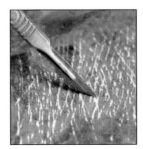

LEFT: *The delicate, complex pattern of the frothy water in this painting was created by scraping with a sharp point. The effect, which can be seen clearly in the detail shown here, would be impossible to achieve by any other means. Opaque white gouache or acrylic could be used, but the texture would be less interesting and the lines less fine and crisp.*

RIGHT: *Sharp, clean lines and highlights can be made by scraping into dry paint with a scalpel or other sharp knife. Take care not to damage the paper by pressing too hard. A fingernail provides another ready tool for scraping back.*

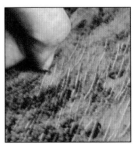

WASH-OFF

This is an unusual and fascinating technique that exploits the properties of Indian ink and gouache. It is not difficult, but it is slow, involving careful planning and a methodical approach.

Basically, the method involves painting a design with thick gouache paint, covering the whole picture surface with waterproof ink and then holding it under running water. This washes off the soluble paint and the ink that covers it, leaving only the ink in the unpainted areas to form a negative image.

First the paper must be stretched – essential, as it has to bear a consider-able volume of water. A light wash is then laid over it and left to dry, after which the design is painted on with thick, white gouache paint. White paint must be used, as a color could stain the paper and destroy the clear, sharp effect. For the same reason the wash should be as pale as possible: its only purpose is to allow the white paint to show up as you apply it.

Once the paint is thoroughly dry, cover the whole picture surface with waterproof ink. Allow the ink to dry completely before washing it off. The "negative" can either be left as a black-and-white image or it can be worked into with new colors, using gouache, watercolor, or acrylic.

Step-by-step: Wash-off

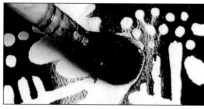

1 In this example, the artist uses a soft brush to remove any excess gouache. The waterproof black ink that was not painted over gouache stays firmly in place, despite repeated washings.

2 The finished effect is a silhou-etted image. This can be left as it is, or it can be developed by adding color to the white parts of the design. For demonstration purposes, the design shown here has deliberately been kept simple. However, the technique is best suited to a more intricate or textural design such as leaves and flowers. Animals, with their fur texture and markings, are another suitable subject.

WAX RESIST

This, a valuable addition to the water-colorist's repertoire, is a technique based on the antipathy of oil and water, and involves deliberately repelling paint from certain areas of the paper while allowing it to settle in others.

The idea is simple, but can yield quite magical results. If you draw or lightly scribble over paper with wax and then overlay this with watercolor, the paint will slide off the waxed areas. You can use either an ordinary house-hold candle or the type of inexpensive wax crayons produced for children.

The wax underdrawing can be as simple or as complex as you like. You can suggest a hint of pattern on wallpaper or fabric in a still life group or portrait by means of a few lines, dots or blobs made with a candle or do something more complex by making quite an intricate drawing using crayons, which are smaller and have good points.

Wax beneath watercolor gives a delightfully unpredictable speckled effect that varies according to the pressure you apply and the type of paper you use. It is one of the best methods for imitating natural textures, such as those of rocks, cliffs, or tree trunks.

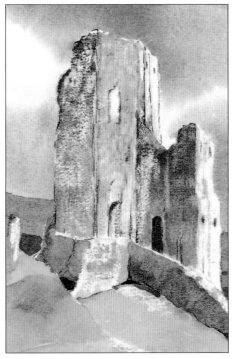

ABOVE AND RIGHT: *In both these examples, a stick of white wax oil pastel was scribbled over paper with a not surface and watercolor washes were then laid on top. In some areas the paint was left to dry and the process repeated. A more pronounced texture can be gained by working on rough paper.*

GUM ARABIC

This is the medium that, together with gelatin, acts as the binder for watercolor pigment (watercolors also contain glycerine to keep them moist). Gum arabic can be bought in bottled form and is often used as a painting medium. If you add a little gum to your water when mixing paint, it gives it extra body, making it less runny and easier to blend. It is particularly suitable for the kind of painting that is built up in small, separate brush strokes, as it prevents them from flowing into one another.

Its other important property is as a varnish. If a dark area of a painting, such as a very deep shadow, has gone dead through too much overlaying of washes, a light application of gum arabic will revive the color and give additional richness. It should never be used undiluted, however, as this could cause cracking. Experience will teach you how much to dilute it when using it as a painting medium, but a general rule of thumb is that there should be considerably more water than gum.

Step-by-step: Using Gum Arabic

1,2 The paper is first covered with a pale wash of blue-green watercolor. When dry, masking fluid is used to mask out the shapes of the fish. A wash of green and blue ink mixed with gum arabic is painted over the whole surface. While the wash is still damp, a clean, wet brush is pressed into the wash to lift out highlights in the water. The wash is left to dry completely before the masking fluid is removed.

3 Darker washes and highlights are built up in the same way. Additional highlights are lifted out with a craft knife while the ink and gum arabic mixture is damp.

4 To complete the picture, the goldfish are painted in tones of orange watercolor.

Mixed Media

Although many artists know that they can create their best effects with pure watercolor, more and more are breaking away from convention, finding that they can create livelier and more expressive paintings by combining several different media.

To some extent, mixing media is a matter of trial and error, and there is now such a diversity of artist's materials that there is no way of prescribing techniques for each one or for each possible combination. However, it can be said that some mixtures are easier to manage than others. Acrylic and watercolor, for example, can be made to blend into one another almost imperceptibly because they have very much the same characteristics, but two or more physically dissimilar media, such as line and wash, will automatically set up a contrast. There is nothing wrong with this – it may even be the point of the exercise – but it can make it difficult to preserve an overall unity.

WATERCOLOR & ACRYLIC

Acrylic used thinly, diluted with water but no medium or white, behaves in more or less the same way as water-color. There are two important differences between them, however. One is that acrylic has greater depth of color so that a first wash can, if desired, be extremely vivid, and the other is that, once dry, the paint cannot be removed. This can be an advantage, as further washes, either in watercolor or acrylic, can be laid over an initial one without disturbing the pigment. The paint need not be applied in thin washes throughout: the combination of shimmering, translucent watercolor and thickly painted areas of acrylic can be very effective, particularly in landscapes with strong foreground interest, where you want to pick out small details like individual flowers (very hard to do in water-color). It is often possible to save an unsuccessful watercolor by turning to acrylic in the later stages.

WATERCOLOR & GOUACHE

These are often used together, and many artists scarcely differentiate between them. However, unless both are used thinly it can be a more difficult combination to manage, as gouache paint, once mixed with white to make it opaque, has a matte surface, which can make it look dead and dull beside a watercolor wash.

Step-by-step: Painting Gourds

1 One of the most attractive qualities of these gourds is the contrast in textures. As the first stage in building up the pitted surface of the orange gourd, the artist mixes her paint with gum arabic, which makes it settle with a slight bubbling.

2 Still using transparent watercolor, she paints the yellow gourd wet-in-wet, allowing the colors to blend softly together.

3 Opaque gouache is now used for the flat background and some areas of the fruit. The texture of the orange gourd is achieved by further applications of paint mixed with gum arabic. This is blotted with a damp sponge.

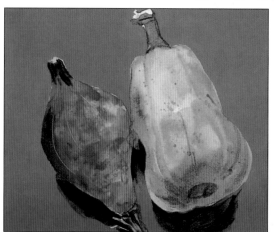

4 The finished result shows the pleasing variety of paint quality typical of mixed-media paintings.

PAINT AND PASTEL

Soft pastels can be used very successfully with watercolor, and provide an excellent means of adding texture and surface interest to a painting. Sparkling broken colors can be created by overlaying a watercolor wash with light strokes of pastel, particularly if you work on a fairly rough paper.

Oil pastels have a slightly different but equally interesting effect. A light layer of oil pastel laid down under a watercolor wash will repel the water to a greater or lesser degree (some oil pastels are oilier than others) so that it sinks only into the troughs of the paper, resulting in a slightly mottled, granular area of color.

Gouache and Pastel These have been used together since the eighteenth century when pastel was at the height of its popularity as an artist's medium. Some mixed-media techniques are based on the dissimilarity of the elements used, which creates its own kind of dynamism, but these two are natural partners, having a similar matte, chalky quality.

Watercolor and Crayons These are, in effect, mixed media in themselves. When dry they are a drawing medium, but as soon as water is applied to them they become paint, and can be spread with a brush. Very varied effects can be created by using them in a linear manner in some areas of a painting and as paints in others. They can also be combined with traditional watercolors, felt-tipped pens or pen and ink.

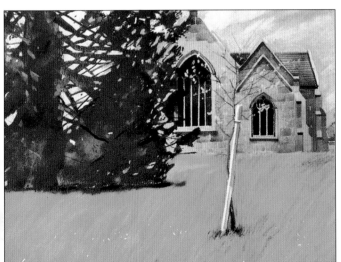

CHURCHYARD
by Ian Sidaway
This combination of media has produced a lively contrast of textures. The building and tree are pure watercolor, while the sky and grass are pastel worked over an initial watercolor wash.

Mixed Media Effects
•••••••••••••••••••••••••••••

PASTEL WITH WATERCOLOR WASH

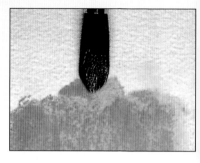

1 The vibrancy of soft pastel colors can be used to enhance the delicate transparency of watercolor washes. Here the artist creates a design with a soft orange pastel.

2 Using a soft watercolor brush, he washes over the pastel with a light toned wash to spread the pastel color. Any surplus moisture is removed with blotting paper.

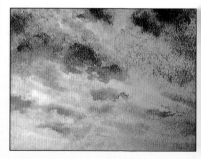

3 While the wash is still damp, the artist adds further details with the point of the pastel stick. When the wash dries, more pastel marks and watercolor washes can be added.

A cloudy sky at sunset is particularly striking. In this painting the artist has used watercolor and gouache, the former for its transparency and the latter for its brilliance of color.

Mixed Media Effects

GOUACHE AND CHARCOAL

1 The artist first applies a thick layer of yellow gouache. When this is completely dry he draws a design onto it with charcoal. Note that if the paint is still wet, the charcoal will not take.

ACRYLIC AND CRAYON

2 Using a No. 4 bristle brush, the artist works into the charcoal drawing with further gouache colors. Interesting variations of tone are achieved by allowing the charcoal to dissolve into the color in places.

Acrylic paints can be used very effectively in combination with oil crayons. The oil crayon resists the watery paint and the design shows up clearly through the colored wash.

Making Changes

CORRECTIONS

It is a common belief that watercolors cannot be corrected, but, in fact, there are several ways of making changes, correcting or modifying parts of a painting.

If it becomes clear early on that something is badly wrong, simply put the whole thing under cold running water and gently sponge off the paint. For smaller areas, wet a small sponge in clean water and wipe away the offending color, or for a very tiny area, use a wet brush.

It must be said, though, that some colors are more permanent than others – sap green, for example, is hard to remove totally – and that some papers hold onto the pigment with grim determination. Arches is one of the latter, but both Bockingford and Saunders papers will wash clean very well.

As a painting nears completion, you may find that there are too many hard edges or insufficient highlights. Edges can be softened by the water treatment described previously, but here the best implement to use is a dampened cotton swab. Both these and sponges are near-essentials in watercolor painting, as they are ideal for lifting out areas of paint to create soft highlights.

Any specks of dark paint that may have inadvertently flicked onto a white or light-colored area can be removed with a scalpel blade, but use the side in a gentle scraping motion, as pressure with the point could make holes in the paper.

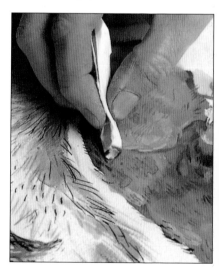

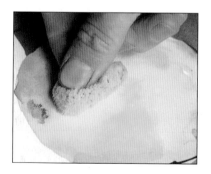

ABOVE *Here the artist finds he needs to lighten the color in this area, so he lifts out some of the paint with a damp sponge.*

ABOVE *If one color floods into another to create an unwanted effect, the excess can be mopped up with a small sponge or piece of blotting paper.*

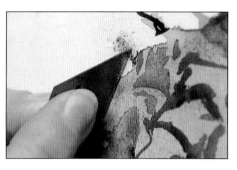

LEFT *Small blots are easily removed by scraping with a knife or razor blade. Be careful not to apply too much pressure or you could make holes in the paper.*

BELOW *Ragged edges can either be tidied up with a knife, or with opaque white gouache paint, as seen here.*

COLOR CHANGES

Newcomers to watercolor often find it difficult to judge the strength and quality of the first color to be applied. There are two reasons for this: one is that the paint becomes a great deal lighter when dry, the other is that it is hard to judge a color against pure white paper – the first wash inevitably looks too dark or too bright.

If you find the first colors are wrong, do not despair. Because watercolors are built up in a series of overlaid washes or brushstrokes, the first color and tone you put down is by no means final: many changes can be made on the paper itself. If a pale yellow wash is covered with a blue one, the color changes to become green, and the tone darkens because there are now two layers of paint. By the same token, a wash that is too pale is very easily darkened by applying a second wash of the same color or a slightly darker version of it. Although it is often stated in books about watercolor that light colors cannot be laid over dark ones, this only means that they will not become lighter, but colors can be modified in this way, particularly greens. A green that is too "cool," that is, with too high a proportion of blue, can be changed into a warmer, richer green by laying a strong wash of yellow on top.

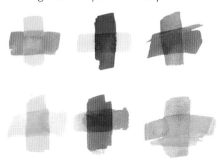

Color and Composition

Having experimented with the range of techniques used in watercolor painting, it is time to look at the art of composing a picture and putting on paper the colors that are before your eyes (or in your mind). There are questions of selection and balance to be addressed, in order to make a three-dimensional subject come to life in a two-dimensional form.

Many of these principles are common to all painting media, so much of the material in this section does not refer specifically to painting with watercolor. If you are already competent in painting with other media, you may be familiar with the principles explained here; but for those fresh to painting, these guidelines will be particularly valuable in the early stages of constructing a painting. Having learned these rules, you may wish to break some or all of them. That is one of the elements of creativity. But it is also important to have a firm grasp of the principles of painting so that you are aware of the effects of each decision you make regarding form and color.

Some people are fortunate enough to have an instinct for good composition and color use; others have to learn how to create a pleasing scene. If you are one of the latter, don't despair – the simple guidelines in this section will clarify the mysteries of color and composition.

Composition

Deciding how large the picture should be, how the objects you are painting should be grouped together and positioned within the picture area, choosing different elements of line and shape, value and color, and applying them in ways that make your painting look right as a whole – all these are the ingredients of composition.

SIZE AND SHAPE

The majority of pictures are rectangular or contained by a rectangle. Partly this is just practical – paper is sold in rectangular sheets and it is easier to make a stretcher for canvas or cut a panel for painting in this regular format, than to prepare a painting surface of a different shape. Visually, a rectangle gives a clear-cut, evenly balanced picture area within which you can organize the elements of your painting. Artists can, and do, make paintings that are round,

elliptical, or irregularly shaped. This may be because the painting is planned for a particular place, but the shape of a painting usually grows out of the demands of an individual subject or approach. Unusual shapes for painting are something that you can consider later if they interest you.

Working with a rectangle, you can choose to make the picture square, or to have a longer dimension from top to bottom, or from side to side. A format in which the upright dimension is longest is often referred to as a portrait shape; one in which the width is longer is called landscape. These terms, however, don't imply a rule for composition – a portrait or figure can occupy a wide canvas, and a landscape can be given vertical emphasis.

When you begin work, you have to choose paper or canvas of appropriate size and, unless you are making a square painting, decide whether you will use it as a portrait or landscape shape. This depends on your choice of

LEFT: *The viewpoint of Stephen Crowther's At The Water's Edge exploits the strong line of the promenade.*

subject and what you decide is the best view of it.

Some artists start painting without deciding on the final dimensions of the painting, letting the shape gradually emerge. Alternatively, an unusual format – a long, narrow rectangle, say – may suggest a particular treatment of the subject.

If you work on paper, you don't have to fill the given rectangle. You can trim it or, later on, use a mount to contain the picture area. You can trim it or, later on, use a mount to contain the picture area. You can even extend it quite easily if your painting becomes too large for the paper by attaching another piece of paper to it. It is easiest to begin with a format that will work for the painting you have in mind. If you find when you start to develop the composition that something important slips off the edge of the picture, you can adjust your composition by redrawing and overpainting.

When you select a size of paper for your painting, consider it in terms of the actual scale of your subject. A small landscape can be powerful, but you might prefer the spacious feel of a large picture. If you choose a large picture area for a small-scale subject, however, say a still-life or portrait, it may mean that you end up painting the objects larger than life size. This can look strange because objects naturally relate to a personal sense of scale; and when you paint them over life size, you encounter problems in

achieving the correct proportions and spatial relationships.

SCALING UP A RECTANGLE

An integral part of squaring up is the enlargement of a rectangle, which can be done quickly and simply, without the need for calculations. This will ensure that the shape used for the finished painting is exactly the same proportion as the sketch or photograph. The same method can be used to reduce a rectangle, though this is less common. You will need a set square, a ruler, a pencil, the original reference, and a sheet of tracing paper, which is taped over the original. First draw the bottom line, then the left vertical line. This forms the bottom left corner shared by the original and the enlargement.

Place the reference in this corner and draw a diagonal line through the bottom left corner and the top right corner of the original. Continue this line extending to the top right. At any point on this line you can drop a vertical to the base line and a horizontal to the left-hand vertical. This will form your new scaled-up rectangle.

ENLARGING WITH A GRID

Preliminary sketches are often drawn smaller than the finished painting, as they are usually done in sketchbooks; to make them full size would be unnecessary. If you are working from photos, they will also need to be enlarged. This can be done solely by eye, but this is difficult to enlarge accurately, as the eye plays tricks. The grid method is an accurate way to transfer, enlarge, reduce, or even deliberately distort an image. It is time-consuming, but you can be sure of accurate proportions. You will need to draw two grids, one to go over the reference and a second, proportionately larger, to act as a guide for the new drawing.

1 Lay a sheet of tracing paper over the sketch or photo and tape the two together at the back with masking tape. Using a ruler and set square, draw a grid of equal squares over the whole of the tracing paper. Number each vertical line and letter each horizontal line, so that you can fix any point of reference.

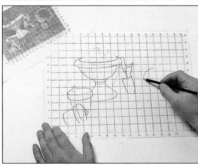

2 This drawing is being enlarged twice up from the original. Take another larger sheet of tracing paper and redraw the grid, exactly twice the size, then label the squares in the same way with numbers and letters. Transfer the drawing from the small to the large grid, using clear, simple lines.

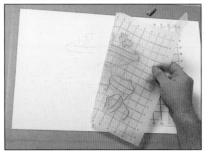

3 When the drawing is completed, rub over the back of the trace with colored chalk, under the drawn lines. Tape the trace in place on the watercolor paper, chalk side down, and redraw over the existing drawing; the lines will be transferred to the paper in the form of chalk marks. Remove the trace.

MEASURING

You should give yourself a very strict framework for measuring up your watercolor and relating the objects within it. Make sure that your viewpoint is always fixed; do not obscure your line of vision with your drawing board and be certain you are comfortable, seated or standing, so that you will not want to move after ten minutes. Do not attempt to draw your objects from too close a view-point or to cover too wide a range. Although we can see through an angle of 180° only a fraction of this, about 45°, is within our proper field of vision.

Anything out of this field quickly becomes distorted and out of focus. You should never attempt to turn your head from side to side in order to see more as this will alter your central line of vision and your view will very quickly become confused. It is also necessary to shut one eye when measuring up distances. This is because our two eyes provide us with binocular vision, which gives us a moving viewpoint. Shutting your eyes alternately will show this to be so, particularly in the relationship of objects close to each other.

Hold a pencil at arm's length and slide your thumb up and down it to calculate the relative sizes of objects.

Hold up a wooden ruler and swivel it till it matches the diagonal, then transfer the line to the drawing.

Making a Viewfinder

Cut out a rectangular window from cardboard of a neutral color, such as black or gray. With a pencil, mark quarter segments on two sides and half segments on the others. These marks will aid in calculating the proportions of different objects.

By holding up the viewfinder, you can eliminate surrounding detail, simplifying the scene and helping you to make decisions on what to include in your picture, and what format to choose.

This shows the possibilities of a landscape format. You can spend time moving the viewfinder around at arm's length, trying out first a landscape format and then a portrait shape, until the composition begins to take shape.

When working outdoors the simple window- type viewfinder is the easiest to use, but if you want to vary the proportions from a standard rectangle, two cut-out "L" shapes can be used. This allows you to plan a square composition, or an elongated landscape shape, as shown here.

Making Thumbnail Sketches

Before starting a painting, spend some time making simple pencil sketches, drawing the basic shapes and directional lines you can see in your subject. Start by making a framework of connecting lines that contain the overall shapes, then start to break down the large areas into small sections, paying attention to the relative height, width, and depth of different elements in your subject, the interaction of straight lines and curves, and the links between shapes in different parts of the picture.

When you have made a variety of quick sketches, play around with the size and proportion of the picture. Try drawing a rectangular frame around each sketch to increase the background area or push the edges of the picture closer into the subject, perhaps allowing important shapes to be cut off at the sides, top or bottom of the frame.

1 The picture frame encloses a conventional view with vertical and horizontal stresses evenly balanced.

2 Moving into the subject, the artist makes the vertical stress more central and the background more busy and active.

3 Featured so closely, the tree becomes an abstract shape that divides the background and breaks up the balance.

CLOUDS IN COMPOSITION

The possibilities of using clouds as an integral part of a composition are often ignored, which seems strange in view of the fact that skies are often the dominant element in a landscape. But the landscape painter must tackle this problem: clouds form exciting shapes in themselves, and these can be manipulated or exaggerated to add extra movement and drama to a subject. Shapes in the sky can also be planned to provide a balance for those in the foreground or middle distance, such as clumps of trees or rounded hills, and if colors as well as shapes are repeated from sky to land, the two parts of the painting will come together to form a satisfying whole. Since the sky is reflected to some extent in the land below, you will often see touches of blue or violet from the undersides of clouds occurring again in shadows or distant hills.

Not all paintings, of course, need this kind of sky interest. A mountain scene, for instance, or winter trees in stark silhouette, will be more successful if the sky is allowed to take second place, but a flat landscape can often be saved from dullness by an eventful sky, so keep a special sketch-book for recording cloud effects so that you can use them in landscapes painted indoors. Skies are very difficult to recreate from memory alone, so in addition to sketches, you could also use photographs of skies.

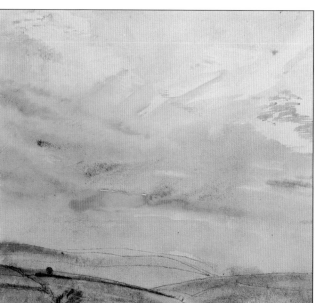

SUNSET, SOUTH DOWNS
Charles Knight
In this painting, the sky is virtually the whole composition, with the hills and fields serving as an anchor to the movement above. Much of the sky and foreground has been painted wet-in-wet, and in the central area the orange and gray washes have been allowed to flood together, giving a realistically soft effect.

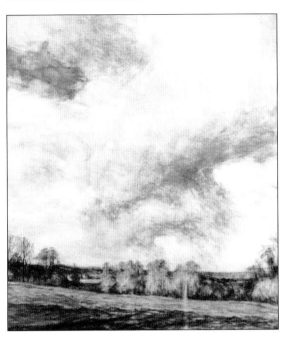

SPRING SHOWER
Donald Pass

This is the perfect example of clouds used as an integral part of a composition. The painting is full of movement, and our eye is encouraged to travel around it as we follow the direction of the dramatic, curving cloud — up to the right, around to the left and then downward through the bright patches of blue to the sunlit trees. The artist has tied the sky to the land both by using the same kind of brushwork throughout the picture and by echoing shapes: the vertical cloud seems a logical extension of the central group of trees.

CLOUD STUDY
Ronald Jesty

This dramatic painting, although giving the appearance of a planned and studio-composed piece, was in fact a study sketch made on the spot after a storm — which just goes to show that nature will do at least some of the

composing if you are receptive enough to her suggestions. The painting is quite small and was done quickly, of necessity, with superimposed washes and the dark clouds at the top painted wet-in-wet. Wet paint was lifted out in places (see LIFTING OUT) and the white cow parsley was suggested by stippling around the shapes with the point of a brush.

COMPOSING A STILL LIFE

Planning the disposition of objects in a still-life group so that they provide a satisfactory balance of shapes and colors is as important as painting it.

A good still life, like any other painting, should have movement and dynamism, so that your eye is drawn into the picture and led around it from one object to another. It is wise to avoid the parallel horizontals formed by the back and front of a tabletop: the eye naturally travels along straight lines and these will lead out of the painting instead of into it. A device often used to break up such horizontals is to arrange a piece of drapery so that it hangs over the front of the table and forms a

rhythmic curve around the objects. An alternative is to place the table at an angle so that it provides diagonal lines that will lead in toward the centre of the picture.

Never arrange all the objects in a regimented row with equal spaces between them, as this will look static and uninteresting. Try to relate them to one another in pictorial terms by letting some overlap others, and give a sense of depth to the painting by placing them on different spatial planes, with some near the front of the table and others towards the back. Finally, make sure that the spaces between objects form pleasing shapes – these "negative shapes" are often overlooked, but they play an important part in composition.

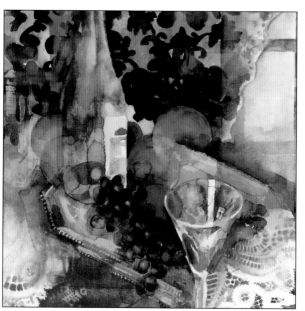

BLACK GRAPES AND WINE
Shirley Trevena
Trevena works straight from her arranged group with no sketching, and composes as she paints. She likes to vary the texture of her paint, using thin watercolor washes in places and thickly built up layers of gouache in others. The lace is the original white paper left untouched. Her work has a lyrical quality: the objects are all recognizable, but we are drawn to the painting by the fluid shapes and colors.

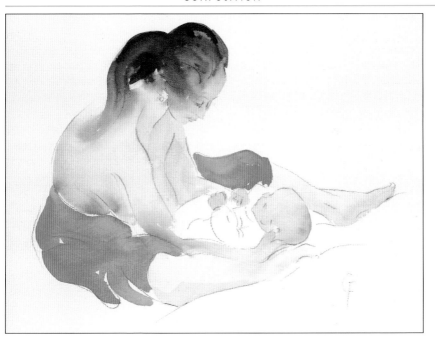

MOTHER AND CHILD Greta Fenton in watercolor and conté crayon

COMPOSING FIGURE PAINTING

It is easy to become so bogged down in the intricacies of the human figure and face that composition is forgotten, but it is every bit as important as in any other branch of painting. Even if you are painting just a head-and-shoulder portrait, always give thought to the placing of the head within the square or rectangle of the paper, the background and the balance of values.

A plain, light-colored wall might be the ideal foil for a dark-haired sitter, allowing you to concentrate the drama on the face itself, but you will often find you need more background or foreground interest to balance a subject. Placing your sitter in front of a window, for example, will give an interesting pattern of vertical and horizontal lines in the background as well as a subtle fall of light, while the lines also have pictorial potential.

Figures or groups of figures in an outdoor setting need careful pre-planning. You will have to think about whether to make them the focal point of the painting, where to place them in relation to the foreground and background and what other elements you should include – or suppress. It is a good idea to make a series of small thumbnail sketches to work out the composition before you begin to paint.

COMPOSING A LANDSCAPE

Whatever the medium used, landscape is among the most popular of all painting subjects. One of the reasons for this is the common belief that it is easier than other subjects. Many who would never attempt a figure painting or flower study turn with relief to country scenes, feeling them to be less exacting and thus more enjoyable. However, a painting will certainly be marred by poor composition or mishandled colors – these things always matter, whatever the subject. The best landscapes are painted by artists who have chosen to paint the land because they love it, and use the full range of their skills to express their responses to it, not by those who choose it as an easy option.

You should never attempt to copy nature itself: painting is about finding pictorial equivalents for the real world. This means that you have to make choices and decide how much to put in or leave out and think about whether you might exaggerate a certain feature in the interests of art. For instance you might emphasize the feeling of space in a wide expanse of countryside by putting in some small figures in the middle distance, or convey the impression of misty light by suppressing detail and treating the whole scene in broad washes.

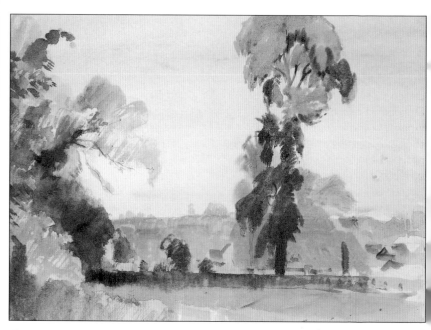

TALL TREE AND BUILDINGS Charles Knight in watercolor

COMPOSING A FLOWER PAINTING

A group of flowers tastefully arranged in an attractive vase always looks enticing – that, after all, is the point of putting them there – but it may not make a painting in itself. Placing a vase of flowers in the center of the picture, with no background or foreground interest, is not usually the best way to make the most of the subject – though there are some notable exceptions to this rule. So you will have to think about what other elements you might include to make the composition more interesting without detracting from the main subject.

One of the most-used compositional devices is that of placing the vase asymmetrically and painting from an angle so that the back of the tabletop forms a diagonal instead of horizontal line. Diagonals are a powerful weapon in the artist's armory, as they help to lead the eye in to the center of the picture, while horizontal lines do the opposite.

One of the difficulties with flower groups is that the vase leaves a blank space at the bottom of the picture area. This can sometimes be dealt with by using a cast shadow across part of the composition, or you can scatter one or two blooms or petals beneath or to one side of the vase, thus creating a relationship between foreground and focal point.

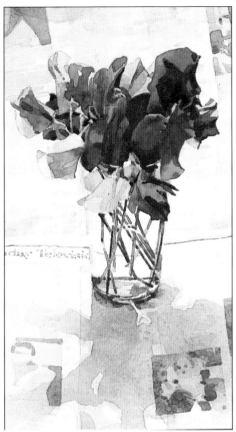

SWEET PEAS IN A TUMBLER Ronald Jesty
Jesty's compositions are always bold, and often surprising, as this one is. We are so conditioned by the idea of "correct" settings for flower pieces and still lifes that the idea of placing a vase of flowers on a newspaper seems almost heretical. But it works perfectly, with the newspaper images providing just the right combination of geometric shapes and dark tones to balance the forms and colors of the sweet peas.

BALANCE AND COUNTERBALANCE

One of the most important goals in composing a painting is achieving visual balance. In other words, the various elements that make up the image – lines, shapes, colors, values and textures – must be arranged with care, so as to create a harmonious result.

Throughout the centuries, artists and critics have put forward innumerable theories about what makes a successful composition. But it was the ancient Greek philosopher, Plato, who expressed most succinctly what good composition is all about. Plato stated quite simply that

"composition consists of observing and depicting diversity within unity." By this he meant that a picture should contain enough variety to keep the viewer interested, but that this variety must be restrained and organized if we are to avoid confusion.

Plato's observation sums up, in fact, the dilemma that faces us each time we begin composing a painting. For though the human eye is drawn to stability, order, and unity, it is also attracted by freedom, diversity, and the element of surprise. The challenge for the artist lies in striking the right balance between these opposite attractions.

The most obvious way to achieve balance is through a symmetrical composition, in which elements of similar value, shape, and size are used together in almost equal proportions. Although at times such a structure may serve a concept well, for most purposes too much symmetry

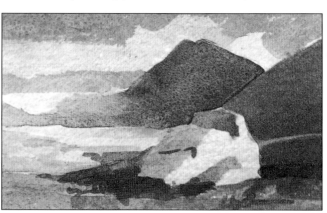

ABOVE: *In this illustration there is an imbalance between the left and right halves. The mass of the mountains and rocks on the right has great visual weight, with its strong color and value contrasts, whereas the left half of the picture is virtually empty. The scales demonstrate this imbalance.*

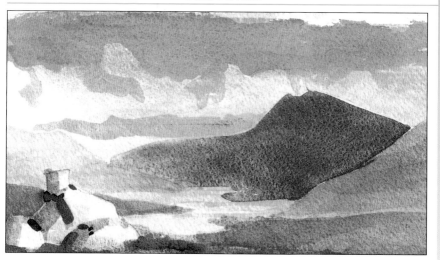

ABOVE: *This version shows how an asymmetrical composition can create visual interest while, at the same time, retaining balance and unity. The artist has enlarged distant mountains and included only the foreground rocks on the left. Thus we have a small mass of light value on the left that has enough visual weight to counterbalance its large mass of dark value on the right.*

results in a rather static and uninspired design, lacking in the element of diversity that Plato talked about.

For most artists, the way to achieve diversity within unity is to create an asymmetrical composition, in which features that are inherently different but of equal interest are arranged so as to counterbalance one another. An asymmetrical composition succeeds in creating a sense of equilibrium, while at the same time allowing a contrast of shapes, colors, and values that lends vitality and interest.

Asymmetrical composition is often compared to a pair of old-fashioned weighing scales, in which a small but heavy metal weight on one side can balance a much larger pile of fruit or vegetables on the other. Think of the

shapes and masses within your composition as "weights" to be balanced and counterbalanced until an equilibrium is found. Remember, it is not only size that gives an object visual weight - strong color, shape, texture, or value will attract the eye when used as a contrasting element, even in small amounts. For example, a large area of light value can be counterbalanced by a small area of dark value that has more visual weight; and a large area of cool color can be offset by a small amount of intense color that creates a strong focus.

CREATING A CENTER OF INTEREST

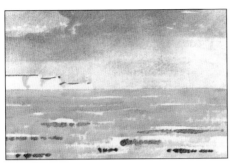

LEFT: *This seascape has few interesting physical features to hold our interest. But the sea and sky could have been made to look more interesting than they are here; the painting has no obvious focal point, and our eyes dart from one are of the picture to another, unable to settle anywhere in particular.*

The nineteenth-century English artist and writer John Ruskin was once asked "Does a picture need a focal point?" His reply was firm: "Indeed it does, just as a meal needs a main dish and a speech a main theme, just as a tune needs a note and a man an aim in life . . ."

In other words, a picture should have one strong center of interest to which the viewer's eye is drawn – the pint which contains the message of the picture. Of course, many paintings don't have a center of interest, but these are usually abstract designs in which the artist sacrifices dramatic interest for the overall unity of pattern or texture. In representational painting, on the other hand, the lack of a center of interest leads to an incomplete feeling.

When planning the compositional arrangement of the painting, your first question to yourself should be "what do I want to emphasize, and how should I emphasize it?" For example, in a portrait the center of interest is normally the sitter's face, whose expression conveys his or her personality. In a still life, the center of interest might be a jug of flowers, with the other objects playing a supporting role.

There are several devices that the artist can use to bring attention to the center of interest, such as placing more detail or texture in that area, or more intense colors, or contrasting shapes. But the most dynamic attention-getter is tonal contrast. It is well known that light areas stimulate the nerve endings in the eye and appear to expand, whereas dark areas absorb light and appear to contrast. Therefore, by placing the lightest light and the darkest dark adjacent to each other at the center of interest, you create a visual tension, a "push-pull" sensation that attracts the viewer's eye and holds his or her interest.

More often than not, the subject that you want to paint won't have an obvious focal point – it's up to you to create one. This applies particularly to

landscapes and seascapes, in which the sheer magnitude of a panoramic view makes it difficult to focus your attention toward a specific point. When you're looking at the real thing your eyes can happily roam at will over the scene without resting on any particular point, and this won't detract from your enjoyment. But it's a quite different matter when you take all that detail, color, and movement and "freeze" it on a small, flat sheet of paper.

One important thing to remember is that there should never be more than one major center of interest in a painting. If there is more than one dominant area, the message becomes diluted and the picture loses impact. Even if the picture contains multiple subjects, the composition needs to be carefully controlled so that one subject or area commands more attention than the rest. For example, if a landscape scene includes two foreground trees of equal size, they will compete for attention and you may have to deliberately reduce the size of one tree in order to lend more importance to the other.

BELOW: *The same scene, but with one marked improvement. Notice how your attention is caught by the light shape of the cliffs against the dark cloud? The artist has placed the lightest and darkest values next to each other, and this sharp contrast makes an arresting focal point. Now the picture has more meaning, and is more satisfying to look at. The dark foreground wave has a part to play, too. It acts as a counterpoint to the center of interest, while creating a sense of movement that directs our eye toward it.*

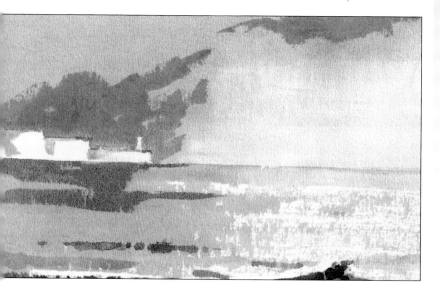

99

Tonal Values

Painting and drawing are an extension of the art of seeing; by viewing a familiar object in an unexpected way we often gain new insights not only into the physical world around us but also into ourselves and our own individuality. This intensity of experience inevitably comes through in our paintings and drawings, which take on a greater power and beauty.

Accordingly, the projects and demonstrations in this chapter are designed to develop your awareness of tonal values through close observation and intelligent inquiry. You'll learn how to spot those dynamic shapes of light and shade that lend poetry to even the most ordinary subject; how to make sense of a complex subject by making value sketches; and how a convincing illusion of reality can be achieved by working with a limited range of values.

If all this sounds like hard work – it is. But as any artist will tell you, painstaking observation is as vital to successful picture-making as the knowledge of practical techniques. Added to which, the discovery and understanding of what makes a thing tick is always a rewarding and exciting experience in itself.

BEACHED FISHING BOAT, SUFFOLK ESTUARY by Edward Wesson

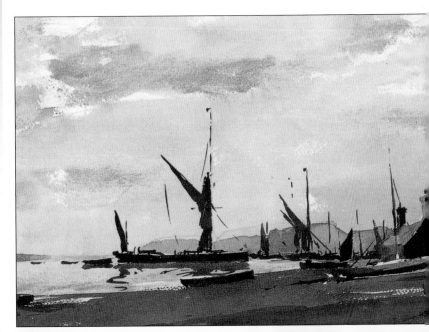

WHAT ARE TONAL VALUES?

The word "value" simply refers to how light or dark an area is, whatever its color. Some colors reflect more light than others, which is why we perceive them as being paler in value. for example, navy blue and sky blue are both the same basic color, but navy blue is dark in value, while sky blue is light in value.

In addition, the value of a color is changed by the way the light falls on it, so that one color can show a variety of values. Imagine a man in a navy-blue sweater standing in front of a window so that he is at right-angles to you. His sweater is all made of the same color of wool, but you'll notice how its value appears darker at the back than at the front, where the light from the window is striking it.

The idea of tonal value is easy to understand if we look at it in terms of black and white. Every color (every pure, unmixed color, that is) has a tonal "value," ranging from white to black and with infinite shades of gray in between. You can test this by looking at a black and white photograph of a painting, or by adjusting the knob of your color television set until the picture goes black and white.

LEFT: *This still life contains a wide range of values. The intense colors in the fruit and flowers contrast with the muted colors of the other objects.*

ABOVE: *The same still life photographed in black and white, allows us to see the arrangements in terms of light and dark value patterns.*

MAKING VALUE SKETCHES

Having trained your eye to perceive values, you're now ready to move on to the next stage – using tonal values to create a balanced and unified composition. In nature the range of values from the darkest dark to the lightest light is extremely wide – far wider than we could ever hope to attain in a painting. As artists we are obliged to select from nature only those elements that seem to capture the essential spirit of the subject, and ignore the inconsequential details; in order to give a painting more force, we have to portray what we see in a crystallized form. The problem is that, when faced with a complex subject like a landscape, we "can't see the forest for the trees." So how, when confronted with a profusion of shapes, values, and colors, lit by changing light, do we begin this process of selection?

The answer is simple: before you begin painting, make a few pencil sketches of the subject in which you concentrate only on the main shapes and value masses. These sketches are useful firstly because they provide a way of getting familiar with the subject so you feel more confident when starting to paint it, and secondly because you can use them to try out

BELOW: *A harbor scene like this one makes an attractive painting subject. The only problem here is that the overall value pattern is too busy and scattered.*

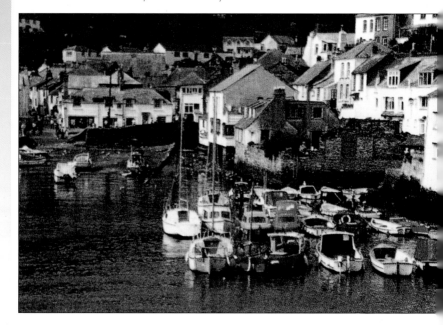

different arrangements of lights and darks until you arrive at the one that seems best. There's an old carpenter's maxim that says "measure twice and cut once." Making preliminary sketches will save you a lot of time and frustration at the painting stage.

ASSESSING THE VALUES

During the eighteenth century, landscape painters often used a device called a Claude mirror to help them see more clearly the simple pattern of lights, darks, and middle values in a landscape. This consisted of a piece of darkened mirror glass which, when held up to the subject, reflected the image in a lower key. It also reduced the image in size, enabling the artist to see a large stretch of landscape as it would appear picture-size. The device was named after the French artist Claude Lorrain (1600–1682), who is well known for his beautiful tonal landscapes painted in mellow colors.

Today, Claude mirrors are no longer made, but you can achieve a similar effect by looking at the subject through a piece of tinted glass or acetate. This won't, of course, reduce the image in size, but it will cut out most of the color and detail so you can see a more simplified arrangement of values. Looking at the subject through sunglasses also works well.

When making your value sketch, work quickly and reduce everything to just three values – light, medium, and dark (save the white of the paper for

the lightest value). Does the finished sketch have a good balance of values? If it doesn't, feel free to arrange and rearrange the proportion and distribution of the light and dark areas, until something "clicks" and you feel happy with the way they hold together. It helps if you can temporarily disregard aspects like color and identifiable subject matter and look at the sketch as a flat, two-dimensional pattern of light and dark shapes. If this simple light/dark pattern doesn't hold together as a harmonious abstract design, then the painting will most likely fail. What you should strive for is a lively interplay of lights and darks that creates a strong movement across the paper. The overall pattern should be simple and cohesive, consisting of a few large, interlocking shapes rather than a lot of small, fragmented ones.

START WITH FIVE VALUES

When a painting contains too many different colors, it is unsatisfying to look at because the colors end up by canceling each other out. Exactly the same thing applies with values – too many will cause a painting to look confused and disjointed. Of course we can discern literally dozens of different values in nature – and there is nothing in nature that looks confused or disjointed – but for the purposes of picture-making we need to reduce the number of values we see to just a few, in order to make a clear, uncluttered statement.

LEFT: *By half-closing his eyes, the artist reduces the scene to just three or four values. In this first sketch, he ties similar values together to make larger, stronger shapes.*

BELOW: *Now he strengthens the areas of darkest value.*

One of the most useful lessons you should learn in painting is how to make less say more. It's a little like giving a speech – if you include too many irrelevant facts, the listener will very soon become bored, whereas a few considered phrases, well delivered, will make a lasting impression.

Most painters tend to work with around nine to twelve values, but it is possible to create a perfectly good picture with just three to five. In fact, if the whole idea of tonal values leaves you feeling puzzled, a good exercise is to make a few paintings or drawings using only five values; white, a light value, a middle value, a dark value, and black. By doing this, you will train your eye to judge the value of any color correctly, and you will learn to see things in terms of broad masses instead of getting bogged down in small details.

A value scale like the one below is helpful in determining the values of the colored objects you are painting. It gives you something positive to gauge the values of your subject by; you simply give each area of color a tone value from one to five on the scale, depending on how light or dark it is.

Start by drawing a bar 5 in. (12.5 cm) long and 1 in. (2.5 cm) wide on a sheet of white paper. Divide the bar into

1 in. (2.5 cm) squares. Leaving the first square white, take an HB pencil and lightly fill in the other four squares with hatched lines. Exerting the same degree of pressure on the pencil, go over the hatched lines again, this time starting with the third square. Now go over squares four and five again, and finally square five only. So long as you exert the same degree of pressure with the pencil each time, this should give you an even gradation in value from white to black.

It's a little more difficult to create a value scale in paint so that you get an even gradation. If I'm using watercolor I start by mixing up a full-strength solution of ivory black in a jar and then dividing it between four saucers. I keep one saucer "neat," to act as the darkest value. Then, to get my light, middle, and dark grays, I add a teaspoon of water to the second saucer, two teaspoons to the third, and three teaspoons to the fourth. for the fifth value, I simply use the white of the paper.

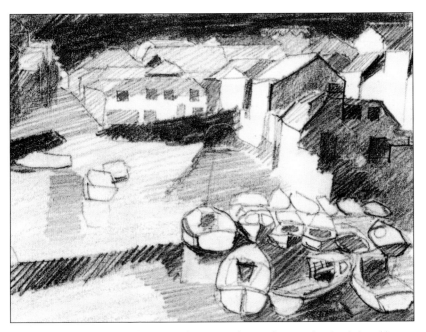

ABOVE: *Having established the main value masses, he can fine-tune the sketch by adding the middle values and reinforcing the linear design. The attractive layout of the harbor scene remains intact, but the composition is now stronger and more unified. The sketch will serve as the basis for a finished painting.*

Still life in Five Values

One of the most fascinating aspects of still life painting is recording the complex interplay of shape and form, value and color, light, and shade – qualities that make each still life unique. The aim of this project is to record those shapes and values as simply and expressively as possible – in other words, to get to the real essentials of the subject.

Set up a simple still life group similar to the one illustrated. It doesn't matter what you choose to paint, so long as the group includes a range of colors from very pale to very dark. Arrange the objects on a table against a wall, and light them from one side so that you get interesting cast shadows.

Use any medium you like, but stick to just five values. In order to keep the values consistent throughout, it's best to premix them beforehand.

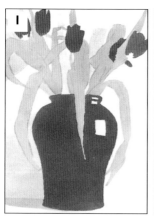

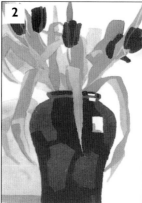

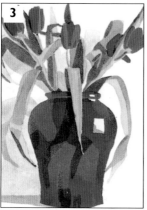

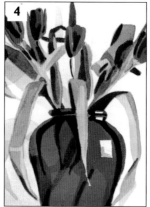

1 Highlights and light values **2** Pale mid-values **3** Dark mid-values **4** Darkest values complete the picture

The Illusion of Depth

Perhaps the greatest challenge in landscape painting is that of creating the illusion of space and depth on a flat piece of paper. The sight of fields, hills and trees stretching away into the hazy distance is a marvelous one, but how can we capture it convincingly in paint?

Simple tricks of linear perspective can work to a certain extent; overlapping one shape in front of another, for example, gives an instant three-dimensional effect, as does the presence of a foreground detail that recedes into the picture, such as a road or fence. But by far the most effective means of improving the quality of depth and distance in a painting is through the use of "aerial perspective." This term, invented by Leonardo da Vinci (1452–1519), describes the phenomenon found in nature whereby dark forms become lighter in the distance but light forms become darker, with the contrasts between values becoming progressively smaller toward the horizon.

This section explains how to use value and color to reproduce the effects of aerial perspective and so

LANDSCAPE LATE AFTERNOON by Charles Harrington

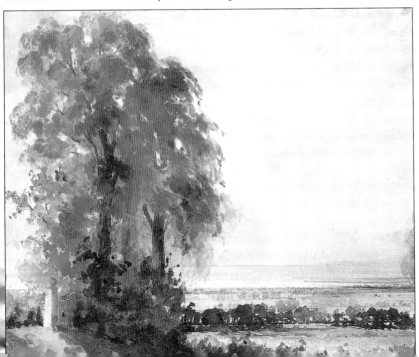

bring your landscapes to life. In addition, you'll find advice on how to choose the best viewpoint so as to emphasize the feeling of depth and recession. Finally, you'll discover ways to capture the subtle nuances of value and color that lend atmosphere to portraits, still lifes, and indoor scenes.

AERIAL PERSPECTIVE

Also know as atmospheric perspective, this is a subject which is of particular concern to the landscape artist. In the picture below Robert Dodd has observed the effects of aerial perspective carefully, controlling his values and colors with great skill so that the middle ground merges gently into the far distance. The tonal contrasts in the foreground are quite strong, while the far-off hills are only just darker than the sky. His painting creates a strong feeling of place and atmosphere as well as of space and recession.

Objects in the foreground are stronger in value and have stronger tonal contrasts within themselves than objects in the middle distance, and these in turn are stronger than objects in the far distance. This difference in value is the result of haziness caused by dust particles and mist and other effects of weather. As values lessen in strength, they take on an increasing blueness; while a far distant range of hills is likely to be seen almost entirely as a limited scale of light blues and blue-grays. Middle distance fields will tend to be seen as greenish blue and foreground features will exhibit the whole range of color and value.

TILLINGBOURNE VALLEY, WINTER by Robert Dodd

VIEW THROUGH THE VALLEY *The control and subtlety exercised here indicate the considerable technical skill of the artist and a good eye for tonal assessment. Full use has been made of atmospheric perspective as the magnificent slopes in the foreground give way to the hazy blue tinge of the distant mountains.*

Another method of establishing depth is by the scale of forms in the foreground. The inclusion of monuments, buildings, figures, and other features adds interest and can create drama. It can often be the visual focus point in the composition as seen here, or the main subject of the painting, with the surrounding landscape providing atmosphere and setting the stage. A building in a landscape can provide an interesting change of tone and form – a basic rectangular shape within softer, more natural forms.

Green is the most dominant color in landscape. It is easily made thin and acid and it takes real sensitivity to achieve vibrant foliage or a good grass green. No one green will be adequate to depict the range of color seen in nature. The same trees and fields will change from season to season; yellow-green spring shoots change to blue-green summer leaves to the purple, yellow, and orange of autumn.

It is important to vary the basic constituents of the greens you use; blue and yellow mixed give the most common result but black, umber, and yellow ocher are frequently added, and mixtures of Prussian blue and raw sienna, or raw umber contrast well with the brighter hue of viridian. The general rule is to make sure that more than one green is used in any painting.

CHOOSING THE BEST VIEWPOINT

Once you have grasped the principles of aerial perspective, the qualities of depth and atmosphere in your paintings will increase tremendously. However, it is equally important to consider the actual composition of your picture, since this can either enhance the feeling of recession or destroy it.

As we have already seen, the way to achieve depth is to divide your picture into distinct areas in terms of distance – the foreground, middle ground and background – and to keep these areas distinct in value. In this respect, your choice of viewpoint becomes vital; it can make all the difference between a flat, insipid picture and an exciting, effective one.

Let's look first of all at the center of interest, or focal point – the part of the picture to which the viewer's eye is drawn. This does not necessarily have to be in the forefront of the picture just because it is the center of interest;; indeed by placing it in the distance or middle distance, you will encourage the viewer to "step into" the picture and explore the composition, thereby increasing the impression of distance and depth.

The foreground needs careful thought, too. It should be the strongest

LEFT: SPRING by Frederick Walker
Influenced by the Pre-Raphaelites, Walker uses carefully observed and highly wrought detail, picking out the foreground with particular care.

FAR RIGHT: LANDSCAPE NEAR LESS BAUX by David Hutter
In this striking image the artist has chosen a bird's-eye view in which the landscape is rolled out like a map in front of us. Notice how the outer edges of the picture are vignetted; these areas of bare paper seem to pull the eye into the picture and back to the distant mountains.

of the three planes in the picture, but not so strong that it sets up a barrier between the viewer and the rest of the composition. For this reason, artists such as Camille Corot (1796–1875) included nothing in the foreground of their pictures that was nearer than 200 or 300 yards (180 or 270 meters) away from their easels. A slight sketchiness in the immediate foreground is often desirable, especially where the values of the landscape are delicate, as in a misty scene.

On the other hand, a prominent object in the foreground can act as a valuable counterpoint to a more distance center of interest. For example, the overhanging branches of a foreground tree can be used to create a frame within the borders of a picture, through which the viewer looks out across the landscape beyond.

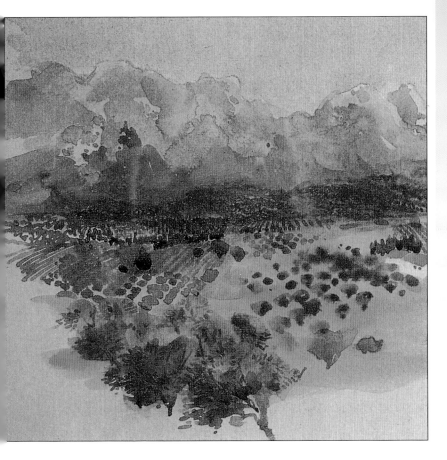

Creating Mood

So far we've looked at ways of using tonal values to describe the *physical* aspects of what we see – in rendering the character and solidity of objects and the nearness and farness of things, for example. But the *emotional* content of a picture is every bit as important, if not more so. Mood, atmosphere, a certain intangible quality conveyed by the way light falls on a subject – these combine to create "the spell that charges the commonplace with beauty," to quote from the great British photographer Bill Brandt.

Here, once again, tonal values play a major role in creating the mood you want to convey in your pictures. There is a strong connection between the value range in a painting and the mood it conveys; a preponderance of dark values gives a somber or mysterious atmosphere, whereas light values create a lively or cheerful impression. The way light and dark values are arranged and distributed can also have an influence on the emotional impact of a painting. For example, dark values in the lower half of the painting convey a feeling of strength and stability; but if the dark values occupy the upper half of the composition, as in a storm scene, the mood alters radically, becoming somber and threatening.

This section explores the many ways in which tonal values can be organized and used as a means of expression. You'll learn how to key tonal values to convey a particular mood; how to capture the atmospheric effects of light, both indoors and out; how to use light to

create mood in portraits; and how to exploit the magic and mystery of shadows in creating powerful and compelling images.

BELOW: A STREET IN MILAN by Phil Wildman
This painting is full of atmosphere. The somber colors, and limited range, consisting entirely of browns, ochers, and purple-grays, create a sense of quiet loneliness. This feeling is accentuated by the shaft of misty sunlight, the empty cars, and the small group waiting for the bus.

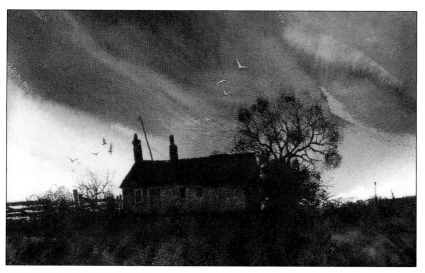

ABOVE: STORM FROM THE SEA by Stan Perrott

ABOVE: *The cottage is outlined against the light part of the sky. Strong tonal contrasts here add impact. Dark, swirling clouds radiate from the center of the picture in a convincingly dramatic way.*

BELOW: *The seagulls are painted with masking fluid to preserve the white of the paper before applying the sky wash. When the paint has dried, the fluid is rubbed off to reveal the bird's delicate white shapes.*

BELOW: *Cobalt blue, Payne's gray and burnt sienna are used for the dark tones of the grass, textured with scumbled brush strokes.*

KEYING YOUR VALUES

To express it simply, the term "key" refers to the overall lightness or darkness of a particular painting. A painting of a dimly lit interior, for instance, could be termed "low-key" because it would contain mainly dark values. A depiction of a cornfield on a summer day, on the other hand, would be the subject of a "high-key" painting, containing mainly light values.

Where many amateur artists go wrong is in not understanding the importance of using a limited range of values to express a particular mood and to give greater power and directness to their paintings. When a painting contains too many different values, it becomes rather uneven and confused, and furthermore, the emotional message becomes dissipated. It is far better to use a limited range of values – certainly no more than five – and exploit them to the full.

It is possible to draw an analogy between the values in a painting and the notes in a piece of music: they should be used in a controlled range in order to achieve pictorial harmony. To take the analogy a stage further, we can compare the whole range of values of a painting with the key of a piece of music, and the way in that they both create a particular mood.

Music that is composed mainly of high-key notes sound either light and cheerful or poignant and romantic, depending on the rhythm of the piece. Low-key notes, on the other hand, produce a more somber, melancholy sound. These high notes and low notes are the equivalent of light and dark values in a painting: light values will create a cheerful and optimistic mood, or a soft and romantic one, whereas dark values will create a sense of drama or mystery.

Look at any successful painting and you'll see immediately that it has a good key – there is a unity, a feeling of strength and solidity that stems from the perfect harmony of values and colors. You'll notice too how the artist has deliberately orchestrated the values to underline the mood he or she wishes to convey. Think of the Impressionists, for example, whose high-key paintings capture perfectly the brilliance of sunshine and the heady warmth of a summer day. At the other end of the scale there are the low-key paintings of the great Dutch masters of the seventeenth century – people such as Rembrandt (1606–1669), Vermeer (1632–1675) and Pieter de Hooch (b. 1629) – in whose portraits and domestic interiors a tranquil atmosphere is conveyed exquisitely through muted darks offset by a few telling areas of soft light.

So by now you can see that values play a vital role in establishing the overall atmosphere or mood of a picture, no matter what your subject is.

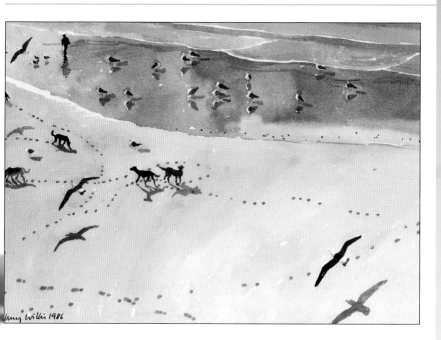

HIGH-KEY PAINTING

In a high-key painting most of the colors are in the light-to-middle value range, and there are no sharp contrasts of value. This creates a slightly hazy, atmospheric effect that is ideal for expressing qualities such as delicacy, tenderness, softness, fragility, or purity.

To create a high-key painting, use pale, gentle colors mixed with a lot of white, and work wet-in-wet so that one color blends softly into another with no abrupt change in value. To keep the colors lively and luminous, don't overmix them on the palette; it's far better to do as the Impressionists did and use small strokes and dabs of broken color (see above) which blend

ABOVE: WATCHING GULLS by Lucy Willis
In contrast to the romantic mood of Jacqueline Rizvi's still life (page 42), the mood of this high-key painting is one of exuberance.

in the viewer's eye while still retaining their vibrancy.

Indeed, it was the Impressionists – notably Claude Monet (1840–1926), Edgar Degas (1834–1917), Alfred Sisley (1839–1899), and Camille Pissarro (1831–1903) – who were perhaps the greatest exponents of high-key painting. They were fascinated by light and the way it affects the appearance of objects, and their canvasses consist almost entirely of high-key colors that capture not only the impression of shimmering light but also the mood of

exuberance that everyone experiences when the sun is shining.

So what kind of subjects are suited to the high-key treatment? Let's take a portrait subject to start off with. Suppose you want to paint a portrait of a small child, or a mother nursing her baby, or a pretty young girl. what makes these subjects so attractive is their qualities of youth, innocence, gentleness and grace – qualities that might be lost if you used too many dark values in the painting. Soft, warm, gentle colors, on the other hand, are more in keeping with the emotional spirit of the subject.

Of course I am not presenting this as a rigid rule that cannot be broken, and I have seen mother-and-child portraits executed in dark values that are full of tenderness and feeling. I am simply trying to suggest one way in which you can deliberately orchestrate your values to better express what you want to say. And in portraiture this is particularly important, since here the emphasis is on the expression of personality. Everything about the painting should be geared to making the viewer aware of the sitter's character.

Landscapes, of course, offer plenty of opportunities for high-key painting. The most obvious examples might be a snow scene on a sunny day; or a river that sparkles with light from the setting sun; or a landscape in autumn, with the sun breaking through a pale mist and clothing everything in a silvery haze. Once again, the trick is to deliberately emphasize the lightness and brightness of the scene – to paint it lighter and brighter than it actually appears if necessary – in order to make a more forceful statement about your emotional response to the fleeting effects of light.

In still life painting, too, you can create a soft, romantic mood with pale values. Choose pretty, delicate objects – a jar of wild flowers perhaps, or pale china teacups – and arrange them on a windowsill with soft, diffused light coming through the window. Remember to keep the shadows soft, in keeping with the high-key effect.

MIDDLE-KEY PAINTINGS

The vast majority of paintings fall into the middle-key range, in which neither extreme lights nor extreme darks predominate. When handled skillfully, a painting consisting mainly of middle values creates a subtle and harmonious image with a quiet., contemplative mood. However, while closely related values may be harmonious, a middle-key painting is in danger of emerging flat, bland, and lifeless unless it contains some positive contrasts, so try to introduce a few telling lights or rich darks into the scheme to give it more "snap."

Give careful thought also to the choice of colors in a middle-key painting. Since you are sacrificing the

dramatic possibilities of chiaroscuro (light/dark contrast) it is vital that the image is exciting in terms of color. By choosing colors that are similar in value but contrasting in temperature or intensity, you will create a picture that is harmonious and vibrant.

BELOW: HAZY SUN AND DAMP MIST, BOULBY DOWN by Trevor Chamberlain
This lovely evocation almost makes us feel the damp but warm atmosphere with the sun about to break through. The artist has worked wet-in-wet, controlling the values and colors with the precision demanded by such a subject.

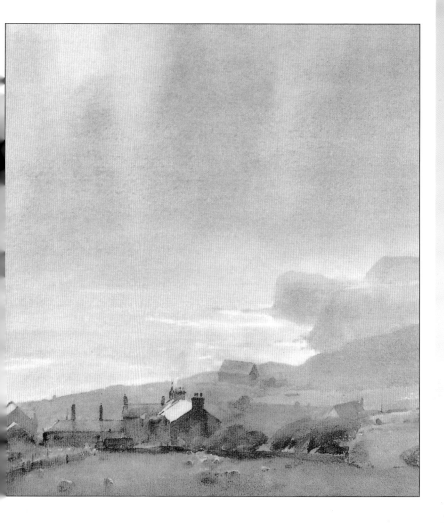

LOW-KEY PAINTINGS

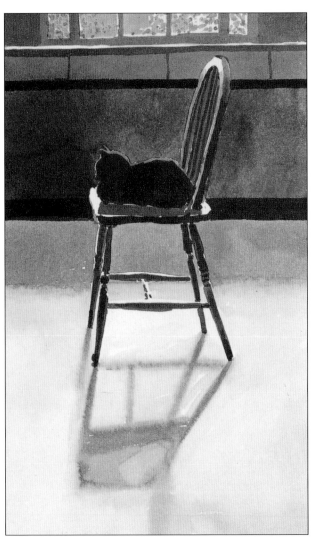

LEFT: CAT ON A CHAIR by Lucy Willis
A low-key painting doesn't have to be somber. In this charming study of a cat on a chair, backlighting throws the subject into near-silhouette and creates interesting positive and negative shapes.

As we have seen, a low-key painting is one that is predominantly dark in value, and such paintings create a very different mood from that of high-key ones. In our subconscious minds, darkness is associated with night, which in turn we associate with mystery, suspense, and emotions such as sadness, fear, and loneliness. Dark values can also create a feeling of strength and calm. By choosing your subject carefully and using colors in the mid to dark value range, you can use the psychological effect of darkness and shadow to create exciting, dramatic images.

The example shown above

demonstrates the powerful impact low-key paintings can have, both visually and emotionally. The appeal of such paintings lies in their air of mystery, and humans have a strong fascination for the mysterious – as all good filmmakers know. After all, doesn't the figure lurking in the shadows strike us with far more terror than seeing the monster face to face?

In the same way, the most memorable paintings are always those that leave just a little to the imagination of the viewer. The portraits that Rembrandt painted are a classic example of this. Rembrandt knew how to use shadow as a veil, softening harsh outlines and creating a subtle atmosphere around the subject. His figures, softly lit, emerge from the shadows and yet seem a part of them. We are mesmerized, and the image continues to haunt us long after we first saw it.

Of course Rembrandt was a great master, and his technical skill with paint was astounding. But don't let that inhibit you: simply study Rembrandt's paintings to absorb the mood they convey, and then see how you can create that mood through your own style of painting.

Never underestimate the value of the power to suggest. When we first start painting, we strive to render everything as clearly as possible in the mistaken belief that clarity equals realism. The result, of course, is that the subject ends up looking flat and two-dimensional, more like a cartoon than a painting. With more experience, we learn how to soften an edge here, darken a value there, and skillfully blend one area into another, in the interests of creating a picture that breathes and has life.

CHOOSING YOUR SUBJECT

As with high-key paintings, it's important that your subject is suited to the low-key approach. A portrait of a child, for example, would not generally be a suitable choice; but portraits of men – particularly older men – benefit from the use of low-key lighting that emphasizes rugged features. Low-key portraits of women work equally well, conveying a sense of mystery and introspection.

A still life of inanimate objects doesn't necessarily suggest a particular mood; it's up to you to create one. Try placing your still life against a dark background, lit by a small light source placed to one side of the group. This will create intriguing highlights and shadows, lending a subtle atmosphere and a mood of intimacy.

Outdoors, the low-key mood is more difficult to achieve because you have no control over the lighting. But landscape artists can take advantage of weather effects that create dramatic pictures; even the most ordinary scene is transformed when a storm threatens, or when dusk approaches. Or you could try painting a woodland scene, with shafts of pale sunlight breaking through the gloom.

MOOD IN LANDSCAPES

In a landscape subject, one of the most important elements to consider is light, because light affects both the values and colors of a picture, and both have a significant effect on mood. Claude Monet put it beautifully when he said: "For me, a landscape does not exist in its own right, since its appearance changes at every moment; but the surrounding atmosphere brings it to life – the air and the light, which vary continually." Monet became so fascinated by the effects of light and color that he would happily return again and again to the same scene, painting it at different times for the day and in all seasons. Making a series of paintings of the same subject over a period of time is certainly an exercise worth trying, because it demonstrates how even quite small changes in the lighting can alter the balance of values in a picture, and therefore alter the mood it conveys.

For example, a seascape viewed at midday might look flat and uninteresting because the light is very even and there is little contrast in values. But a few hours later, as the sun is going down, the luminous

BELOW: THE AUVERGNE by Moira Clinch
Strong contrasts between warm and cool color and light and dark values lend a vibrant mood to this sunny landscape in southern France.

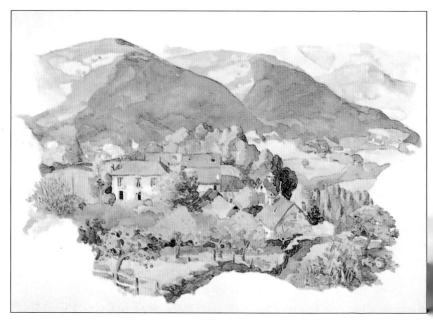

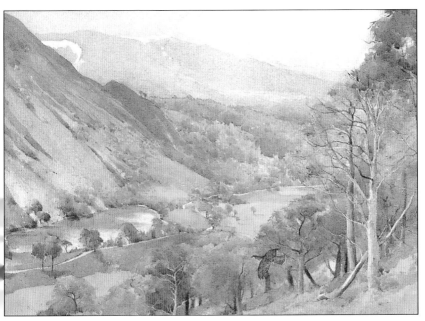

This is an unusually large watercolor painted on location in Scotland. The artist had to cope with squalls of cold rain before completing the the painting in more comfortable conditions.

values of the evening sky contrast with the cool blue values of the sea and the land, creating a subtle and evocative image.

The seasons, too, offer splendid opportunities to explore the magic of light on the landscape. In winter, bleakness, silence, and isolation can provide strong mood themes, as when the branches of bare trees create dramatic patterns of light and dark against the sky. Then again, the same scene is transformed by the sparkling light of a bright frosty morning; this time you might choose a limited range of light values with which to capture the bright, high-key mood. A snow-covered landscape on a dull day creates bold patterns of light and dark and there's also an interesting reversal

of values as the sky, for once, appears darker than the land, creating a bleak, wintry feeling.

Viewpoint and composition are important elements in creating mood. The brooding atmosphere of an approaching storm is made more dramatic by placing the horizon line very low so as to place emphasis on the sky. On a sunny day you could try positioning your easel so that much for the view is in shadow except for one telling, sunlit spot. This will create a more dramatic and unusual picture than if the subject were evenly lit.

MOOD IN INTERIORS

Domestic interiors are often not seen as suitable painting subjects by beginners, perhaps because they are so much a part of everyday life that it's easy to take them for granted. This is a pity, since interior scenes offer marvelous opportunities for creating unusual and exciting tonal compositions. Whether illuminated by natural daylight or artificial light, the closed environment of a room is rich with luminous values and soft, deep shadows that create a calm and tranquil atmosphere.

Interiors offer one distinct advantage over landscapes in that you can control both the compositional arrangement of the subject and, to a great extent, the lighting, so as to express what you want to say in your picture. The following are just some of the ideas worth considering:

� A darkened room with an open door in the background that offers a tantalizing glimpse of a scene beyond. The scene might be part of a sunlit landscape, or another room that is brightly lit; this will give you an opportunity to explore the dramatic contrast of light and dark values and warm and cool colors.

✎ An interior at evening, lit only by a table lamp that sheds a soft pool of light in an otherwise shadowy room. This sets up an intimate, low-key mood.

BELOW: INTERIOR GWYNDY BACH
by Keith Andrew
Subtle colors and soft mid-tones contribute to the quiet mood of this domestic interior.

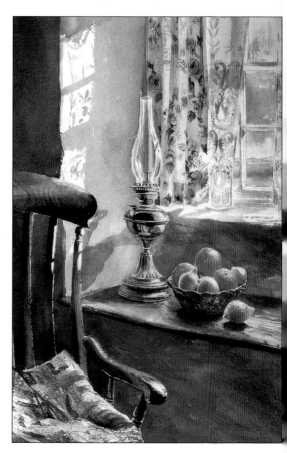

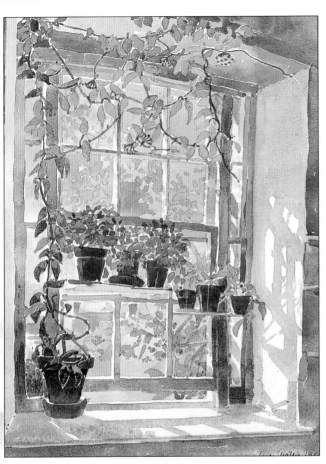

🖋 To create a mysterious and evocative mood, include a shadowy figure, perhaps sitting at the fireside or reading by a lamp.

Before you begin to paint it's a good idea to make value sketches of the room from different viewpoints, until you find the composition that appeals to you. Observe how and where the light falls. Do the shadows and highlights create interesting patterns? Is the main area of light positioned where you want the center of interest to be? Is there a lively interplay of shapes and angles formed by the walls, floors, windows, and furniture? All these things must be carefully considered; if necessary, rearrange, add or subtract objects until you get the effect you want. This is part of the process of learning to select from what you see in order to amplify what you want your painting to say.

ABOVE: HOYA IN THE WINDOW
by Lucy Willis

This scene has a much more high-key mood. It consists of a frame within a frame. The warm greens of the garden, seen through the window, are surrounded and emphasized by the cool blues of the interior wall.

🖋 Sunlight filtering through thin curtains bathes the room in diffused light that lends a still, timeless atmosphere.

MOOD IN PORTRAITS

Painting a portrait involves much more than simply achieving a likeness. Your painting should also say something about the character and personality of the sitter, an emotional quality that the viewer can empathize with. In this respect, the amount, quality, and direction of the light will have an influence on the impression you wish to convey. As in a landscape, lighting affects the values and colors in the subject, which in turn convey a particular atmosphere and sense of place and time. For example, bright sunlight creates strong contrasts that convey energy and light-heartedness, whereas low lighting conveys an air of mystery and introspection. You can also play two sources of light on the subject: the cool, weak daylight coming in from a window and the

stronger, warmer light of a lamp. This creates a range of warm and cool colors that give a special luminosity to the portrait.

So before you start painting a portrait, first decide what kind of mood you wish to convey and arrange the lighting accordingly. Even if you don't have an actual studio, this shouldn't be too difficult; all you need is a couple of lights with adjustable stands.

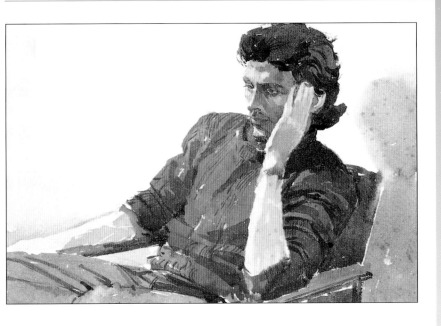

PORTRAIT SKETCHES
by Terry Longhurst

A portrait does not have to be highly finished, but to be successful it must convey a sense of the person portrayed. None of these studies has more than minimum background, and the treatment of the faces and figures is spontaneous. But, each gives a feeling of the sitter's character as well as describing features, hairstyle, and postures.

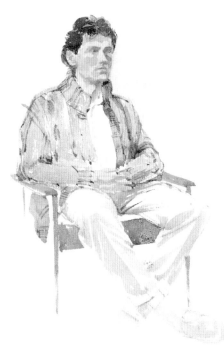

USING SHADOWS CREATIVELY

The power of suggestion can be used to great effect in a painting, turning an ordinary image into one that is arresting, mysterious, and evocative. Shadows are not always dramatic or threatening; they can also introduce beauty and poetry to a painting. Most landscape painters prefer to work in the early morning or late afternoon, when the sun is at a low angle to the earth and trees and buildings cast long, descriptive shadows. My own favorite painting time is later afternoon on a sunny day in autumn.

when everything is bathed in a soft, golden light and the lengthening shadows lend a magical air of calm and stillness to the scene.

When a cast shadow travels across another object that lies in its path, that object becomes much more interesting to look at. In addition to describing three-dimensional form, the graphic lines of the shadows offer an interesting paradox: unconsciously we shift back and forth between seeing the shadows as a descriptive element and as a purely abstract pattern. In this way our imagination is fueled and we play an active part in the work.

Carry a sketchbook with you whenever you can and make visual notes of any interesting shadow patterns you come across, such as those cast by a tree, or a wrought-iron gate, or the dappled shadows of trees and plants on a garden path. Indoors you can experiment by moving a lamp around the room, shining it on objects from different heights and angles to see what kind of shadows it creates (adjustable desk lamps are great for this).

BELOW: A COURTYARD IN SPAIN
by Hazel Soan

In the final stages of the painting, the artist decided that the foreground shadow was too heavy and too regular a shape. She decided to wash down the area and change it to a dappled tree shadow, softer and more in keeping with the rest of the picture.

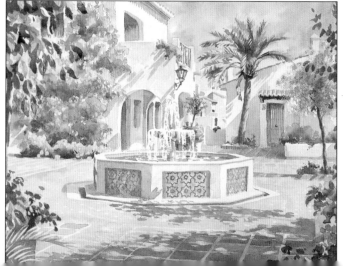

Choosing Colors

The three primary colors – red, yellow, and blue – can be mixed to produce all the other colors, so obviously these must be included in our basic palette. But if we ask in our local art supply store for red, yellow, and blue paint, we will be asked "Which one?" because there are so many different reds, yellows, and blues to choose from. The first ones to buy must be of the brightest, most intense hues because mixing always results in loss of color intensity.

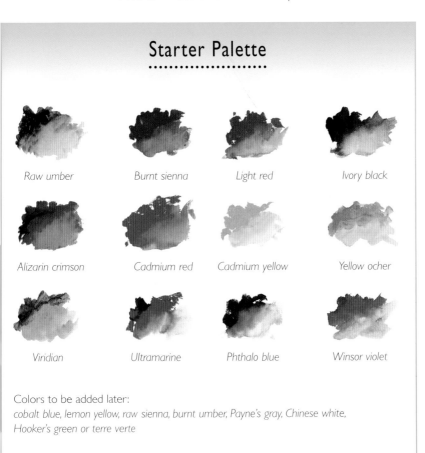

Starter Palette

Raw umber	*Burnt sienna*	*Light red*	*Ivory black*
Alizarin crimson	*Cadmium red*	*Cadmium yellow*	*Yellow ocher*
Viridian	*Ultramarine*	*Phthalo blue*	*Winsor violet*

Colors to be added later:
cobalt blue, lemon yellow, raw sienna, burnt umber, Payne's gray, Chinese white, Hooker's green or terre verte

Tinting Chart

Watercolors have different tinting strengths, and it is impossible to tell how dark or light a color you've mixed up in your palette will be when applied to the paper. With practice, you will learn to estimate roughly the amount of water to add for each color, but to start with it is a wise course to try out a mixture on a spare piece of paper before committing yourself. Let it dry first, as watercolor is considerably lighter when dry. Beginners usually add too much water because they are alarmed at how dark the color looks when wet.

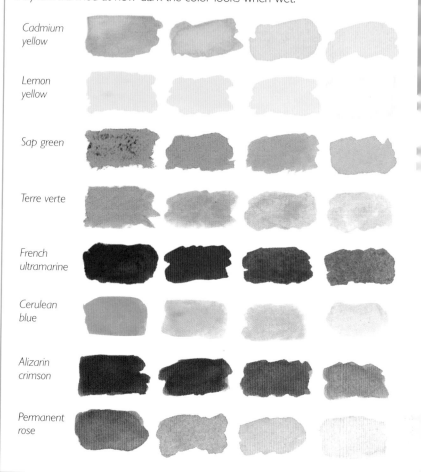

Cadmium yellow

Lemon yellow

Sap green

Terre verte

French ultramarine

Cerulean blue

Alizarin crimson

Permanent rose

TRANSPARENCY OF PAINT

One of the most exciting, if unpredictable, qualities of watercolor is its ability to impart color while allowing underlying layers to remain visible to a greater or lesser degree. Linked to this is the way in which pigments can be diluted with water so that the white of the paper itself dilutes the color, rather than "polluting" the color with white, as is the case with opaque paints. Because of the transparency of watercolor, the usual way of working is from light to dark, gradually building up layers. Transparency, however, is relative, and because some pigments are considerably more opaque than others they are categorized as transparent or semi-transparent and semi-opaque.

The amount of water used is a matter of personal preference, but generally a tighter more detailed style uses a higher mix of pigment to water than a looser one. As a rule the more water used the more unpredictable the result. No two mixes will ever contain the same amount of water, and the solution with the higher percentage of water will "run" into the less diluted mix. This "pushes" the pigment creating intriguing, if unpredictable, effects. It is seldom possible to recreate them, as they are never exactly the same.

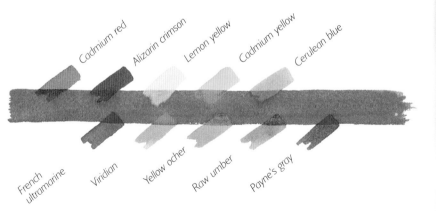

ABOVE: **RELATIVE TRANSPARENCY**
Some colors are less transparent than others. The more opaque colors in the starter palette are cerulean, lemon yellow, and yellow ocher. Any of these used in a fairly strong solution, will lighten the value of a darker color beneath.

JUDGING COLOR RELATIONSHIPS

Color relationships can be established by continually comparing your picture to your subject and marking alterations and modifications until you judge the relationships to be satisfactory. This does require very careful observation which develops with experience. Try to look at the world around you with a painter's eye while thinking which colors you could mix for that yellow-edged cloud or those interesting greenish shadows on the unlit side of someone's face. You'll learn a lot, and you may find being stuck in a traffic jam less frustrating.

A good way of analyzing color changes is to use a piece of cardboard with a ¼ in. (0.6 cm) hole cut in it. Hold this up about a foot from you and look at an area of color which appears at first sight to be the same all over – an orange, for example, or the cover of a sketchbook. The little square of color you see, isolated from its neighbors, will look pretty meaningless, but now try moving the card slightly and you will begin to see variations in the color. You will notice darker shadow areas and slight changes in color intensity caused by reflected light or the proximity of a different-colored object. By taking one area of color out of context you are able to see what is really happening in terms of color instead of simply what you expect. You don't have to use a piece of cardboard – your fist with a little hole between the fingers will do.

MAKING COLOR NOTES

You may also find it useful to make some color notes so that you can recreate a scene in the studio. You may remember the general impression of a color, but no one can recall the subtle variations, so if you're out looking for a likely landscape subject try to jot down some impressions on a rough pencil sketch. This can be done in words, for instance "sky very dark blue-gray, mixture of Payne's gray and ultramarine." If you have paints, pastels, or even crayons with you, make some quick visual notes there and then, trying out various combinations until you are satisfied.

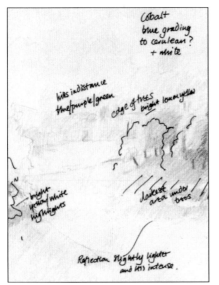

The Artist's Palette

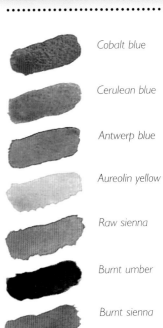

Cobalt blue

Cerulean blue

Antwerp blue

Aureolin yellow

Raw sienna

Burnt umber

Burnt sienna

These three blues, combined with aureolin, a slightly stronger color than lemon yellow, enable the artist to mix a wide range of delicate greens. No tube greens at all have been used here, and no black or Payne's gray. A tiny amount of Chinese white was mixed with the blue of the sky.

Color Combinations

Cerulean blue + Aureolin yellow

Cobalt blue + Aureolin yellow

Antwerp blue + Aureolin yellow

Burnt sienna + Cerulean blue

Burnt umber + Cerulean blue

Burnt umber + Cobalt blue

COLOR TEMPERATURE

Warm colors are those closer to the red end of the spectrum.

Cold colors are those closer to the blue end of the spectrum.

Mixing Colors

Having chosen your colors, the next stage is to practice making new colors from mixtures of the "basic palette" shown on page 16. There are only 10, which may seem a small number, but the charts show how many more colors those 10 can produce. The chart colors are all two-color mixes: you can make an even wider range by using three. It is not advisable to mix more than three.

Charts like these are useful for reference, but you'll learn more if you do your own experiments on the same lines. First, though, here's a brief look at some of the properties of colors and the terms used to describe them.

Primary colors are the ones you can't produce by mixing other colors. They are blue, yellow, and red. Secondary colors are made by mixing two primaries, such as blue and yellow, which make green. Tertiary colors are mixtures of one primary color and one secondary, or three primaries.

You can buy both secondary and tertiary colors ready-made. (You already have three of them in your palette: viridian, raw umber and Payne's gray.) However, you can achieve more variety of color through mixing – and it is much more fun.

The quantity of paint to mix should always be more than you think you'll need. This applies particularly to watercolor washes, which really need a lot of paint. It is infuriating to run out of a mixture which has taken a long time to make. Try to keep your mixture clean. Each color should be thoroughly mixed – unless you want it

otherwise – and not allowed to run into its neighbors. In general, you should avoid mixing colors on the painting itself; although this can be done successfully, it often leads to muddying or an uncontrollable mess.

The tubes or jars of paint themselves must be looked after carefully. It is most important that their caps are screwed on immediately after use. If not, oil paints leak everywhere; acrylics, gouaches, and watercolors harden in their tubes. Pastels should be replaced in their correct position in their box, otherwise you'll never find the one you want, especially if you are using a large number.

TWO-COLOR MIXES

This chart shows all the colors in the starter palette (top and left hand side) mixed with one another in a half-and-half proportion. When you experiment with color mixing you will discover how dramatically the proportions affect the mixture and how much stronger some colors are than others. Compare the cerulean and Payne's gray mixture on the far right of the chart with Payne's gray itself and you will detect little difference. This is because cerulean is a relatively weak color, and Payne's gray is strong.

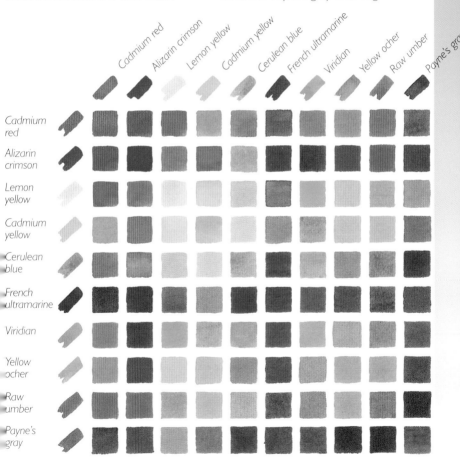

MIXING SECONDARY COLORS

The secondary colors, green, orange, and purple, can be bought as various hues in tube or pan form, but generally more colors can be achieved – and it is more fun – if you mix your own.

These next pages show how by mixing two primaries together, or by mixing a primary with one of the proprietary secondaries, such as sap green or one of the purples, you can create both intense and muted secondaries.

There are some secondary hues, however, such as viridian and cadmium orange, which cannot be mixed from two primaries as they have an intensity which it is impossible to reproduce.

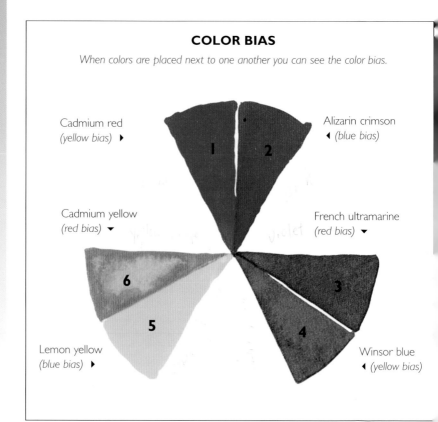

COLOR BIAS

When colors are placed next to one another you can see the color bias.

Cadmium red
(yellow bias) ▶

Alizarin crimson
◀ (blue bias)

Cadmium yellow
(red bias) ▼

French ultramarine
(red bias) ▼

Lemon yellow
(blue bias) ▶

Winsor blue
◀ (yellow bias)

UNDERSTANDING THE MIXTURES

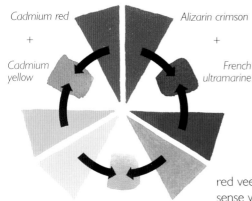

Cadmium red

+

Cadmium yellow

Alizarin crimson

+

French ultramarine

Lemon yellow + Cerulean blue

◀ MIXING INTENSE SECONDARIES

red veers toward yellow, so it makes sense when trying to achieve an intense secondary to exploit the bias.

Conversely, if you want to mix a neutral secondary or neutral colors, mixing colors that contain the opposite or complementary color on the color wheel will give a muted or even muddy result.

When mixing secondaries, you will need to know which of the primaries to use, as there are many versions of each one. As you can see from the color wheel, each one has a bias toward another; for instance, cadmium

MIXING MUTED SECONDARIES ▶

These charts show how the choice of the primary color affects the mixture. Those closest together on the wheel create intense secondaries, while those furthest apart create neutrals.

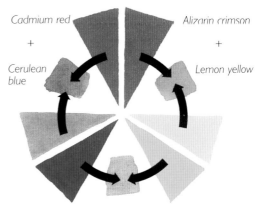

Cadmium red

+

Cerulean blue

Alizarin crimson

+

Lemon yellow

French ultramarine + Cadmium yellow

MIXING WARM PIGMENTS

The warm colors of burnt sienna, yellow ocher, and burnt umber form the basis of Moira Clinch's *La Bougainvillea*. The versatility of a single watercolor pigment is demonstrated by the fact that burnt umber was used to depict both the somber nature of the gate and the delicate plasterwork of the wall. The only difference between the two is the amount of water used to apply the paint.

ABOVE: *A strong diluted flat underwash of burnt sienna was used as the basis for the brickwork. Individual bricks were then over-painted in diluted mixtures of cadmium deep red, raw sienna, and yellow ocher.*

LEFT: *The highlights of the bougainvillea flowers were painted in concentrated rose madder carmine, while shadows were formed by subduing the color with indigo.*

BELOW: *The iron gate was painted in a mixture of burnt umber and lamp black, with extra black and indigo for the shadow area.*

RIGHT: LE BOUGAINVILLEA by Moira Clinch

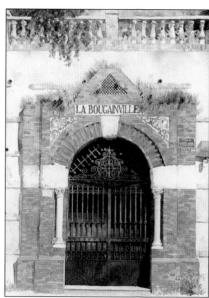

MUTED COLORS

This painting by John Lidzey is taken from a sketchbook, and shows the art of mixing colors very clearly. The artist has used the actual page as a palette on which to mix and drop in the fluid colors. A very limited selection of colors was used to convey a dull winter's day. The cool colors — ultramarine, indigo, and Payne's gray — and the spiky, linear pencil drawing emphasizes the bleak atmosphere, but this is cleverly counterbalanced by thin washes and mixes of alizarin crimson and yellow ocher, giving the painting slight touches of warmth.

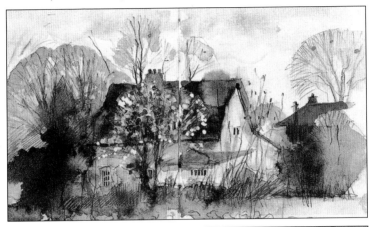

RIGHT: FEN COTTAGE by John Lidzey

ABOVE: *The basis of the whole painting can be seen in this detail: the artist has used various mixes of ultramarine, indigo, alizarin crimson, and yellow ocher to create the desired cool and warm tones.*

ABOVE: *The skeleton drawing of the tree is given substance by washes of yellow ocher and ultramarine, with a little alizarin crimson for warmth.*

LEFT: *Dots and blobs of white gouache were used to depict the blossom on the leafless tree.*

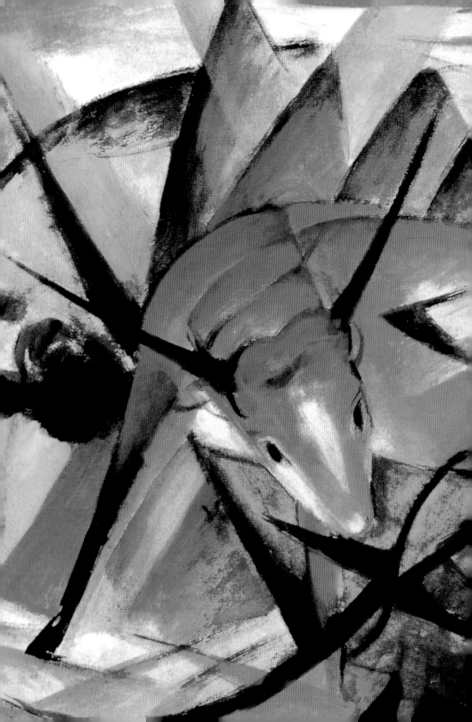

Style

Before art schools were established, most artists learned to paint in the studios of successful painters. As apprentices they copied their master's work, and once they were sufficiently competent they sometimes even blocked in the master's paintings, leaving perhaps only the finishing touches to the master himself.

The tradition of copying persisted even into the Impressionist era. Pierre-Auguste Renoir (1841–1919), for example, copied the work of the great eighteenth-century masters such as Antoine Watteau (1684–1761) in the Louvre, a task that helped formulate his love of light, luminous colors. In his figure paintings, Cézanne returned constantly to arrangements based on the work of Michelangelo, Rubens, and Poussin. Actual copying continues to be practiced by some artists and students today, but it is no longer obligatory. Many modern artists, however, make visual references in their work to paintings they admire, sometimes using the same compositional elements or re-interpreting a particular theme. As you develop your skills as a watercolorist, you will find it useful to study the work of past masters in order to understand and establish your own stylistic preferences.

Painting an Impression

Impressionism set the standards of a new realism that we now take for granted. Despite all the innovation of twentieth-century art, Impressionist paintings still seem fresh and inspirational, and the approaches remain valid for application to contemporary themes. The term "Impressionist" was originally coined as a critical insult, implying that the paintings appeared hasty and unfinished, and that the artists were careless in their perceptions. Yet what we see in the work of Claude Monet, the figurehead of this movement, is a detailed, analytical process of observation and record, which nonetheless results in images that are vital, colorful, and celebratory.

THE DIRECT APPROACH

Of the new concepts developed by Monet and his colleges, two principles featured importantly. One was the requirement to complete a painting by direct reference to the subject – for example, working outdoors in the landscape, building up an image of the immediate view. Previously on-the-spot sketches were made which would then be used as reference for a formally constructed studio composition. The other principle was the technique of working directly onto white canvas, often allowing new colors to blend with undried layers below, a method known as working wet-in-wet. This contradicted the traditional method of developing a painting slowly layer by layer, beginning with a dark or mid-toned ground and proceeding to a monochrome underpainting in which the main forms were modeled in value alone. When this had dried, colors were introduced, usually in the form of glazes (successive layers of thin paint) and more detailed brushwork.

These concepts were not previously unknown but the Impressionists were the first to adopt them as standard procedures for painting finished works. The immediate impression of the subject became the final image without the imposition of artistic theories and conventions. Essentially, they understood that a painting should reflect the transience of observed realities. Their paintings reflected the ways in which solid form and surface detail can appear to change with changing circumstances – above all, the variable effects of natural light. Another significant feature of Impressionism was that it challenged traditional concepts of comparison and drawing. It was no longer considered necessary to have objects precisely defined and clearly distinguished from one another. Paintings did not have to be neat and distinct close-up as long as they could be read at a distance.

RESPONDING TO THE MOMENT

The practical guideline for an Impressionist approach is to free your mind from what you know, or think you know, about your subject and respond directly to the purely visual sensations of color and light. Monet described it thus: "When you go out to paint, try to forget what objects you have in front of you, a tree, a field. Merely think, here is a little square of blue, here an oblong of pink, here a streak of yellow, and paint it exactly as it looks to you, the exact color and shape, until it gives you your own naive impression of the scene." This "naive impression" is not simplistic, as the word naive sometimes implies, but it is unique – consisting only of what you saw in that place at that moment. As Monet stressed, your painting records this impression "exactly as it looks to you."

The Impressionists, who drew inspiration from the English landscape painter John Constable (1776–1837), applied their paint in thick dabs and strokes of broken color to depict what was their main preoccupation – the ever-changing effects of light on the landscape.

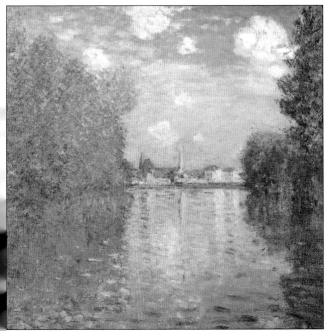

AUTUMN AT ARGENTEUIL by Claude Monet (1840–1926).
The French Impressionists were very much influenced by Constable's landscape paintings, and Monet in particular took the preoccupation with the effects of light almost to the point of an obsession. He frequently worked out of doors, and would paint several versions of the same scene in different lights, building up the paint in thick impastos to achieve the ever-changing effects suggestive of motion which he sought.

Expressionist Approaches

Expressionist painting goes beyond appearances, using devices of technique and composition to develop mood and atmosphere. By distorting or exaggerating particular aspects of the subject, the artist directs the viewer's response towards the emotive qualities of the picture. The picture is drawn subjectively rather than objectively. An Expressionist painting is not necessarily "unreal," and it need not be threatening, but it has to challenge our normal perceptions of reality.

COMPOSITION AND STYLIZATION

Distortion and stylization are characteristic features of the Expressionist approach. As in the Schiele painting, the impression of space and distance can be heightened through exaggerated perspective. In landscape, architectural and interior subjects, selective composition, and distortion of the subject can create a particular mood. Paintings from the figure commonly use a method similar to caricature. The characteristic features of faces and bodies are exaggerated, even to the point of deformity, as a means of emphasizing the narrative point of the image or its associations. It can also be helpful to simplify detail, so that a person or object is reduced to those essential ingredients that still make it recognizable. But Expressionism does not always aim to provoke or disturb. Sometimes Expressionist devices are used to create lyrical, appealing visions of alternative realities.

LEFT: TAUREAU ROUGE by Franz Marc.

A founder member of the Blue Rider group, Franz Marc experimented with the expressiveness of color and Cubist-inspired rhythmic harmonies in watercolors of his favorite animal subjects.

COLORS AS EXPRESSION

The colors of *Women Upside Down* (page 142) are intense and hectic , with dominant high-key tones that create an unnatural brightness.

A startling feature of the painting is the dominant yellow, used as the theme color in several Expressionist works. Although yellow has some pleasant associations, particularly with sunlight, it is not always easy on the

LEFT: WOMEN UPSIDE DOWN by Egon Schiele (1915).

Heightened color and expressionistic distortion of form are characteristic features of Egon Schiele's anguished portraits of Viennese society.

eye and a large expanse of brilliant yellow can have a disturbing effect. The particular hue and tone of the main color in this painting make it solid and suffocating.

Expressive use of color always involves a subjective element, but there are also predictable interactions between colors that can be exploited to create a particular mood. Deliberate contrasts of hue or tone can introduce discordant notes to a composition, underpinning the portrayal of a violent event or uneasy atmosphere. Conversely, color harmonies and carefully related tones can help to evoke calm and pleasant emotions.

Abstracting from Nature

For some people, the word "abstract" automatically signals that a painting will be difficult to understand and possibly uninteresting to look at. Abstraction frequently evokes an unsympathetic, even hostile reaction, because it seems to reject our common experiences of seeing the world around us.

It is true that an abstract work is one artist's unique response to particular themes and methods, and in that respect it is not as readily accessible to the casual viewer as, say, a recognizable still life or figure painting. But it is also true that such a work contains the kind of perceptions that are common to us all. For example, an abstract painting can be a two-dimensional rendering of three-dimensional space and form; or it may obey particular conventions of composition and division of the picture plane. It is also composed of the same materials as other paintings, and therefore represents similar preoccupations with technique and surface values.

The idea that figurative and abstract approaches are worlds apart is absolutely false. But this is not helped by some artists and critics who have felt it necessary to create a kind of competition between them, and to claim one approach as being more universally valid than another. In fact, since abstraction became a common, even for a while dominant, form of painting in the middle of the twentieth century. The two apparently different disciplines have usefully exchanged developments of style,

concept and technique, so stimulating both areas of image-making.

If you are one of the people who has felt excluded from abstract art, this is most likely because you have not been given the means to relate it to things you do know and understand about painting. This section on abstraction may leave you knowing a bit more.

SOURCES OF ABSTRACT IMAGERY

There are two basic methods of developing an abstract style. One is to use objects and images from the real world as reference points from which you evolve a personalized, "abstracted" interpretation. The other is to employ purely formal pictorial elements and material qualities such as nonreferential shapes and color relationships and surface effects directly relating to the material properties of the chosen medium. The second approach is investigated on pages 148–151.

Abstracting from nature we can take to mean deriving abstract imagery from things actually seen. Landscape is a frequently used

resource for this kind of approach, perhaps because its enormous scale enables us to look at it in broad terms and disregard incidental detail that cannot be clearly identified at a distance. But this basic method can equally well be applied to other themes like figures, natural and man-made objects, indoor and outdoor environments, and actual events.

blocking in the landscape in the early stages of the painting – broad contours and color areas not yet broken up by the particular detail of individual features. In the same way, a face can be seen as an elliptical shape colored an overall uniform pink. Arms and legs can be interpreted as basically cylindrical forms and clothing as separate areas of bold color and pattern.

ROAD TO THE SEA by Milton Avery, c.1938.

To describe this process of abstract analysis in the most simple terms, we can take possible examples and relate them to figurative interpretations. For instance, a landscape of fields, hedgerows, and distant hills can be seen as a series of rhythmic shapes, each of which has a dominant color; an abstract painting of such a view might look something like the image that a figurative painter would achieve while

Often, in any subject, you can identify linked and repeated shapes and forms that give a sense of unity to your interpretation. The same type of linkage can be made within the range of hues and tones that you see, so that you can discover a pattern of similarity and contrast. Abstraction means initially breaking down what you see before you into simple, sometimes very obvious visual elements.

How Far Does it Go?

So far, we have examined a fairly simplistic approach that opens the door to abstraction but does not wholly bridge the gap between what an artist sees and what goes on the canvas or paper. This is because at some point a new conceptual leap may occur that eliminates some of the links between observed and interpreted realities.

For instance, if you were working on an abstracted landscape, you might see a sudden shaft of sunlight falling on a grassy field, which might then become a slash of bright yellow on your painting. As you step back and see the effect on your image, it may occur to you to give the yellow a different hue or tone, or to turn the slashed brush mark into a distinct, hard-edged shape. Alternatively, you might suddenly decide that every area that had previously represented green grass should be painted bright red, to completely change the character of the painting. Or you might create a broad pattern corresponding to the linear texture of the blades of grass, not necessarily in naturalistic colors. As such ideas develop, you gradually remove the particular associations that would enable an uninvolved viewer to relate elements of your painting directly to those of the original subject.

If you are interested in abstraction and have not previously understood it very well, try looking at abstract paintings in these terms and imagining what might have been the inspiration for specific shapes and colors. But keep in mind that in abstract art there is also an emphasis on the material, surface qualities of the painting, and it is often more directly influential than in figurative works.

ABOVE: DORIS TYSTERMAN by Roy Sparkes
A natural subject such as flowers can suggest ways of unleashing abstract properties freely, but from a basis of observed reality.

Abstract Starting Points

Collage from a Landscape or Still Life

Choose a landscape theme – a view that is familiar to you – or set up a simple still life, and create an abstracted color study using cut and torn pieces of colored paper collaged to your base paper. Try to deal with distinctive, strong shapes, eliminating small-scale detail. Don't worry about making the shapes too precise, and you can allow the paper pieces to overlap and modify each other. You can make changes simply by gluing pieces over each other.

A Painted Abstraction

Repeat the project, but using paint to create the color areas. Apply the paint in different ways to vary the surface qualities within the different shapes. For instance, use heavy impasto contrasted with patches of transparent color glazing; or opaque, flat color next to active, broken brushwork.

Drawing with Color

Using a similar subject, make a color drawing with brush and paint, following the contours of shapes and including some detail elements, such as interesting textures on the surface of the objects you are looking at. Try using a bright-colored piece of paper for your painting in this project, so that you have to select your paint colors boldly to make sure they have an impact.

ABSTRACTION by Stuart Davis, 1937.

Pure Abstraction

In abstract painting, which makes no reference to the real world, it is the basic ingredients of color, composition, and execution that, in effect, become the subject of the work. Some artists, like Piet Mondrian (1872–1944), arrived at a form of pure abstraction by working their way through figurative styles and processes of abstracting from nature. Others, particularly in the late twentieth century when so many more examples of abstract work have been produced, seen, and commented upon, have moved very quickly into this way of thinking and working early in their careers.

It may be impossible to eliminate completely all references to the normal range of human visual experiences, and sometimes a viewer may feel that, for example, a landscape reference can be seen in a particular painting that purports to be wholly abstract. This is because we tend to see marks on canvas or paper as suggesting space and form, and when we are looking for references to real situations or objects, we may claim to identify what seem to us reasonable associations. However, this is unconnected with the artist's intentions; when working in a purely abstract mode, the artist is dealing with shapes and forms, colors, and textures in terms of what they actually are, not what they represent.

COMPOSITION ELEMENTS

As in any form of image-making, the abstract artist deals with basic elements of pictorial construction – line, mass, color, tonality, surface texture, and pattern, shape, contour,

spatial depth, and apparent volume. If the painted image is not to refer to anything known, the important question seems to be, where do you start? What prompts the artist first to put down a line rather than a block of color? Why position the line in one place rather than another? What should be the next mark, and why? It is because such questions cannot usually be answered precisely, or by reference to something else, that many people find it difficult to become interested in abstract art. The logic of an abstract painting seems too personal and inaccessible.

The artist makes positive and negative responses in producing an abstract work. Its logic can lie in what the painting is supposed to do, and in what it should not do. Mondrian is a good example to study because his geometric grids and limited color range are so apparently restrictive and severe. His intention was to create "dynamic equilibrium," a sense of movement and tension in an image that also had absolute balance.

Mondrian chose the right-angle as a pure and constant factor – it is a fixed and balanced relationship between two lines. When using this to construct squares and rectangles, however, he still had a great deal of scope to vary the proportions and interactions of these simple geometric shapes. In limiting his color range to the three primaries and the neutral colors of red, yellow, blue, black, white, and gray he had a palette that incorporated absolute qualities of hue and tone. As these were applied to the geometric grid, they further influenced the tensions and balances in the painting.

What these paintings are not supposed to do is to create an impression of three-dimensional space, or refer to external dimensional space, or refer to external reality. In this sense, Mondrian challenges both himself and the viewer to discard received notions of pictorial space. We might tend to relate a grid structure to architectural frameworks. The use of black and white usually implies light and shadow, a means of modeling three-dimensional form. But Mondrian's paintings lie flat on the picture plane, and neither the color nor the construction suggest any element of real space and form. This requires careful judgment of the proportions of the shapes and the extent of the color areas, and their interactions. Painterly features are also eliminated – the color is flat and opaque, the marks made by the brush are virtually invisible.

SELF PORTRAIT by Piet Mondrian (1872–1944).

THE RANGE OF ABSTRACTION

Mondrian aimed at, and achieved, what he described as "an expression of pure reality," but as you can see from looking through any book on modern art, straight lines and limited color are by no means the only ingredients of abstract art. It is interesting to compare Mondrian's work with that of the German-born American painter Hans Hoffman (1880–1966), some of whose paintings also conform to a grid-like structure and contain very strong colors and tones. Yet Hoffman's work is vigorous, free and gestural, the colors and textures of the paint are rich and varied. A suggestion of three-dimensionality sometimes occurs when shapes overlap and colors seem to advance or recede but, as with Mondrian, the image exists on the surface of the canvas and is self-referential – the viewer is not led into an illusory pictorial space.

Looking at abstract painting in terms of simple definitions, there are distinctly different styles. In hard-edged abstraction, shapes are sharply defined although not necessarily geometric, and color interactions are usually strictly controlled. Another style is gestural painting, which is visually busier and more complex, with vigorous brush marks, splashes, spots, and dribbles. There are also more decorative forms of abstraction, in which the

LEFT: COMPOSITION
by Wols, c.1950.
In Europe, watercolor was used by abstract artists working in a style called Tachisme.

picture surface appears heavily patterned. There are other categories, and works by individual artists who draw on all of these conventions.

You may find that it is easiest to develop an approach to pure abstraction by beginning with abstracting from nature. As you work through particular images, you will become gradually more interested in what is happening on your canvas or paper, and you may forget about the actual source. You can start to deal directly with color interactions; relationships of line and mass, textural contrasts, or developing a composition that suggests space while also emphasizing the flatness of the picture surface. Try to pin down your intentions and ask yourself if the painting is really working in terms of what you tried to do. But beware – it is more tempting to let yourself get away with unsatisfactory solutions in abstract than in representational work, as you have no external points of reference by which to judge what the picture should look like.

ABOVE: LIGHT COMING ON THE PLAINS I
by Georgia O'Keefe, 1917.
With an almost oriental economy, Georgia O'Keefe used watercolor to evoke the American landscape.

You will realize that many of the preoccupations involved are the same as those you had to apply to figurative work, but at some point your subject becomes the painting itself and your own instinct, technical skills, and experience will enable you to carry it through.

15

Subject

As the previous section demonstrated so clearly, painting techniques are no more than vehicles for the expression of ideas. In this section, we will look specifically at how watercolor can be harnessed to depict a personal vision. The explanations and step-by-step demonstrations are grouped according to theme, ranging from still life and plants and flowers through to animals and portrait and figure work.

For the newcomer to painting, it is worthwhile to work through these themes in order. Still life offers the luxury of a subject that doesn't move and which can be easily arranged into a pleasing composition, then rearranged and relit to suit the artist. People and animals present particular challenges as living subjects; although they can be especially satisfying to paint, they are at the same time more demanding. A wide variety of different techniques and approaches is shown in each of the subject areas, together with some explanations of the particular difficulties associated with certain themes. Someone who has never dared to attempt to portray the effects of changing light may see the perfect method for the first time here and say, "so that's how it's done. I could do that too." You probably can.

Still life

Still life, as its name implies, simply means a composition of objects which are not moving and which are incapable of doing so, usually arranged on a table; the French rather depressingly called it "dead life" (nature morte).

The subjects can be whatever you like, but traditionally the objects in a still life group are in some way associated with each other – a vase of flowers with fruit, a selection of vegetables with cooking vessels or implements, and sometimes dead fish, game, or fowl with a goblet of water, perhaps, or a bunch of parsley. (Culinary still lifes are less popular nowadays, possibly because they run the risk of looking like the cover of a cook book.) Good paintings can be made from quite homely subjects. Vincent van Gogh (1853–1890) made a wonderful and moving still life from nothing but a pile of books on a table.

Most artists have painted still lifes at one time or another, and several, notably Jan Vermeer (1632–1675), included them in their figure paintings. In the seventeenth century a group of Dutch artists became obsessed with still life to the exclusion of all other subjects, and vied with one another to produce every more lavish portrayals of tabletops gleaming with edible produce, rare porcelain, and golden goblets. In many of these, tiny insects are visible among the foliage, blood drips from the mouths of freshly killed hares or rabbits, and bunches of grapes shine with tiny droplets of moisture, every object

painted with breathtaking skill.

Because the subject of a still life painting can be entirely controlled by the artist, as can its arrangement and lighting, still lifes present an unusual opportunity for exploring ideas and experimenting with color and composition. The greatest master of the still life, Paul Cézanne (1839–1906), found that the form allowed him to concentrate on such fundamental problems as form and space and the paradox of transferring the three-dimensional world to a two-dimensional surface.

The ability to control the subject of a still life means that you can take as much time as you like to work out the composition, and you can practice painting techniques at leisure, trying out new ones as you feel inspired. Oddly, watercolor was seldom used in the past for still lifes other than flower paintings, but it is now becoming extremely popular.

RIGHT: STILL LIFE WITH GRAPES
by Shirley Felts
For reasons not entirely understood, shapes have particular properties, and circles are natural eye-catchers. Many still lifes incorporate circles in some form: plates, fruit, the tops of bottles, or a circular table, as in this painting.

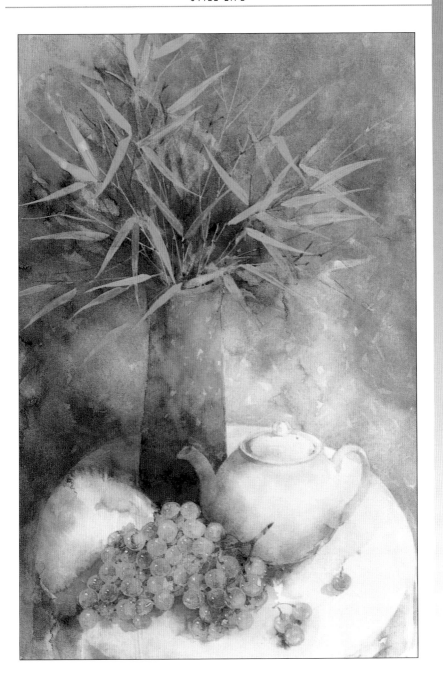

SETTING UP A STILL LIFE

There are no specific problems in painting a still life or flower piece once it has been set up. The real challenge is arranging it, and this may take some time – plunking an assortment of objects down on a table will not give you a good painting. The wisest rule to follow at first is to keep the composition simple. The more objects you have the more difficult it is to arrange them in a harmonious way. It is also best to have a theme of some kind: if the various objects are too different in kind they will look uneasy together.

Start with something you like, a bowl of fruit on a patterned table-cloth, perhaps, or a potted plant, and keep arranging and rearranging until you are satisfied that you have achieved a good balance of shapes and colors. Drapery is often used to balance and complement the main subject, and it is useful to have a selection of fabrics or tablecloths on hand for this purpose. Many artists make small sketches or diagrams to work out whether a vertical line is needed in the background, or a tabletop shown as a diagonal in the foreground. Finally, when you are fairly sure that the arrangement will do, look at it through a viewing frame to assess how well it will fill the space allotted to it. Move the frame around so that you can assess several possibilities. Often you may find that allowing one of the objects to run out of the picture actually helps the composition.

Lighting is also very important. It defines the forms, heightens the colors, and casts shadows which can become a vital component in the composition. If you are working by natural light other than a north (in the northern hemisphere) light, it will, of course, change as the day wears on. This may not matter very much so long as you decide where the shadows are to be at the outset and do not keep trying to change them; but often it is more satisfactory to use artificial light. This solution sometimes brings its own problem, however, since if you are painting flowers or fruit they will wilt more quickly.

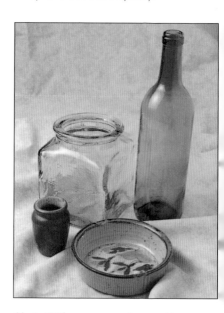

Most still lifes are arranged on a tabletop or similar flat surface, so you'll need to get the right perspective for the front, back, and side edges, or the entire painting will look tilted.

THEMES

A successful still life is seldom, if ever, a random collection of objects – there should always be some kind of theme. One of the most popular types of still life is the culinary one, where fruit, vegetables, and kitchen equipment are grouped together. Attractive in themselves, they also are related in subject, so that the viewer is not worried by the discordant notes of objects that seem not to belong. Another kind of theme is the "literary" one. Some still lifes tell a story about the personal interests of the artist. The best-known examples of such still lifes are those of Vincent van Gogh (1853–1890), whose paintings of his room at Arles and his moving portrayals of his own work-soiled boots are almost a form of pictorial biography, telling us as much about the artist as about the objects themselves.

You can also take colors and shapes as the theme, choosing objects that seem to be linked visually or set up exciting contrasts. Visual themes need very careful handling at the painting stage – if the objects are widely dissimilar in kind you may have to treat them in a semi-abstract way, allowing them to hide their identity behind their general forms or outlines.

BELOW: BY THE COTTAGE DOOR
by Michael Emmett
This delightful outdoor group is an example of a still life with a narrative content: we can see that someone, perhaps the painter's wife, has been sitting in the sun preparing fruit and vegetables.

BACKGROUNDS

One of the commonest mistakes in still life painting is to treat the background as unimportant. It is easy to feel that only the objects really matter and that the spaces behind and between them are areas that just need to be filled in somehow. All the elements in a painting should work together, however, and backgrounds, although they may play a secondary role, require as much consideration as the placing of the objects.

The kind of background you choose for an arranged group will depend entirely on the kind of picture you plan. A plain white or off-white wall could provide a good foil for a group of elegantly shaped objects, such as glass bottles or tall vases, because the dominant theme in this case would be shape rather than color, but a group you have chosen because it allows you to exploit color and pattern would be better served by a bright background, perhaps with some pattern itself.

The most important thing to remember is that the background color or colors must be in tune with the overall color key of the painting. You can stress the relationship of foreground to background when you begin to paint, tying the two areas of the picture together by repeating colors from one to another. For example, if your group has a predominance of browns and blues, try to introduce one of these colors into the background also.

ABOVE: PLUMS IN A DISH by Ronald Jesty
This artist likes to exploit unusual viewpoints in his still life paintings, and in this example he has chosen to paint his subject from above.

This not only neatly solves the problem of a separate background and foreground, it also allows him to make the most of the elegant shape of the metal platter.

Step-by-step: Arranging a Floral Group

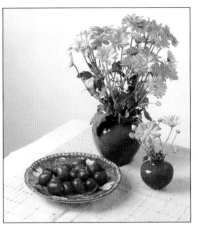

1 Because a vase of flowers makes a tall shape it often needs to be combined with other objects. Here, the small blue pot and the bowl of fruit harmonize with the pink and blue color scheme.

2 The long line of the back table edge is distracting: moving the group to the other end provides a more interesting corner view. Moving the small pot away from the vase makes each shape distinct.

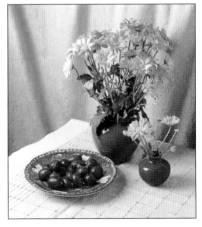

3 The background needs some color and "action," so a piece of blue fabric is pinned up and arranged to give a feeling of movement.

4 The napkin complicates the composition. It is removed.

Step-by-step: Cyclamen

1 A careful outline drawing was made of the flowers and pot, and then the flowers were painted in with a mixture of cadmium red and purple lake. Particular attention was paid to the arrangement of the spaces created by the flowers against the background.

2 The mid-to-light tones of the leaves in the center were laid on quite freely, sharper definition being reserved for those at the sides, to form a clear, sharp outline. The colors – emerald green, sap green, Payne's gray, and a touch of raw sienna – were put on wet and allowed to mix on the paper.

3 The leaves and flowers were darkened in places and a first wash was then laid on the pot. Here, too, the colors were applied wet and moved around on the paper until the artist was satisfied with the way they had blended together.

4 A very pale wash was put on the underside of the dish, leaving the rim white to stand out against the checks. The blue used was chosen to echo the blue on the pot, and the shadow was added later.

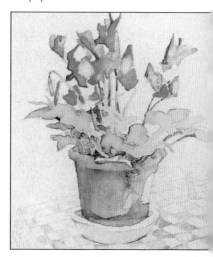

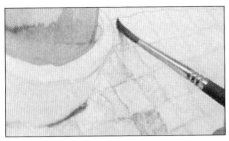

 5 Here the artist is using the tip of a sable brush to paint the blue checks. Although they were painted carefully, and varied in size and color to suggest recession, the artist has not attempted to produce perfectly straight or regular lines, which would have looked mechanical and monotonous.

 6 The wet-in-wet technique was used for painting the pot, giving it a lively appearance suggestive of light and texture. Widely varying colors were applied with plenty of water and blended into one another. If the paint is too wet, or blends in the wrong way, it can be dabbed off with a sponge or tissue.

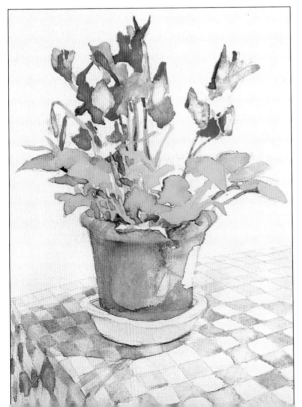

Flower arrangements are among the most popular of all still life subjects. Indeed, they are often regarded as a separate branch of painting. In purely practical terms, however, they are a type of still life, posing the same problems as well as sharing the major advantage of being a captive subject.

Step-by-step: Persimmon and Plums

1,2 Ronald Jesty is an artist who likes to exercise full control over his medium, and he works almost exclusively wet-on-dry. This painting has been planned very carefully, and is built up in a series of separate stages. First he transferred a full-scale drawing to the paper by drawing over a tracing.

He began with several small, neutral-colored washes and then painted the golden-brown background. He turned the board sideways to make it easier to take the paint around the edges of the bottle.

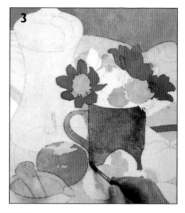

3 It is important to establish the color key early on, so once the background is complete he puts down a pale pinkish gray for the tabletop and areas of vivid red for the petals of the anemones. Without the background it would have been difficult to assess the strength of color needed for these. The next stages are the persimmon and the mug that holds the flowers, close in tone and color but with clearly perceptible differences. None of these areas of color is completely flat: the modeling on the persimmon and the jug begins immediately, with darker, cooler colors in the shadow areas, linked to the blue-gray of the mortar and pestle.

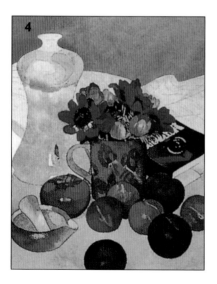

4 The flowers and fruit are now virtually complete, with the dark rich colors built up in a series of small, overlapping washes to leave highlights of varying intensity. The light blue-gray of the vase on the left represents the color and tone to be reserved for highlights.

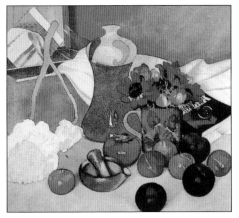

5 The box on the left is painted in a color that picks up that of the persimmons and yellow plums. Although the painting is vivid and colorful, the colors are deliberately orchestrated to give an overall strength and unity to the composition. A further wash is laid on the blue vase to stand as the mid-value highlights when the darkest values have been added.

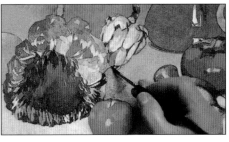

6 The complex forms of the artichoke head are described with delicate but accurate brush strokes. Again, the colors used are versions of those elsewhere in the painting – there are no blacks or dead browns even in the darkest outlines.

7 With the deep blues and purples of the jug now complete, the painting has a sure and definite focal point. Although the whole picture is eventful and there are some delightful touches, such as the book title we cannot quite read and the sketch on the left, our attention is drawn to the center by the strong, dark tones and glowing colors. It is not easy to achieve this intensity in watercolor without muddying the paint by overworking, and this is why Jesty plans so thoroughly. He overlays washes to a considerable extent, but avoids overworking by using barely diluted paint from the outset where the tones are to be dark.

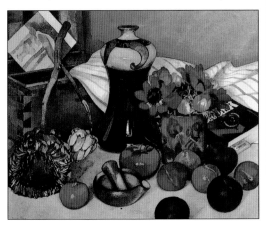

Plants and Flowers

Flowers, with their rich and varied array of glowing colors, intricate forms, and delicate structures, are an irresistible subject for painters. There are many different approaches to this branch of painting, all suited to the medium of watercolor. Flowers can be painted in their natural habitats or indoors as still life arrangements, they can be treated singly or in mixed groups, they can be painted in fine detail or broadly and impressionistically.

INDOOR ARRANGEMENTS

The great advantage of painting cut flowers indoors is that you can control the set up and work more or less at your leisure – at any rate until the blooms fade and die. The main problem is that flowers can look over-arranged, destroying the natural, living quality that is the subject's greatest charm. Always try to make them look as natural as possible, allowing some to overlap others, and placing them at different heights, with some of the heads turned away from and others toward you, as they would appear when growing in a garden.

Give equally careful thought to the overall color scheme – of the flowers themselves, the vase you put them in, and the background. Too great a mixture of colors can lead to a muddled painting that has no sense of unity because each hue is fighting for attention with its neighbor.

The best flower paintings are often those with one predominant color, such as white, blue, or yellow, with those in the background and foreground orchestrated to provide just the right element of contrast.

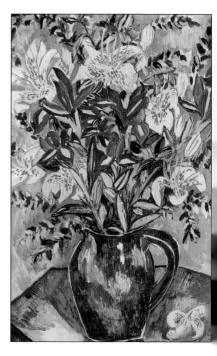

ABOVE: BRIGHT GARDEN BOUQUET
by Muriel Pemberton
Here the off-center placing of the vase and the way the flowers lean to the left give a rhythm to the composition, leading the viewer's eye around it from one area to another. Pemberton's technique is equally lively and varied.

RED ROSES IN A FLOWER BED
by Audrey Macleod

One of Macleod's concerns, whether she is painting flowers or portraits, is the overall design of her paintings. Here she has used the different characteristics of the plants to create a strong pattern in which soft, round shapes are contrasted with spikier, more angular ones. Parts of the paper have been left bare to stand as highlights.

COMPOSITION

A group of flowers tastefully arranged in an attractive vase always looks enticing – that, after all, is the point of putting them there – but it may not make a painting in itself. Placing a vase of flowers in the center of the picture, with no background or foreground interest, is not usually the best way to make the most of the subject – though there are some notable exceptions to this rule. So you will have to think about what other elements you might include to make the composition more interesting without detracting from the main subject.

One of the most-used compositional devices is that of placing the vase asymmetrically and painting from an angle so that the back of the tabletop forms a diagonal instead of a horizontal line. Diagonals are a powerful weapon in the artist's arsenal, as they help to lead the eye in to the center of the picture, while horizontal lines do the opposite.

One of the difficulties with flower groups is that the vase leaves a blank space at the bottom of the picture area. This can sometimes be dealt with by using a cast shadow as part of the composition, or you can scatter one or two blooms or petals beneath or to one side of the vase, thus creating a relationship between foreground and focal point.

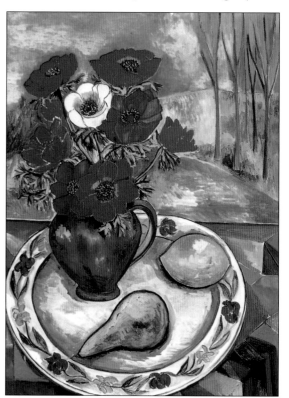

LEFT: ANEMONES
by Mary Tempest
This bold, highly patterned composition, with the emphasis on carefully distributed areas of bright color, is somewhat reminiscent of French painter Henri Matisse (1869–1954).

SINGLE SPECIMENS

The most obvious example of flowers and plants treated singly rather than as part of a group are botanical paintings. Botanical studies have been made since pre-Renaissance times and are still an important branch of specialized illustration. Many of the best of these drawings and paintings are fine works of art, but their primary aim is to record precise information about a particular species. For the botanical illustrator, pictorial charms are secondary bonuses, but artists, who are more concerned with these than with scientific accuracy, can exploit them in a freer, more painterly way.

However, this is an area where careful drawing and observation is needed. You may be able to get away with imprecise drawing for a broad impression of a flower group, but a subject that is to stand on its own must be convincingly rendered. Looking at illustrated books and photographs can help you to acquire background knowledge of flower and leaf shapes, but it goes without saying that you will also need to draw from life – constantly.

Most flowers can be simplified into basic shapes, such as circles or bells. These, like everything else, are affected by perspective, so that a circle turned away from you becomes an ellipse. It is much easier to draw flowers if you establish these main shapes before describing each petal or stamen.

ABOVE: CROWN IMPERIAL by Jenny Matthews
The shapes, structures, and colors of some flowers are so fascinating that they seem to demand the right to shine out proud and alone, without the need for background, foreground, or other diversions. This is certainly the case here.

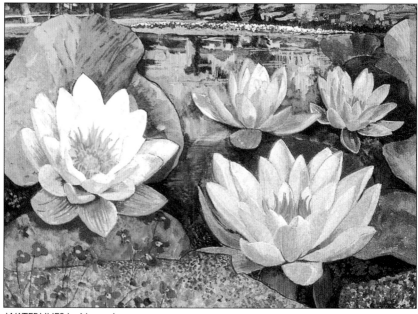

WATERLILIES by Norma Jameson

NATURAL HABITAT

Oddly, the term "flower painting" makes us think of cut flowers rather than growing ones, perhaps because most of the paintings of this genre that we see in art galleries are of arranged rather than outdoor subjects. Flowers, however, are at their best in their natural surroundings, and painting them outdoors, whether they are wild specimens in woods, hedgerows or city wastelands, or cultivated blooms in gardens, is both rewarding and enjoyable.

It can, however, present more problems than painting arranged groups indoors, because you cannot control the background or the lighting, and you may have to adopt a ruthlessly selective approach to achieve a satisfactory composition.

You will also have a changing light source to contend with. As the sun moves across the sky the colors and values can change dramatically, and a leaf or flower head that was previously obscured by shadow will suddenly be spot-lit so that you can no longer ignore its presence. The best way to deal with this problem, if you think a painting may take more than a few hours to complete, is to work in two or three separate sessions at the same time of day or to make several quick studies that you can then combine into a painting in the studio.

Narcissi in Sunlight

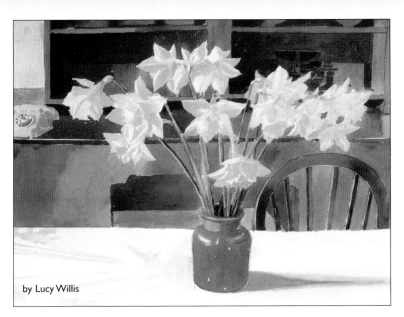

by Lucy Willis

ABOVE: *Flower forms are built up from light to dark with glazes of warm and cool color. Areas of white paper provide "breathing spaces." Flowers viewed from the back can be just as interesting as those viewed from the front.*

ABOVE: *Spontaneous brush strokes and lost and found edges give a sense of natural, living forms.*

Landscape

Watercolor has always been closely associated with landscape and seascape painting, and even with today's proliferation of new media for the artist there is still none more able to render the transient and atmospheric qualities of countryside, sea, and sky.

THE ENGLISH WATERCOLOR TRADITION

In England, the country which more than any other can claim to have founded the great tradition of landscape painting in watercolor, landscape was not really considered a suitable subject in its own right until the late eighteenth century. The formal, classical landscapes of the French artists, Claude Lorraine (1600–1682) and Nicolas Poussin (1594–1665), were much admired by artists and discerning collectors, as were the realistic landscapes of artists of the Dutch school such as Jacob van Ruisdael (1629–1682), but the general public in the main wanted portraits and historical subjects. The great English portrait painter, Thomas Gainsborough (1727–1788), had a deep love of his native landscape and regarded it as his true subject, but in order to earn a living he painted many more portraits than landscapes.

The two artists who elevated landscape and seascape to the status of fine art were Constable and Turner. Their influence on painting, not only in Great Britain but all over the world, was immeasurable. By the early

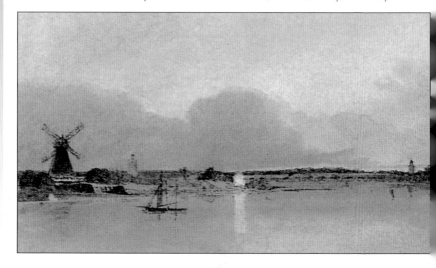

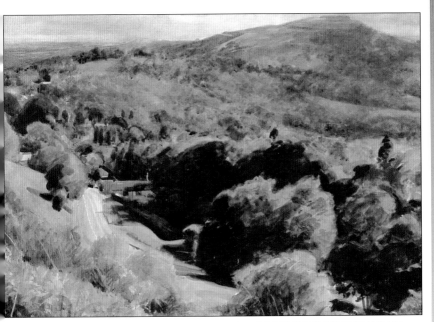

FAR LEFT: THE WHITE HOUSE, CHELSEA by Thomas Girtin

Thomas Girtin was a pioneer of watercolor painting much admired by his contemporary, Turner. He worked with only five colors — black, monastral blue, yellow ocher, burnt sienna, and light red — to create subtle evocations of atmosphere.

ABOVE: JUBILEE DRIVE, MALVERN HILLS by David Prentice

The brushwork is evident in this painting, particularly in the foreground trees, where dark strokes of different directions were laid over lighter colors.

nineteenth century landscape had arrived, and at the same time watercolor, a medium hitherto used for quick sketches and for coloring maps and prints, had become the chief medium for many landscape artists. Constable used watercolor as his predecessors had, as a rapid means of recording impressions, but Turner used it in a new and daring way and exploited its potential fully to express his feelings about light and color.

At much the same time John Sell Cotman, the cofounder of the school of painting known as the Norwich School, was producing some of the finest watercolor landscapes ever seen before or since. These paintings by the artists of the English watercolor school have never been surpassed; they became an inspiration to artists everywhere, and remain so today.

HINTS FOR OUTDOOR PAINTING

ABOVE: *A watercolor of stones at Avebury. The cool tones express the clarity of daylight and the calm grandeur of this ancient monument.*

Once landscape had become an "official" subject for painters, working outdoors directly from nature became increasingly common, the more so after the French Impressionists set the example. It is not now so popular. Photographers lining up to record a scenic view are a more usual sight than artists doing so. It is, however, an excellent discipline, which forces you to look hard at a subject and make rapid decisions about how to treat it and lends immediacy and spontaneity to the work itself.

Watercolor is a light and portable medium, ideally suited to outdoor work, but on-the-spot painting, whatever the medium, always presents problems. Chief among them is the weather. You may have to contend with blazing heat that dries the paint as soon as it is laid down, freezing winds that numb your hands, sudden showers that blotch your best efforts or wash them away altogether, and changing light that confuses you and makes you doubt your initial drawing and composition. If the weather looks unpredictable, take extra clothes (a pair of old gloves with the fingers cut off the painting hand are a help in winter), a plastic bag or case large enough to hold your board in case of rain, and anything else you can think of

for your comfort, such as a thermos of tea or coffee and a radio. If the sun is bright try to sit in a shaded place; otherwise the light will bounce back at you off the white paper, which makes it difficult or sometimes impossible to see what you are doing. If you are embarrassed by the comments of passers-by, using headphones to listen to your radio serves as an efficient insulation device. Some people also find it an aid to concentration, though others do not. Always take sufficient water and receptacles to put it in, and restrict your palette to as few colors as possible.

Choose a subject that genuinely interests you rather than one you feel you "ought" to paint, even if it is only a back garden or local park. If you are familiar with a particular area you will probably already have a subject, or several subjects, in mind. When

vacationing in an unfamiliar place, try to assess a subject in advance by carrying out a preliminary reconnaissance rather than dashing straight out with your paints. Finally, try to work as quickly as you can without rushing, so that the first important stages of the painting are complete before the light changes. If necessary make a start on one day and complete the work on another. Seascapes are especially difficult, since the color of the sea can change drastically — from dark indigo to bright blue-green, for example — in a matter of minutes. It is often advisable to make several quick color sketches and then work indoors from them.

BELOW: THE CLEARING by Roland Roycraft
Even in the highlight areas, snow is seldom pure white, and the shadows are darker than you might think.

TREES AND FOLIAGE

Trees are among the most enticing of all landscape features. Unfortunately, they are not the easiest of subjects to paint, particularly when foliage obscures their basic structure and makes its own complex patterns of light and shade.

To paint a tree in leaf successfully it is usually necessary to simplify it to some extent. Start by establishing the broad shape of the tree, noting its dominant characteristics, such as the width of the trunk in relation to the height and spread of the branches. Avoid becoming bogged down in detail, defining individual shapes in a manner that does not detract from the main mass. If you try to give equal weight and importance to every separate clump of foliage you will create a jumpy, fragmented effect. Look at the subject with your eyes half closed and you will see that some parts of the tree, those in shadow or further away from you, will read as one broad color area, while the sunlit parts and those nearer to you will show sharp contrasts of tone and color.

A useful technique for highlighting areas where you want to avoid hard lines is that of lifting out, while sponge painting is a good way of suggesting the lively broken-color effect of foliage. Dry brush is another favored technique, well suited to winter trees with their delicate, hazy patterns created by clusters of tiny twigs.

BELOW: LAKELAND TREE by Moira Clinch

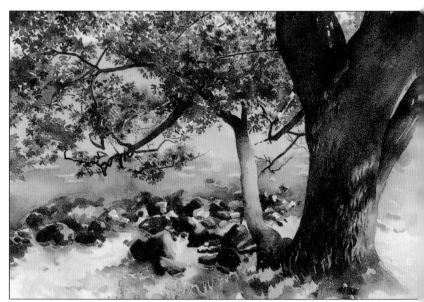

FIELDS AND HILLS

ABOVE: AMBERLEY AND KITHURST HILL, SUSSEX by Robert Dodd

Dodd has given drama to his quiet subject by the use of bold tonal contrasts and inventive exploitation of texture.

Hills and mountains always make dramatic subjects, their powerful presence needing only the minimum of help from the painter, but quieter country – flat or with gentle contours – can easily become dull and featureless in a painting. It is seldom enough just to paint what you see, so you may have to think of ways of enhancing a subject by exaggerating certain features, stepping up the colors or tonal contrasts, introducing textural interest, or using your brushwork more inventively. Interestingly, there have been artists throughout history who have believed that they have been painting exactly what they have seen, but they never really were – consciously or unconsciously improving on nature is part of the process.

Part of the problem with this kind of landscape is that, although it is often beautiful and atmospheric, much of its appeal comes from the way it surrounds and envelopes you. Once you begin to focus on the one small part of it you can fit onto a piece of paper, you often wonder what you found so exciting – a feeling well known to anyone who takes photographs. So take a page from the photographer's book and use a viewfinder – a rectangle cut in a piece of cardboard is all you need.

175

Step-by-step: Morning Headland

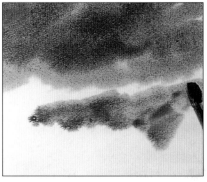

1 Working on stretched and well-dampened paper, the artist begins by dropping dark gray paint into light to create the effect of heavy clouds.

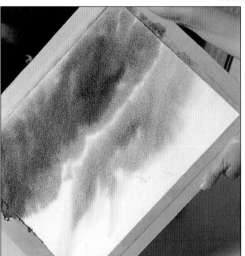

2 Holding the board sideways at a sharp angle makes the paint flow toward the bottom corner. You can exert control by varying the angle of the board; if the paint flows too far in one direction, simply reverse the angle.

3 The mountain was created by allowing the paper to dry slightly, laying a rough band of gray, and tilting the board upside down until the paint flowed into a suitable shape. The board was then laid flat.

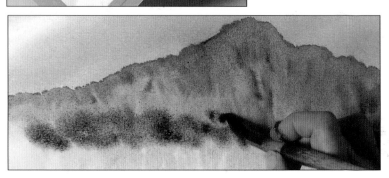

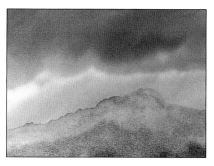

4 The paint will continue moving until it has dried. Be prepared to lose an effect you liked. The detail added in Step 3 became a series of blurred, rounded shapes.

5 The color flowed upward and downward, creating a jagged edge at the top of the mountains, and giving a realistic impression of a dark forest below.

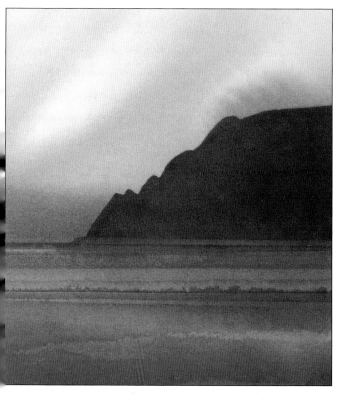

MORNING HEADLAND by Robert Tilling

This artist exploits the wet-on-wet method extensively in his atmospheric seascapes, but always combines it with wet-on-dry work. The sky and parts of the sea were painted wet-on-wet. The paper was allowed to dry before the dark headland – which required crisp edges – was added, and darker blues introduced into the sea.

Step-by-step: Distant Hills

1 The wash for the sky, put on with a No. 10 squirrel brush, was deliberately laid slightly unevenly to suggest a pale blue sky with a light cloud cover.

2,3 As soon as the wash for the sky was dry, the same squirrel brush was used to put on a darker shade, with Payne's gray added to the cobalt blue, to the area of the far hills.

The second wash had to be darker than that for the sky but not too dark, as the artist knew that he would have to increase the tonal contrasts in the middle distance to suggest its relative nearness to the picture plane.

4,5 As each wash has to be allowed to dry before putting on the next, in this particular technique, a hairdryer is sometimes used to hasten the process. The third and fourth washes, darker shades of the second, were laid on next, leaving the whole of the foreground and middle distance still untouched.

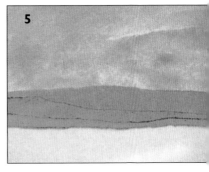

ROCKS AND MOUNTAINS

Mountains are a gift to the painter – they form marvelously exciting shapes, their colors are constantly changing and, best of all, unless you happen to be sitting on one, they are far enough away to be seen as broad shapes without too much worrying detail.

Distant mountains can be depicted using flat or semi-flat washes with details such as individual outcrops lightly indicated on those closer to you. For atmospheric effects, such as mist or light cloud blending sky and mountain tops together, try working wet-in-wet or mixing watercolor with opaque white.

Nearby rocks and cliffs call for a rather different approach, since their most exciting qualities are their hard, sharp edges and their textures – even the rounded, sea-weathered boulders seen on some seashores are pitted and uneven in surface and are far from soft to the touch. One of the best techniques for creating edge qualities is the wet-on-dry method, where successive small washes are laid over one another (if you become tired of waiting for them to dry, use a hairdrier to speed up the process). Texture can be built up in a number of ways. The wax resist, scumbling, or salt spatter methods are all excellent.

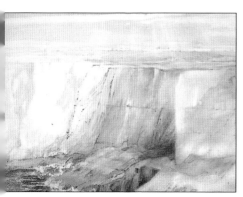

LEFT: WELSH CLIFFS by Michael Chaplin
Very light pen lines accentuate the directional brush strokes used for the sharp verticals of the cliff face, and texture has been suggested in places by sandpapering washes, a technique that works particularly well on the rough paper the artist has used.

Paint dabbed onto paper with a sponge looks entirely different from paint applied with a brush. You'll find you have an attractive mottled effect that is perfect for subjects like weathered stones or rocks. In the example on the right, several layers of sponging, using a pale gray-brown mixture with touches of yellow, create an accurate impression of the weathered, mottled surface of the rock.

Light and Weather

The British landscape painter John Constable (1776–1837) once said that "... the sky is the source of light and governs everything." Sky is, of course, the mirror of the weather, and it is part and parcel of all landscape, transforming it – sometimes in a matter of minutes – from a peaceful, sunny scene to a dark and brooding one.

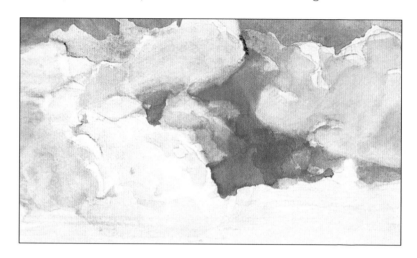

PAINTING CLOUDS

It is easy to think of clouds as simply gray and white, but if you look at them carefully, you will be surprised by the variety of colors they contain: the "white" areas may contain hints of pink, yellow, and blue, and the gray areas may appear purplish or brownish.

You will find that your clouds will gain a new vitality and luminosity if painted with delicately "colored" grays. For a start, reject black and try instead a mixture of ultramarine and burnt umber, or ultramarine and alizarin crimson as your darkening agent. Add water to lighten the color, and a touch of yellow ocher, raw sienna, or cadmium red for pink or yellow grays. You will find these mixes for grays more lively: adding straight black or white reduces the intensity of the mixture and produces a lackluster, often muddy gray.

Payne's gray is a very useful ready-mixed gray which is both a yellow and a pink gray. Once you have experimented with mixing grays. you will find that Payne's gray has its place and, like any other color, there are times when it is suitable to use it

straight. Payne's gray, because it is such a delicate mixture of colors, can safely be used for darkening other colors.

Pastel colors come ready-mixed in a choice of tints, which can be very useful for making speedy cloud studies. For example, yellow ocher tint 0 is the very palest tint of yellow, perfect for a sunlit highlight. It will save you from some blending, but it is worth remembering that colors which are not too uniformly combined are often more interesting than those which are efficiently blended.

Highlights are not always found on the tops of clouds – it depends on the position of the sun. In the early evening, when the sun is low, the highlights are underneath the clouds and often tinged pink or yellow. When the sun is high in the sky, the highlights on the tops of the clouds are yellow,

reflecting the sun, and the shadows underneath have a bluish tinge, reflecting the sky. Yellow ocher is better than lemon yellow for mixing sunlight highlights.

You will find that if you tint your grays with complementary colors, encouraging minute patches of the pure color, you will achieve more lively clouds.

BELOW: CARBIS BAY, ST IVES
by Ashton Cannel
The spaciousness of this painting is due in part to the treatment of the sky. There is perspective in skies, just as in land features. Clouds appear largest and most clearly defined when high in the sky directly above you, and smaller the closer they are to the horizon. The colors are also paler on the horizon, and usually lighter than distant cliffs or hills.

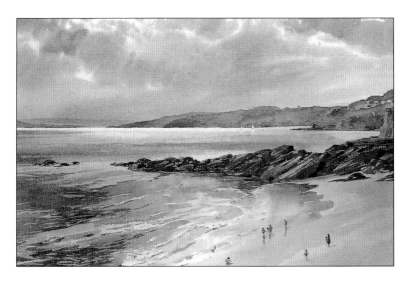

Cloud Formations

Clouds are always on the move – gathering, dispersing, forming, and re-forming – but they do not behave in a random way. There are different types of cloud, each with its own individual structure and characteristics.

To paint clouds convincingly you need to recognize the differences. It is also helpful to realize that they form on different levels, and this affects their tones and colors.

Cirrus clouds, high in the sky, are fine and vaporous, forming delicate, feathery plumes where they are blown by the wind. The two types of cloud that form on the lowest level are cumulus clouds, with horizontal bases and cauliflower-like tops, and storm clouds (or thunderclouds) – gray, heavy masses that rise up vertically, often resembling mountains or towers. Both these low-level clouds show strong contrasts of light and dark. A storm cloud will sometimes look almost black against a blue sky, and cumulus clouds are extremely bright where the sun strikes them and surprisingly dark on their shadowed undersides.

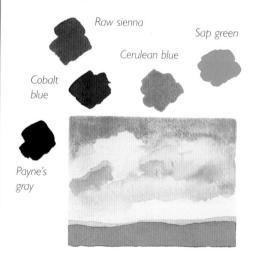

Raw sienna

Sap green

Cerulean blue

Cobalt blue

Payne's gray

Cerulean is a good blue, particularly for a summer sky. Here, the artist has encouraged it to be retained in the dips of the rough paper. Note the sharp edge painted around the highlit top edge of the cloud. The shadows are created by merging colored gray washes wet-in-wet; touches of raw sienna, Payne's gray, and cobalt blue are visible. Further darker grays are added wet-on-dry.

Step-by-step: Lifting Out Clouds

The technique of lifting out produces, with little effort, magic amorphous clouds. In this demonstration the sky is painted with a thin wash of yellow ocher, overlaid when dry with a thin wash ocher, overlaid when dry with a thin wash of Antwerp blue. The clouds are created by lifting out the paint before it dries, using a crumpled tissue. (Alternatively you could use a cloth, a sponge, or even a dry brush, depending on the type of cloud you are creating.)

1 The artist has to work fast. As soon as the wash is completed, a crumpled piece of tissue is used to gently dab off the blue paint. Slightly more pressure is applied to define the clean edge of the brightly lit top surface of the cloud.

2 Having established the outline, the tissue is reshaped and used to lift off the main body of the cloud. As you work, vary the pressure applied with the tissue to create the irregular shape of the cloud. Take care not to rub the paper or you will destroy the surface; use a press-and-lift motion.

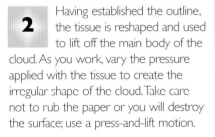

3 Cloud shadows appear, created by the thin layer of blue left by the lifting off process, combining with the yellow ocher wash beneath. To build up these shadows further, washes of gray are applied using the wet-in-wet technique.

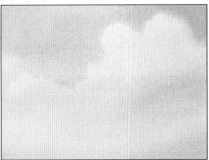

PAINTING SKIES

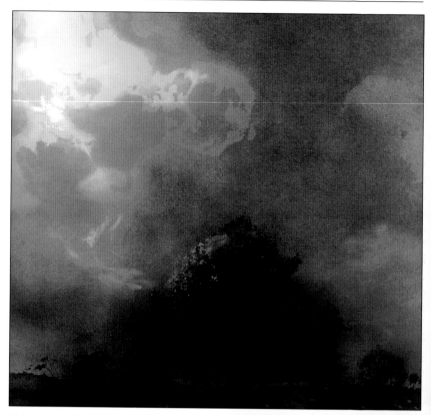

ABOVE: THE TEMPEST by Roland Roycraft
Besides being exciting to paint, skies also play a vital role in landscape composition. Here the sky is the main subject of the painting. Even when the sky occupies only a small part of a picture, you can use clouds (invent them if you like) to give extra color and movement to a landscape.

RIGHT: MOONLIGHT, NORWAY
by William Wyllie

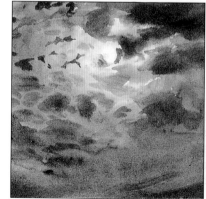

PAINTING A VIBRANT SKY

Inexperienced artists often find it difficult to capture the intensity of blue, and the light which emanates from it, of a high summer sky. On a clear day, the sky positively pulsates with light, but it is impossible to translate this into paint because pigment is opaque and absorbs light. The artist must therefore resort to artifice and create an *impression* of shimmering light by mixing colors optically – in the eye rather than on the paper or canvas. Optical mixes, as we all know, were used to great effect by the Impressionists in capturing the elusive nature of light. The principle is based on the fact that our eyes are unable to focus properly on small areas of color which are the same shade. The colors resonate on the retina, in effect "dazzling" us, just as light dazzles. For example, green can be mixed from yellow and blue; but a green composed of small dabs, flecks, or strokes of yellow and blue, left unblended, appears more vibrant because the pure yellow and blue are still discernible, and they resonate on the eye. (It is important to point out, however, that this only works if the constituent colors are of equal or near-equal value.) Optical mixes also appear more vibrant because the paint is applied in small dabs, strokes, and stipples, which themselves have more energy than a flat color. The trick with skies is to introduce hints of warm pinks, mauves, and yellows into the blues.

JUDGING THE TONAL STRENGTH OF BLUE SKY

When you are faced with the intense blue of the sky on a perfect summer's day, the temptation is to paint it with the deepest blue pigment you can conjure up. However, this could lead you into trouble because the shade of the sky can easily become too strong – and the rule is that a blue sky is always tonally lighter than the landscape below.

You may find it easier, particularly if the composition contains only a small area of blue sky, to paint the rest of the picture first and then add the sky in a lighter shade.

If, however, the sky dominates the composition, leaving an expanse of sky until last can impair your judgment of the values in the landscape below. In cases such as these, it is a good idea to block in the sky area with a pale blue wash and then work it up when the rest of the painting is well on its way. Working back and forth between the sky and the land is also a useful exercise; it helps to integrate the two, thus creating a more natural and atmospheric effect.

To help you judge the comparative tonal values in a complex landscape, look at it through almost closed eyes. This helps to take the colors out, leaving you better able to judge the tones.

THE QUALITY OF LIGHT

Any painting that aims in some way to represent the world around us by creating the illusion of reality, is a painting about light. None of the considerations with which the painter is occupied – value, color, form, space – is independent of it.

Light can be the source of inspiration as well as the means of revelation. When light sparkles on water, catches and animates a face, shines through the leaves of a tree, or gently illuminates a misty morning, we, as artists, are captivated and inspired. Yet light itself is an elusive and transitory thing.

In order to capture an accurate impression of light in your paintings, you have to be able to judge its quality. This quality can be seen in the color and strength of the light and the effect it has on our perception of what is before us. There are various factors which affect the quality of the light: the weather, the time of day, the time of year, and of course where exactly you are in the world and how close you are to the equator.

It can be very instructive to record in a series of sketches or paintings the effect that changing light throughout the day has on a particular scene. There are various things you will notice when you compare them.

Shade: The light is weaker in the early morning and evening when the sun is low in the sky, so the tonal values are softer and less intense. Such light reduces the limits of the value range, but it plays up the variety in the middle shades. In contrast, the power of the midday sun pushes the value range to its extremes, but you will find it bleaches out the subtle middle values.

Color: Sunlight can cast a cold, blue light in the early morning and a golden or pink light in the evening which will qualify all colors it falls on. At these times of day, colors are generally softer, graduating from highlight to shadow more gently. In bright sunlight, colors appear more vibrant with few middle shades between highlight and shadow.

Outline: You will notice that the weaker the light, the softer the outline an object has. In the light of dusk, even objects in direct light will have soft outlines, while those in deep shadow will be almost indistinct. Bright sunshine produces clearly defined edges where it shines directly on objects.

Shadows: As the sun travels across the sky, shadows alter in length, position, color, and value. Strong light produces dark, hard-edged shadows, while soft light produces paler, ill-defined shadows.

CHANGING LIGHT

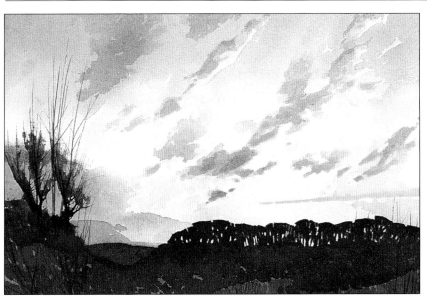

ABOVE: SUNRISE, NINE SPRINGS
by Ronald Jesty

Ronald Jesty has captured one of the those beautiful, accidental phenomena which make the sky a constant source of wonder and inspiration. The dark silhouette of the landscape accentuates the brilliance of the sky and focuses our attention upon the wonderful conformity of the clouds.

The great theatrical effects of light and color in the sky have produced some of the most magnificent and sublime works in the history of art. Glorious sunsets, towering banks of sunlit cumulus cloud, dark, storm-filled skies, the feathery patterns of cirrus clouds against a clear blue expanse: these are the kind of subjects that have attracted artists for generations.

Unfortunately, you cannot freeze the sun's relentless progress across the sky, so you have to learn to cope with it. "Work fast," they say – but that is always more easily said than done. You may find it helps to restrict yourself to working on a small scale, using a large brush and few colors. This will certainly discourage time wasted on detail, but you may not

want to produce this type of work. If you don't want to be hurried, you could try tackling the shadows first, and building up the painting around them. Still another solution is to paint for only an hour or so at a time, returning at the same time of day, until the painting is completed – if you can rely on the weather to remain constant, that is.

If you have to finish your painting in one sitting, amass as much information at the start as you can. Your visual memory can be improved if you work at it by concentrating hard and exploring every part of the scene as if you were painting it. Study the comparative values, scan the contours, explore the character of the patches of light and shadows. Some artists find that sketching these aspects in any detail tends to impair the power of the memory. But it helps to do both.

Unless you specifically want to paint a scene in bright sunlight, you will be better advised to paint outdoors on a slightly overcast day, when drastic changes in the position and intensity of lights and shadows are less likely to occur.

PAINTING SHADOWS

Without shadows, light does not exist. So if you want to paint pictures filled with sunlight, you will need to master the art of painting shadows. You can paint a bright highlight, but without an equally dark shadow to give it emphasis, that highlight will not mean anything. Shadows vary enormously, depending on the quality of light. In bright sunlight, shadows are hard-edged and dark; in more gentle light, they are subtle and indistinct. But more than that, changes in the quality of the light during the day and according to the season affect the shade, color, and configuration of the shadows cast.

It is a common mistake to regard shadows as negative areas of a painting. Not only do shadows help to strengthen the compositional structure, they can also contribute to the atmosphere of a scene and to the mood you wish to convey. For example, bright, crisp sunlight casts sharply defined areas of light and shadow that will emphasize the bracing atmosphere of a seaside scene. But that same scene, painted in late afternoon when the shadows lengthen and the light is hazy, will have an air of calm and peace.

Shadows are never completely black, and only rarely are they a neutral gray. The color of a shadow is influenced by the local color of the object on which the shadow falls, and by the color of the prevailing light. also, shadows are often tinged with colors complementary (opposite) to the color of the object casting the shadow; for instance, a yellow object may throw a shadow with a blue-violet tinge. Shadows vary in density, becoming lighter in shade the further they are from the object casting them.

ABOVE: MRS MAUDSLEY'S GREENHOUSE
by Ronald Jesty
In this wonderfully inviting picture it is the contrast between the intense, dark shadows and the bright sunshine that gives the strong impression of light and depth. The telling spots of dappled sunlight which break into the shadow on the wall heighten this effect and entice us into the illuminated greenhouse.

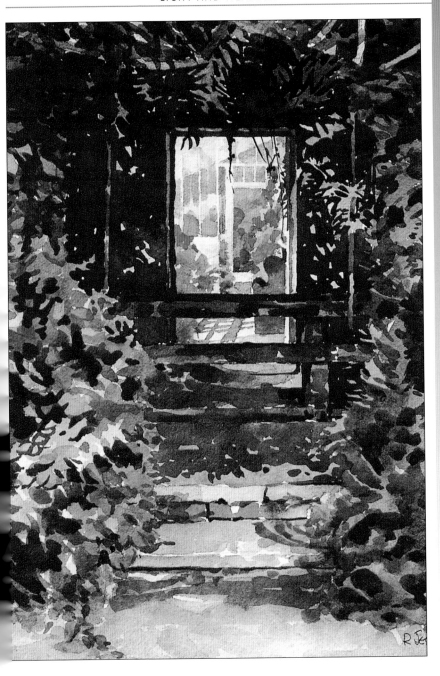

Step-by-step: Hot Sun

This watercolor painting speaks of the hot Mediterranean sun. The artist was attracted by the geometric pattern created by the strong verticals of the walls, countered by the diagonals of the roof against the sky and the mid-morning shadow cast across the wall. The artist's general plan is to work from cool to warm, starting with blues, through to yellows and finally red. In this painting the artist is working mainly from memory, but with the aid of a sketch supplemented with notes and photographs.

1 Having sketched in the outline of the composition, the artist applies masking fluid over those areas which are to be left white, such as the flowers in the foliage.

2 With a large softhair brush loaded with cerulean blue warmed with a little cobalt, the artist paints in the sky area and then the shadows.

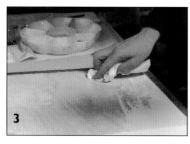

3 A wash of yellow ocher, applied wet-on-dry, runs down further than planned, so the paper is laid flat and a tissue is used to fashion the edge of the step.

4 Now the artist starts to work on the details, starting from the center of the painting with the foliage. The areas of dried masking fluid mean that a merged wash of dark and light green can be painted in without worrying about the intricate shapes of the flowers and stems.

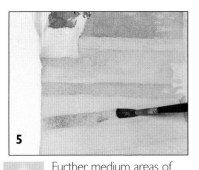

5 Further medium areas of shadow are located with diluted cobalt blue, applied with a small round brush to give more detail.

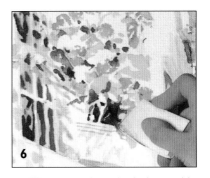

6 When the paint is thoroughly dry, the masking fluid is removed by rubbing with a soft kneaded eraser. Note the delicate, darker shadows which have been added to the window panes.

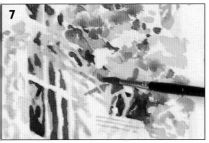

7 The geranium flowers are painted wet-in-wet. First, a pale pink underwash is applied and allowed to dry. It is then wetted and a spot of alizarin crimson is added and allowed to fuse and spread.

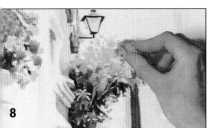

8 The artist decides that the foliage in the center is too hard-edged, so with a small piece of natural soft sponge she stipples on some green paint to soften it.

9 To make the painting "sing," a stronger dilution of yellow ocher is taken through the painting, representing reflected light. It is applied on the steps here using the dry brush technique with a flat bristle brush.

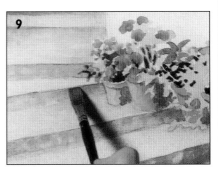

Step-by-step: Hot Sun (continued)

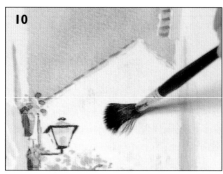

10 Finally, the gabled end of the house is knocked back with a gentle scumble of yellow ocher, applied with a dry brush in a circular motion.

BELOW: SPANISH STEPS by Hazel Soan
Finally satisfied, the artist declares the painting finished.

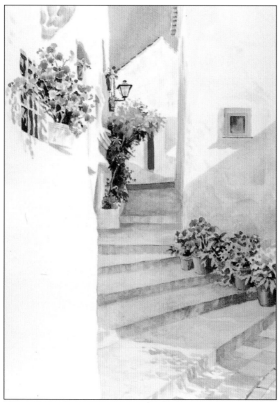

There is probably no subject quite as appealing as sunlight and shadow, and it is most pleasant to paint outside on a warm, sunny day under the shade of a tree.

Look carefully at the colors of shadows. They are rarely gray or black; they veer toward blue or mauve, crimson, or green, as they are colored by both the surfaces on which they fall and by reflection from adjacent objects. Analyze their shapes; like clothes draping a person's body, shadows can be used to describe the forms over which they lie.

MIST AND FOG

Sunny, warm days are much more inviting to the painter than wet, cold days. Yet if the practical problems of painting in bad weather can be overcome, painting in bad weather is exciting because of the transformation that takes place in the landscape. Rainstorms, fog, ice, and snow: each of these weather conditions has its own magic, and can turn an ordinary scene into a memorable painting.

On a foggy day you will notice how contrasts in color and tone are reduced to subtle modulations. The water vapor held in the air acts like a filter, neutralizing bright colors and flattening masses and contours. Dark tones appear lighter than normal, and light tones appear darker. The mist disperses the light so that shadows disappear and tonal contrasts are minimized. The effects of aerial perspective are more pronounced, so that objects only a short distance away seem to melt into a blur.

Capturing the veiled and mysterious aspect of a foggy landscape requires sensitive observation and a certain amount of restraint in handling the paint. Use subdued, harmonious colors and closely-related tones; too many sharp contrasts will destroy the illusion of all-enveloping mist. In watercolor, washes can be applied to damp paper and allowed to blur at the edges. In acrylics, oils, and pastels, use the techniques of blending and scumbling. Reserve any clear details and dark tones for the foreground; these will enhance, through contrast, the mistiness in the background.

Step-by-step: Wet-in-wet Mist

1 On a sheet of dampened paper, pale washes of rose madder are laid in horizontal strokes, starting at the top of the paper. While the paint is still wet, patches of color are lifted out with a small piece of dampened sponge to reveal the white of the paper.

2 The contours of hills are added, using a wash of cobalt blue mixed with light red. The paper is dampened once more to produce the softly dappled color of the sky and water.

SNOW SCENES

For those who rarely see snow and regard it as a treat, it is a sight that brings pleasure and excitement. For others it betides the onset of long weeks or months of cold and discomfort, so they greet it with a less positive attitude. As in all paintings of weather, the artist's emotional response to the subject is at least as important as the presentation of the facts. And it is not only moods that have to be recreated, but sensations such as cold and wet as well.

No wonder there are many who are intimidated by the prospect of painting snow. They feel unable to cope with such an expanse of white, and sub-zero temperatures do not exactly encourage them to take their paints outside to try. But even if you demur from braving the elements in order actually to paint, you can sketch a scene from the inside of a car, or simply take a walk and observe your surroundings with an artist's eye. Certainly it is worth studying at first hand the effect that snow has on the landscape and, particularly, the effect of different kinds of light on the snow itself. Getting closer to your subject in this way, you will soon discover that snow is a fascinating subject to paint.

If you have ever woken up in bed when there is snow outside, you will know how the room appears bathed in a cool light. This is because snow, being a highly reflective surface, reflects light from the sky in the same way that a body of water does.

For this reason, snow is rarely a blanket of pure white; its color is affected by the quality of the prevailing light. On a sunny day the sunstruck areas of snow appear dazzlingly white, but the yellow sunlight produces shadows which contain its complementary color – blue or blue-violet, depending on the warmth or coolness of the sunlight. Warm evening light creates softer highlights, often with a yellowish or pinkish tinge, and deep blue shadows.

In transparent watercolor you have to establish the position of the brightest highlights on the snow in advance and paint around them. Or you could try working on a toned paper and adding body color (Chinese white) to the colors. The slight chalkiness of Chinese white renders the appropriate powdery effect of snow.

Watercolor is the most economical medium for painting snow scenes, as you can leave some areas of white paper to represent the lightest lights. Model the contours in the snow with pale washes of blues, grays, and yellows. Use straight lines and hard edges where the snow is fresh and clean; indicate patches of melting snow by using scrubby drybrush strokes to represent the earth peeping through.

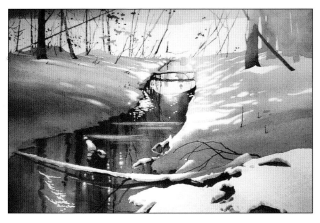

LEFT: THE CLEARING
by Roland Roycraft
Even in the highlight areas, snow is seldom pure white, and the shadows are darker than you might think. Here pale yellows and blues were laid as preliminary washes, but the strength of the deep blue-gray and blue-green shadows ensures that the highlights appear white.

BELOW: *Masking fluid was used in this painting to reserve the white paper for the snow on the branches. The snowflakes were made by spattering thick white gouache over the top half of the painting with a toothbrush.*

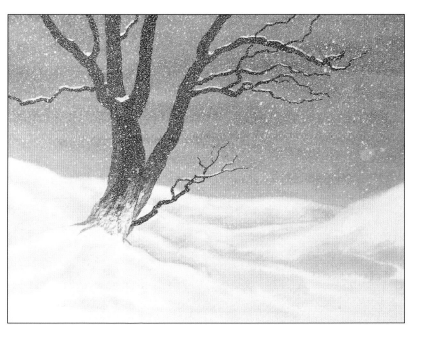

LIGHT ON WATER

The effects of light on water are almost irresistible. Obviously they can seldom be painted on the spot; a shaft of sunlight suddenly breaking through cloud to spotlight an area of water could disappear before you lay out your colors. But you can recapture such effects in the studio as long as you have observed them closely, committed them to memory and made sketches of the general lie of the land.

When you begin to paint, remember that the effect you want to convey is one of transience, so try to make your technique express this quality. This does not mean splashing on the paint with no forethought – this is unlikely to be successful. One of the paradoxes of watercolor painting is that the most seemingly spontaneous effects are in fact the result of careful planning.

Work out the colors and tones in advance so that you do not have to correct them by overlaying wash over wash. It can be helpful to make a series of small preparatory color sketches to try out various techniques and color combinations. Knowing

BELOW: THE RIVER GUADALUPE by Shirley Felts

This lovely painting shows a breathtakingly skillful use of reserved highlights. Each pale reflection, tiny sunlit twig and point of light has been achieved by painting around the area. This can result in tired, overworked paint, but here nothing of the luminosity of the watercolor has been sacrificed and it remains fresh and sparkling.

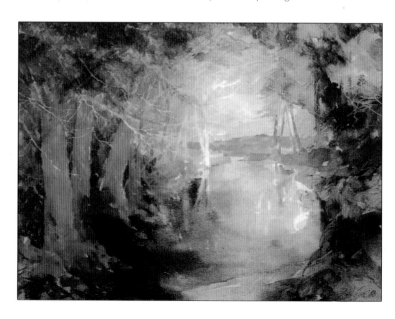

exactly what you intend to do enables you to paint freely and without hesitation. If you decide to paint wet-in-wet, first practice controlling the paint by tilting the board. If you prefer to work wet-on-dry, establish exactly where your highlights are to be and then leave them strictly alone or, alternatively, put them in last with opaque white used drily.

MOVING WATER

Most people have experienced the disappointment of finding that a photograph of a waterfall or rushing stream has completely failed to capture the movement and excitement of the subject. This is because the camera freezes movement by its insistence on including every tiny detail, and this provides an important lesson for the painter. You can never hope to paint moving water unless you simplify it, so learn to make "less say more" by looking for the main patterns and ruthlessly suppressing the secondary ones.

Rippling water under a strong light shows very distinct contrasts of tone and color, often with hard edges between the sunlit tops and the shadows caused by broken reflections. Working wet-on-dry is the best way of describing this edgy, jumpy quality, but avoid too much overlaying of washes, as this can quickly muddy the colors. masking fluid is very helpful here, as you can block out small highlights on the tops of ripples or wavelets while you work freely on the darker tones.

The wax resist method is tailor-made for suggesting the ruffled effect of a broken spray on the tops of breakers, while the delicate, lace-like patterns formed when a wave draws back from the beach can be very accurately "painted" by scraping back.

Whatever technique or combinations of techniques you decide on, use as few brushstrokes as possible – the more paint you put on the less wet the water will look.

STILL WATER

There are few sights more tempting to the painter than the tranquil, mirror-like surface of a lake on a still day or a calm, unruffled sea at dawn or dusk. But although it would be reasonable to believe still water to be an easy subject, particularly in a medium that has such an obvious affinity with it, it is surprising how often such paintings go wrong.

The commonest reason for failure is poor observation. A calm expanse of water is seldom exactly the same color and tone all over because it is a reflective surface. Even if there are no objects such as boats, rocks, or cliffs to provide clearly defined reflections, the water is still mirroring the sky and will show similar variations. These shifts in color and tone – often very subtle – are also affected by the angle of

viewing. Water usually looks darker in the foreground because it is closer to you and thus reflects less light.

It is also important to remember that a lake or area of sea is a horizontal plane. This sounds obvious, but has powerful implications for painting. A horizontal plane painted in an unvaried tone will instantly assume the properties of a vertical one because no recession is implied. It can sometimes be necessary to stress flatness and recession by exaggerating a darker tone or even inventing a ripple or two to bring the foreground forward.

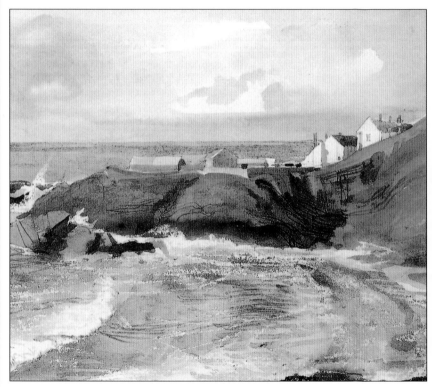

ABOVE: HEADLAND by Charles Knight
Knight is a committed land- and seascape painter, and a master of the watercolor medium. This wonderfully atmospheric painting provides the perfect illustration of the secondary role played by technique in art. He has made excellent use of wax resist for the waves and given a lovely feeling of movement and drama to the headland with crisp, dark pencil lines, but his techniques, although fascinating to analyze, remain "in their place" as no more than the vehicles which allow him to express his ideas.

Buildings

Watercolor is particularly well suited to architectural subjects. You can lay broad, flat washes of one color, or deliberately uneven ones suggesting the slightly irregular surface on old buildings. You can make clean, crisp edges, and define decorative details with a small brush. The paintings made by architects or professional architectural "renderers" to show prospective clients are more often in watercolor than in any other medium, and some of these are fine works of art in their own right.

LINEAR PERSPECTIVE

Many people are afraid of drawing and painting buildings because they have guessed that perspective matters a lot. But you will not make the problem go away by avoiding architectural subjects, because perspective matters whatever you are trying to represent – a landscape with a river winding into the distance, a bowl of fruit on a tabletop, a chair, a group of figures, or even a single figure.

The feelings of gloom and inadequacy that most people experience at the thought of learning perspective are not surprising. I was recently looking through an encyclopedia article on the subject, and was horrified by the complexity of the diagrams and the impossibility of relating them to anything real, such as a house, or even a table. But it need not be made as difficult as this, and I hope that the drawings and diagrams that you will see in this section of the book will dispel some of the darkness.

OPTICAL TRICKERY

Because the real world is three-dimensional and a painting is a flat surface, artists have over the centuries evolved a series of conventions, or tricks, to translate one into the other. Linear perspective is the most important of these, providing a way of

LEFT: HOTEL VIRGILIO, ORVIETO by Ray Evans
Here perspective gives a feeling of space, with the diagonal lines leading the eye toward the group of buildings.

making objects look solid and convincing by suggesting space and volume. There is another kind of perspective, called aerial perspective, which is concerned with tone and color. This is explained on pages 108 and 109.

In a way, perspective is the easiest part of painting because it is simply a set of rules that can be learned. The more advanced aspects of art, such as composition or the use of particular colors and shapes to create a specific mood, can involve a long-term personal quest and the conventions adopted are different for every artist, but perspective is the same for everyone. Once you have become familiar with the rules you will find that you can draw with much more confidence because they will have become second nature to you.

SIMPLE PERSPECTIVE

If you have a mathematical bent you could probably devote much of your life to the study of perspective, but this section is about buildings, so it makes sense to follow the "need to know" principle and keep matters as simple as possible. The whole system of perspective is founded on one basic tenet, which can be readily observed by eye – the apparent decrease in the size of objects as they recede towards the horizon. Suppose the objects in question are a series of simple cubes – then it follows that the

side planes will appear smaller the further away they are. And to make this happen the parallel lines have to become closer together (a geometrical impossibility but an optical fact) until they meet on the horizon line.

ABOVE: *One-point perspective is the term for the simplest kind of perspective, in which all the receding horizontal lines meet at the same vanishing point (called VP in this and all subsequent diagrams). In this case the artist has drawn from the middle of the street, so the vanishing point is in the center of the picture. If he had been further over to the right it would have been somewhere on the left. Often it is outside the picture, so you have to estimate its position.*

THE VANISHING POINT

This brings us to the golden rule that all receding parallel lines met at a vanishing point, which is on the horizon. This sounds simple, as indeed

it is, but where, you may ask yourself, is the horizon? It is easy enough when you are looking at an expanse of sea or a flat landscape – the horizon is where the land or sea meets the sky – but where is it located when you are in the middle of a city and can see nothing but houses? The answer is that the horizon is exactly at your own eye level, and this is what determines where the lines will converge. Normally, when you are sitting sketching or simply walking about, your eye level (horizon) will be lower than the tops of the buildings, so the horizontal lines of roofs and high windows will appear to slope down, but if you choose a high eye level, for example looking down on a group of houses from the top of a hill, the horizontal lines will slope upward.

Establishing the vanishing point is the essential first step when drawing and painting buildings, because it gives you a definite framework on which to work – the angle of every horizontal, from the top of a roof to the bottom of a door, is determined by it. If you are in the middle of a street, with a row of houses on either side, nothing could be easier – the vanishing point is directly in front of you and at your eye level. First mark in the horizon line and then lightly rule as many lines as you need to establish the diagonals of rooftops, window lines and so on.

If you are viewing at an angle, however, the vanishing point will no longer be in front of you and you will

have to work out its position. mark in the horizon as before, draw in the nearest vertical to the required height and then assess the angle of the rooftop by holding up a pencil or ruler in front of you. Extend this line to the horizon, and you have your vanishing point. Sometimes the vanishing point will be outside the picture area, in which case a certain amount of guesswork is involved, combined with careful observation.

VP Horizon

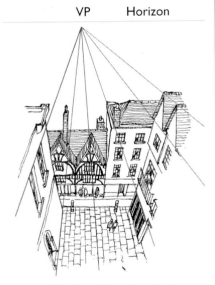

ABOVE: *High viewpoint is still one-point perspective, but because the scene has been viewed from above, the receding lines slope upward to the vanishing point instead of down, as in the drawing on the left. When you are working on location it is very important not to change your viewpoint, as this immediately alters the perspective. Try this out by holding up a ruler in front of you and then moving your head, or even shutting one eye.*

Step-by-step: Painting Buildings

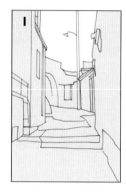

1 First make a drawing, then lay a flat or gradated blue wash for the sky and leave it to dry. Lay a very pale wash, perhaps yellow ocher with a touch of alizarin crimson, over the rest of the painting.

2 Paint the shadowed side of the building, then begin to darken the colors in the central area and foreground shadow. Paint the lamppost over the other colors.

3 Add further dark washes to the central area (notice shadows are blue-gray) and then begin to build up detail on the buildings.

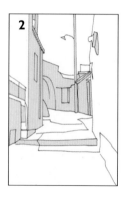

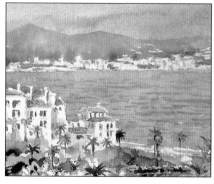

4 Continue to add detail and strengthen colors where necessary.

White buildings such as those adorning Mediterranean landscapes are best reserved as white paper. Define their shapes by using the colors of the landscape around them, so that they shine out like jewels against the dark terrain, then pick out details with small brush strokes.

Step-by-step: Granulated wash

Rough paper, a size 7 brush, and tube color are used to create a granulated wash for the stucco surface of the windmill. Use very wet paint and let the colors mix and settle undisturbed in the tooth of the paper.

1 Ultramarine and burnt sienna have been flooded into dampened paper. When dry, dampen the windmill and its reflection and paint a very wet, loose mixture of cerulean blue, yellow ocher, and burnt sienna. Watch it granulate as it settles.

2 Paint in the banks of the river and use granulating washes on the wall and cottage. Draw the sails with the tip of the brush.

3 When the windmill is dry, paint the windows in with very thick wet paint (indigo and Indian red); tilt the paper so the paint settles unevenly.

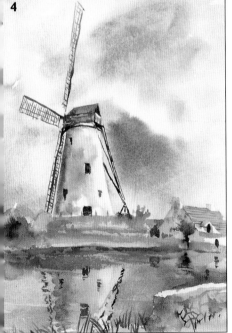

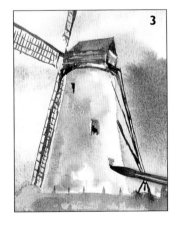

4 Dampen the shaded side of the windmill and, with a strong swift stroke, darken that side against the sky. Lay a broken glaze over the water and paint the foreground details.

INSIDE LOOKING OUT

The way in which you approach a view through a window depends very much on the aim of your painting. Window views, or glimpses of the outside world seen through open doors, have always fascinated artists, as they provide an intriguing and challenging set of pictorial possibilities. But like all good subjects, they have their attendant problems.

The main difficulties are those of creating a sense of space and emphasizing the different qualities of inside and outside without losing the unity of the picture. Of course, not everyone sees things in terms of space – some artists will deliberately ignore it, treating interior walls, windows and the outside landscape as a more-or-less flat area of color and pattern. If you want to do this, fine, but if your approach is more literal, the following advice may be helpful.

BELOW: INTERIOR WITH DESK AND CHAIR by John Lidzey
The houses outside have been deliberately "held back," with the minimum of detail and tonal contrast so that they do not compete with the interior.

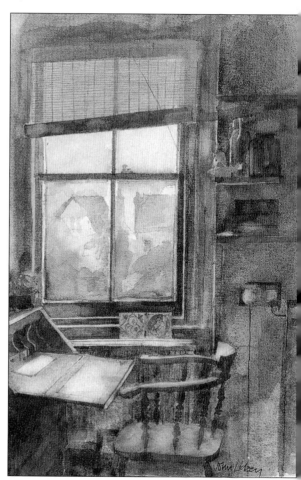

FRAMING A VIEW

First decide how much of the picture area is to be devoted to the view out of the window or door. Suppose this view is an exciting cityscape and you want to make it the main subject of the painting, with the window itself acting as little more than a frame around the edges. In this case, you can treat the scene just as you would if you were painting it outdoors. But you will have to give extra emphasis to the window in terms of tone or color – or both – because objects nearer to you always have brighter color and more tonal contrast (a more obvious division between light and dark) than those in the middle and far distance. This is a neat way of giving a feeling of space and recession to the view itself, because the window will immediately come forward to the front of the picture – known as the picture plane.

ABOVE: ROADSIDE CAFE by Moira Clinch
In this painting, the sharp contrast of light and shade between the front and the side of the building contributes to the strong sense of perspective. The deep shadows and bright highlights give an impression of the heat and glare of midday in New Mexico.

The Animal World

The animal kingdom presents the commonest of all problems to the would-be recorder of its glories: none of its members stay still long enough to be painted. One can usually bribe a friend to sit reasonably still for a portrait, but you cannot expect the same co-operation from a dog, cat, or horse. If movement is the essence of a subject, however, why not learn to make a virtue of it?

Watch an animal carefully and you will notice that the movements it makes, although they may be rapid, are not random – they have certain patterns. If you train yourself to make quick sketches whenever possible and also take sequences of photographs as an aid to understanding their movement, you will find that painting a moving animal is far from impossible – and it is also deeply rewarding.

Understanding the Basics

Painters and illustrators who specialize in natural history gain their knowledge in a wide variety of ways. Many take powerful binoculars and cameras into remote parts of the countryside to watch and record birds and animals in their natural habitats, but they also rely on illustrations and photographs in books and magazines or study stuffed creatures in museums. All this research helps them to understand basic structures, such as the way a bird's wing and tail feathers lie or how a horse or cow's legs are jointed. In the past, artists were taught that a detailed study of anatomy was necessary before they could even begin to draw or paint any living creature. Some wildlife painters, whose prime concern is accuracy, still do this, but for most this depth of study is unnecessary.

Sketching from Life

Although background knowledge is helpful because it will enable you to paint with more confidence, books and magazines are never a substitute for direct observation. When you are working outdoors, whether in a zoo or on a farm, try to keep your sketches simple, concentrating on the main lines and shapes without worrying about details such as texture and coloring. If the animal moves while you are in mid-sketch, leave it and start another one – several small drawings on the same page can provide a surprising amount of information. You may find it difficult at first, but quick sketches are a knack and you really will get better with practice,

Step-by-step: Squirrel

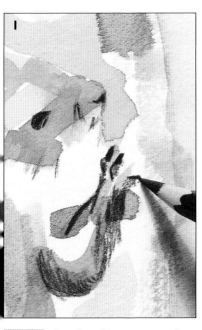

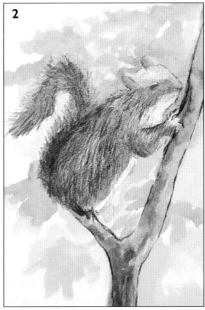

1 A series of loose watercolor washes are laid, and then a colored pencil is brought in to define the details.

2 For the soft gray fur, the artist uses a graphite pencil, making use of the slight grain of the paper to give a broken texture.

3 Fine lines are then added on top with white gouache to indicate the silvery shimmer so characteristic of a squirrel's fur.

BIRDS

Birds are a perennially appealing subject, but they are also a complex one. The fur of a smooth-haired animal does not obscure the structure beneath, but the feathers of a bird do — if you look at a skeleton in a museum you may find it hard to relate it to the living, feathered reality. To portray a bird convincingly it is important to understand the framework around which it is "built," and the way the small feathers follow the contours of the body while those of the wing and tail extend beyond it. Never be ashamed to draw on the store of knowledge built up by others: look through natural history books and photographs in wildlife magazines as well as sketching birds whenever you can.

If you are painting birds in their natural habitat, you will need to concentrate on shape and movement rather than detail. Both the line and wash and the brush drawing methods are well suited to this kind of broad impression, but the two most exciting features of birds, particularly exotic ones, are color and texture, and many bird painters employ a more detailed technique to show these in their full glory. You can practice painting feathers and discover ways of building up texture by working initially from a photograph or another artist's work or even by painting a stuffed bird. If you find that watercolor is hard to control or becomes overworked, you could try gouache, acrylic, or one of the many mixed media techniques.

ABOVE: MACAWS by Laura Wade. Watercolor, gouache, and colored pencils
The artist has made good use of mixed media to build up the bird's vivid colors and delicate textures. Like many professional illustrators, she used photographs as well as drawings from life for her reference.

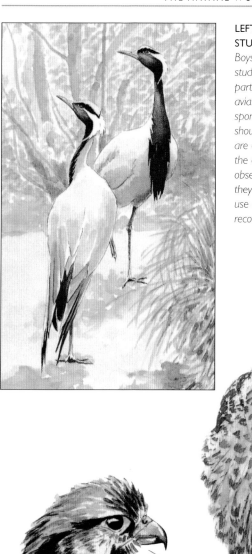

LEFT AND BELOW: SKETCHBOOK STUDIES by David Boys

Boys is a professional wildlife artist, whose studies are used by the London Zoo as part of the information labels outside their aviaries and animal cages. The free and spontaneous appearance of his sketches should not blind us to the fact that they are extremely accurate, and each one is the end-product of several days of careful observation and careful drawing. However, they provide an excellent example of the use of watercolor as a medium for recording rapid impressions.

DOMESTIC AND FARM ANIMALS

SHANDIE by Ronald Jesty

Although this is not a particularly small picture, the artist has chosen a circular format reminiscent of a miniature for his delightful dog portrait and has adapted his technique to suit the idea. His usual style, illustrated elsewhere in this book, is a precise yet bold use of wet-on-dry, but here, although still working wet-on-dry, he has used very fine, linear brushstrokes to build up the texture of the fur. The buildings behind are treated in equal detail, but with the tones and colors carefully controlled so that they recede into the background.

All the best paintings are of subjects that the artist is deeply familiar with. Rembrandt (1606–1669) painted himself, his wife and his children, while much of John Constable's (1776–1837) artistic output was inspired by his native Suffolk. So if you want to paint animals and have a captive subject, such as your own dog, cat, or pet rabbit, why not start at home?

One of the great advantages of pets is that they are always around and you can make studies of them sleeping (cats are particularly good at this), running, eating, or simply sitting in contemplation. If you live in the country, on or near a farm, sheep, cows, and goats are also willing models, as they tend to stand still for long periods when grazing. One of the commonest mistakes in painting an animal is to pay insufficient attention to its environment, so that it appears to be floating in mid-air. Whether you are painting a cat lying on a windowsill or a cow in a field, always try to integrate the animal with the background and foreground, blurring the edges in places to avoid a cut-out effect.

The techniques you use are entirely a matter of personal preference and will be dictated by your particular interests, but it is worth saying that if you opt for a very precise method, using small brushstrokes to build up the texture of an animal's fur or wool, you must use the same approach throughout the painting or the picture will look disjointed and unreal.

Step-by-step: Horse's Head

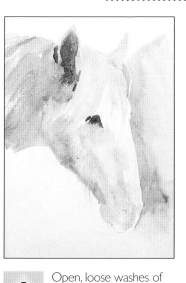

2 Further transparent washes painted wet-on-dry complete the modeling of the head, and are left to dry before the fine hairs over the jaw are suggested with dry brush work.

1 Open, loose washes of blue-gray over a light pencil sketch create the initial light and shade.

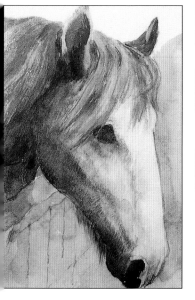

3 A pencil is then used for added definition in the mane.

4 With any watercolor, too much fiddling around can lose the freshness of the initial washes, so the dry brush and pencil work has been kept to a minimum.

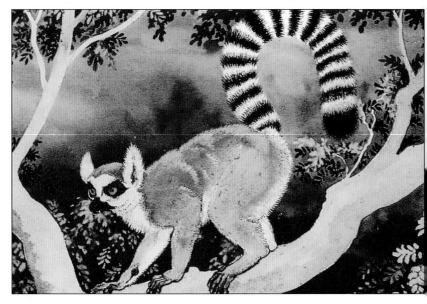

WILD ANIMALS

Painting wild creatures in their natural habitats is becoming an increasingly specialized branch of art, mainly because it involves so much more than simply painting. Professional wildlife artists devote their lives to watching and studying birds and animals in the field, often using sophisticated equipment such as powerful binoculars and cameras with telephoto lenses. However, this does not mean that wild animals are beyond the reach of the ordinary artist. Wildlife is the bread and butter of these specialist painters, and their patrons often require a high standard of accuracy, but not all those who want to paint animals need to be so constrained.

There is no need, either, to choose inaccessible subjects. Deer, for

ABOVE: RING-TAILED LEMUR by Sally Michel
Michel trained as an illustrator, but began to exhibit paintings when her book illustration work decreased. She became a wildlife artist more or less by accident and is well known as a painter of cat and dog portraits.

example, are eminently paintable and will often come quite close to the viewer in country parks, while shier, more exotic creatures can be sketched at zoos. A zoo, of course, is not a true habitat for a lion, tiger, or monkey, so if you want to use sketches for a painting of a tiger in a forest you may have to resort to books and magazines for a suitable setting. There is nothing wrong with this — after all, not everyone has the opportunity to paint the forests of Asia and Africa from firsthand experience.

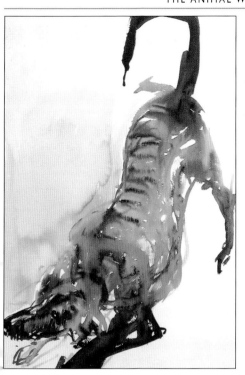

LEFT: DOG WITH A STICK III
by Lucy Willis

Willis has painted rapidly without waiting for washes to dry, so that some brush strokes have run together. This is offset by crisp brush work on the muzzle and front paws.

In the dramatic study of an owl in flight (below) the artist uses very loose brush marks, which not only capture the texture of the feathers but also accentuate the impression of flight.

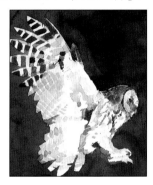

MOVEMENT

When we watch an animal in movement, such as a horse galloping, our eyes take in an overall impression of shape and color but no precise details – these become blurred and generalized in direct ratio to the speed of the animal's movement. The best way of capturing the essence of movement is to choose a technique that in itself suggests it, so try to keep your work unfussy, applying the paint fluidly and letting your brush follow the direction of the main lines. Alternatively, you could try watercolor pastels or crayons, which can provide an exciting combination of linear qualities and washes. A sketchy treatment, perhaps with areas of paper left uncovered, will suggest motion much more vividly than a highly finished one – the surest way to "freeze" a moving animal is to include too much detail. This is exactly what the camera does: a photograph taken at a fast shutter speed gives a false impression because it registers much more than the human eye can. Photographs, though, are enormously useful for helping you to gain an understanding of the way an animal moves and there is no harm in taking snapshots to use as a "sketchbook" in combination with direct observation and on-the-spot studies.

TEXTURES

The fur of an animal or the feathers of a bird are among their most attractive features, but they do present certain problems.

One is that too much attention to texture, the animal's "outer covering," can obscure the underlying form and structure, so you must be careful to paint textures in a way that hints at the body beneath. Perspective makes all objects appear smaller as they recede into the distance, and in the same way the brushstrokes you make to represent fur must vary in size, becoming smaller as the form recedes away from you.

The other problem is the more technical one of how to represent soft fur or stiff, bristly hair with an aqueous medium. Take heart – this is not a real problem at all, but only in

the mind, springing from the widely held belief that watercolor can only be used in a broad and fluid manner. In fact, the medium is an extremely versatile one, as can be seen from the illustrations throughout the book.

Fine, linear brushstrokes are an excellent way of painting fur or feathers and, if necessary, the paint can be thickened with opaque white to give it extra body. Another useful technique is dry brush, which can be worked over a preliminary wash or straight onto white paper, while the perfect method for highlighting tiny details, such as whiskers catching the light, is scraping back with the point of a knife, which gives an infinitely finer line than can be achieved with a brush.

BELOW: YOUNG HIMALAYAN FOX
by Sally Michel
Pastel was laid over watercolor washes to build the dense texture of the animal's fur.

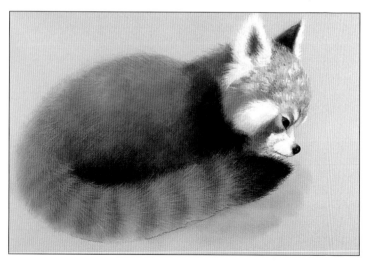

Figures and Portraits

The human face and figure can seem an impossibly ambitious subject, and that is why it was saved for the end of this book. Ambitious it may be, but it is certainly not impossible, and by now you will have acquired enough skill in handling watercolors to tackle human subjects with a degree of confidence.

PROPORTIONS OF THE FIGURE

The key to successful figure drawing is to get the various parts of the body in their correct proportions. This is easier said than done, since our eyes tend to mislead us into seeing some parts as larger or smaller than they really are. The hands and feet, for example, are frequently drawn too small.

Most artists gauge body proportions by taking the head as their unit of measurement. Allowing for slight differences from one person to another, the adult human figure measures seven to seven-and-a-half heads from top to bottom. Although no two people are exactly alike, it is helpful to memorize the proportion of the "ideal" figure and keep these in mind as you draw.

RIGHT: *The rule that the head fits into the body about seven times is a useful one, but no human conforms absolutely to the norm, so use your observation along with your knowledge. The greatest variation is found in the hips and shoulders.*

DRAWING OR PAINTING THE HEAD

When drawing and painting the head, as in a head and shoulders portrait, it is important to remember that the features occupy a relatively small part of the head. The bottom of the eye socket is the mid-point. Beginners often make the features too large, with the eyes placed too high. Although faces vary widely (and the first step to successful portraiture is being able to pick out individual differences in proportions) you'll find it useful to remember the basic rules.

The task of drawing the human head becomes much easier if you break it down into manageable portions: first, draw an outline of the head, then sketch guidelines to enable you roughly to position the features, and finally adjust the position of the features according to the individual face before you.

The easiest way of visualizing the shape of the head is to think of it as an egg sitting on top of the cylinder of the neck. Seen from the front, the egg is upright, while from the side it is tilted at roughly 45 degrees. Having established the shape of the head, you can position the features, and here the "rule of halves" is useful. Lightly sketch a horizontal line halfway down the head; this marks the position of

the eyes, and from here it is easy to gauge the eyebrow line. Sketch a line midway between the eyebrow line and the base of the chin in order to find the position of the base of the nose; then draw a line midway between the base of the nose and the chin to find the line of the lower lip. Finally, draw a vertical line down the center of the head to guide you when positioning the features on either side.

BELOW: PLACING THE FEATURES
A common mistake is to underestimate the size of the forehead and top of the head, and place the eyes too high up. It is helpful to remember that the mid-point of the head – allowing for individual differences – is the bottom of the eye sockets.

THE HEAD FROM AN ANGLE

One of the most difficult things when drawing a head is to apply the "rules" of proportion if the head is seen in semi-profile, or is tipped back or forward. From the angles, the eyes, nose and mouth may appear compressed together or distorted, because they are seen from a fore-shortened viewpoint. Because our mind finds it difficult to accept these distortions, and therefore tries to recreate the head-on measurements, the proportions of the head and the positioning of the features have a tendency to go awry.

Drawing the head from an angle involves careful observation and some precise measuring. As you draw, use your pencil as a tool to measure the distance between, say, the nose and the back of the ear and then compare that with the distance from, say, eyebrow to chin. By constantly measuring and comparing in this way you should arrive at an accurate result.

TILTING THE HEAD

When the head is tilted, the features are seen in perspective. To place the features correctly, see the head as an egg shape and draw some light guidelines around it, as shown in these three examples.

Skin Tones

LIGHT SKINS

The best approach to painting skin is to establish the overall color and make a suitable mixture. This can then be lightened for highlights by adding water, and darkened for shadows using touches of blue or green. There is no recipe for skin colors, as they vary so much, but for most light skins yellow-ocher and red will be among the colors used. Here are some suggestions for "basic skin colors." Payne's gray or raw umber can be used for shadows.

DARK SKINS

Again, look for the predominant color, which may be yellow brown, reddish brown, or even bluish brown. There are often considerable color variations between the highlights and the shadow areas, but these will always be related. If you mix the main color and add darker colors for the shadows, you won't go wrong. If you use too many different colors you may create a disjointed effect. The color combinations shown provide a starting point. Viridian or indigo can be used for shadows.

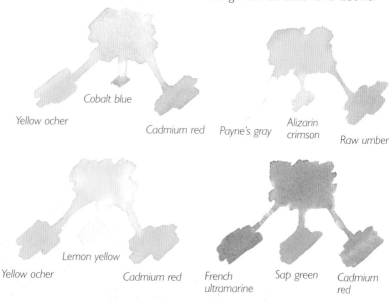

Cobalt blue

Yellow ocher

Cadmium red

Payne's gray

Alizarin crimson

Raw umber

Lemon yellow

Yellow ocher

Cadmium red

French ultramarine

Sap green

Cadmium red

Step-by-step: Painting Hair

1 After making a light preliminary pencil drawing, broad, loose washes are laid over the whole of the hair. These are allowed to dry before crisper definition is added.

2 The artist is aiming at a hard-edged effect, so he works wet-on-dry to give distinct edges to each wash. He also uses masking fluid to reserve the clearer highlights.

3 In the final stage the effect of the masking fluid can be clearly seen, giving the effect of "negative" brushstrokes in the area above the forehead.

Glossary

Alla prima A direct method of painting in which an image is developed in wet pigment without reliance on preliminary drawing or underpainting.

Binder A medium which can be mixed with powder pigment to maintain the color in a form suitable for painting or drawing.

Blocking in The techniques of roughly laying out the forms and overall composition of a painting or drawing in terms of mass and tone or color.

Body color Paint, such as gouache, which has opacity and therefore covering power. In watercolor this can be achieved by adding white to eliminate transparency.

Broken color This is an effect achieved by using colors in a pure state, without blending or mixing them, and dragging paint of a stiff quality across the support so that previous layers can be seen through the new application.

Complementary colors There are three basic pairs of complementary colors, each consisting of one primary and one secondary color.

Composition The arrangement of various elements in a painting or drawing, for example, mass, color, tone, contour etc.

Cross hatching A technique of laying an area of tone by building up a mass of criss-cross strokes rather than with a method of solid shading.

Dry brush A means of applying watercolor with a soft, feathery effect by working lightly over the surface with a brush merely dampened with color. The hairs may be spread between finger and thumb.

Foreshortening The effect of perspective in a single object or figure, in which a form appears considerably altered from its normal proportions as it recedes from the artist's viewpoint.

Fresco A technique of painting in which color is applied to a ground of fresh plaster.

Gouache A water-based paint made opaque by mixing white with the pigments. Gouache can be used, like watercolor, to lay thin washes of paint but because of its opacity it is possible to work light colors over dark and apply the paint thickly.

Grain The texture of a support for painting or drawing. Paper may have a fine or coarse grain depending upon the methods used in its manufacture.

Ground The surface preparation of a support on which a painting or drawing is executed. A tinted ground may be laid on white paper to tone down its brilliance.

Gum arabic A water soluble gum made from the sap of acacia trees. It is used as the binder for watercolor, gouache, and soft pastels.

Half tones A range of tones or colors which an artist can identify between extremes of light and dark.

Hatching A technique of creating areas of tone with fine, parallel strokes following one direction.

Hue This term is used for a pure color found on a scale ranging through the spectrum, that is red, orange, yellow, green, blue, indigo, and violet.

Impasto A technique of applying paint thickly so that a heavy texture is discernible, created by brush or knife marks. Gouache, having more body than watercolor, is suitable for this technique and impasto is commonly used in oil painting.

Masking A technique of retaining the color of the ground in parts of a painting by protecting it with tape or masking fluid while colors are applied over and around the masked areas.

Medium This term is used in two distinct contexts in art. It may refer to the actual material with which a painting or drawing is executed, for example, gouache, watercolor, or pencil. It also refers to liquids used to extend or alter the viscosity of paint, such as gum or oil.

Not A finish in high quality watercolor papers which falls between the smooth surface of hot pressed and the heavy texture of rough paper.

Ochers Earth colors derived from oxide of iron in a range from yellow to orange-red.

Opacity The quality of paint which covers or obscures a support or previous layers of applied color.

Palette The tray or dish on which an artist lays out paint for thinning and mixing. This may be of wood, metal, china, plastic, or paper.

Pastel A drawing medium made by binding powder pigment with a little gum and rolling the mixture into stick form.

Perspective Systems of representation in drawing and painting which create an impression of depth, solidity and spatial recession on a flat surface.

Pigment A substance which provides color and may be mixed with a binder to produce paint or a drawing material.

Primary colors In painting the primary colors are red, blue, and yellow. They cannot be formed by mixtures of any other colors, but in theory can be used in varying proportions to create all other hues.

Resist This is a method of combining drawing and watercolor painting.

Sable The hair of this small, weasel-like animal is used in making soft brushes of fine quality which are usually favored by watercolor artists.

Scumbling A painting technique in which opaque paint is dragged or lightly scrubbed across a surface to form an area of broken color which modifies the tones underneath.

Secondary colors These are the three colors formed by mixing pairs of primary colors; orange (red and yellow), green (yellow and blue), and purple (red and blue).

Spattering A method of spreading paint with a loose, mottled texture by drawing the thumb across the bristles of a stiff brush loaded with wet paint so the color is flicked onto the surface of the painting.

Stippling The technique of applying color or tone as a mass of small dots, made with the point of a drawing instrument or fine brush.

Study A drawing or painting, often made as preparation for a larger work, which is intended to record particular aspects of a subject.

Support The term applied to the material which provides the surface on which a painting or drawing is executed, for example, canvas, board, or paper.

Tone In painting and drawing, tone is the measure of light and dark as on a scale of gradations between black and white.

Tooth A degree of texture or coarseness in a surface which allows a painting or drawing material to adhere to the support.

Transparency A quality of paint which means that it stains or modifies the color of the surface on which it is laid, rather than obliterating it. Watercolor is a transparent medium and color mixtures gain intensity through successive layers of thinly washed paint.

Underpainting A technique of painting in which the basic forms and tonal values of the composition are laid in roughly before details and local color are elaborated.

Value The character of a color as assessed on a tonal scale from dark to light.

Wash An application of paint or ink considerably diluted with water to make the color spread quickly and thinly. Transparency is the vital quality of watercolor and ink washes whereas gouache washes are semi-transparent.

Watercolor Paint consisting of pigment bound in gum arabic, requiring only water as the medium or diluent. Transparency is the characteristic of watercolor as compared with other types of paint and the traditional technique is to lay in light tones first and build gradually to dark areas.

Watermark the symbol or name of the manufacturer incorporated in sheets of high quality watercolor paper. The watermark is visible when the paper is held up to the light.

Wet-in-wet The application of fresh paint to a surface that is still wet, which allows a subtle blending and fusion of colors. Watercolor artists often prefer to lay washes wet over dry so that a series of overlapping shapes creates the impression of a structured form.

Index

Picture Credits

The material in this book previously appeared in:

Watercolor Techniques Source Book; The Complete Watercolor Artist; Watercolor Step-by-Step; The Encyclopedia of Watercolor Landscape Techniques; The Artist's Manual; Practical Watercolor Techniques; The Complete Drawing and Painting Course; The Complete Artist; Painting in Watercolor; The Encyclopedia of Watercolor Techniques; The Illustrated Book of Watercolor Techniques; The Illustrated Book of Painting Techniques; Watercolor School; Light How to See It, How To Paint It; Watercolor Painter's Question & Answer Book.